Images of America
High Road to Taos

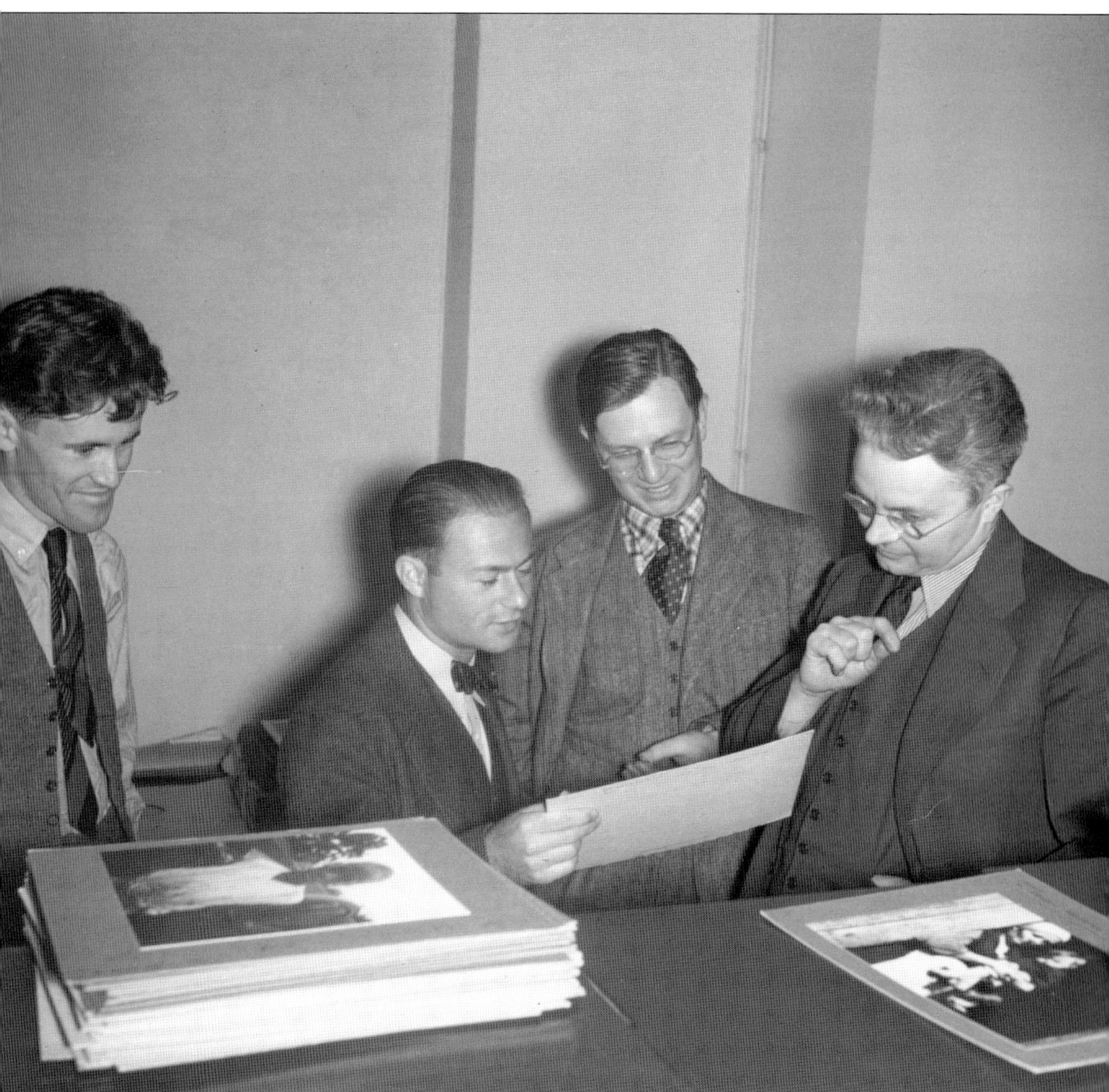

FARM SECURITY ADMINISTRATION PHOTOGRAPHERS, 1937. This photograph taken by Beaumont Newhall shows, from left to right, Farm Security Administration (FSA) photographers John Vachon, Arthur Rothstein, and Russell Lee meeting with their boss, Roy E. Stryker. Photographs by Rothstein and Lee of High Road to Taos villages are included in this book. (Courtesy of Library of Congress, LC-DIG-ds-01154.)

ON THE COVER: LAS TRAMPAS, JANUARY, 1943. John Collier Jr., another FSA photographer, captured this view of Las Trampas looking northeast to the high mountains of the Sangre de Cristo Range. The tall building in the left center is the San Jose de Gracia Church, constructed in 1760. Snow blankets the ground, and the truck seems to need a new tire on the right rear. (Courtesy of Library of Congress, LC-USW3-017751-E.)

IMAGES of America
HIGH ROAD TO TAOS

*To Rose and Carey
Enjoy the High Road!*

Mike Butler

Copyright © 2016 by Mike Butler
ISBN 978-1-4671-1605-3

Published by Arcadia Publishing
Charleston, South Carolina

Printed in the United States of America

Library of Congress Control Number: 2015952318

For all general information, please contact Arcadia Publishing:
Telephone 843-853-2070
Fax 843-853-0044
E-mail sales@arcadiapublishing.com
For customer service and orders:
Toll-Free 1-888-313-2665

Visit us on the Internet at www.arcadiapublishing.com

This book is dedicated to all the past, present, and future residents of the High Road communities and to those who travel along it.

Contents

Acknowledgments		6
Introduction		7
1.	Nambé, Chimayó, and Córdova	11
2.	Truchas and Ojo Sarco	25
3.	Las Trampas	43
4.	Chamisal	73
5.	Picurís Pueblo, Peñasco, Vadito, and Placita	93
6.	Pot Creek, Fort Burgwin, Talpa, and Ranchos de Taos	107
Bibliography		127

Acknowledgments

Most of the photographs in this book appear courtesy of the Library of Congress (LC). Its collection of Farm Security Administration (FSA) photographs from the 1930s and 1940s exists thanks to a presidential executive order in 1944, which decreed that all film negatives and transparencies of the FSA (some 172,000 images) be preserved in the library's collection. As these photographs were taken by US government employees, they are in the public domain and are available on the library's website at www.loc.gov. Photographs courtesy of the Library of Congress are annotated in this book with the library's image identification number, beginning with the initials LC. Other photographs courtesy of the library's collection are from the Historic American Building Survey (HABS) and the Historic American Engineering Record (HAER), and those photographs are annotated with those initials. Photographs with no annotation were taken by the author.

Historic dates are somewhat problematic in New Mexico. Unless there are specific written historic records (e.g., Mexican independence in 1821 or New Mexico statehood in 1912), most dates in the text should be regarded as approximate, particularly settlement dates and church construction dates.

Introduction

Taos, New Mexico—the very name conjures images of native pueblos, adobe churches, towering mountain peaks, deep river canyons, and quaint art studios and galleries. And it is all here on the historic High Road to Taos Scenic Byway—approximately 52 miles of history, culture, and scenery that is unmatched in the United States. The byway begins 16 miles north of Santa Fe at the junction of US Highway 84/285 and New Mexico Highway 503. From there, it heads north to its endpoint at Ranchos de Taos, affording the traveler with a trip back through time to the 1600s when Spanish settlers arrived in New Mexico. Indian pueblos along the route date back to the 1300s. Surviving adobe Catholic churches date from the 1760s. Small Hispanic mountain villages cling to the sides of the road, often exhibiting a lifestyle little changed since the 1800s. The High Road to Taos was listed in the New Mexico Register of Cultural Properties in 1975 in recognition of the rich cultural heritage of the places along the road.

New Mexico history is quite complex, and only a brief overview can be given here to help the traveler begin to understand the sights along the High Road. It all began when Spanish explorer Hernando Cortez landed with his fleet of 10 ships from Cuba on the mainland of Mexico, which he promptly named New Spain in 1519. The viceroyalty of New Spain was established by the Spanish crown in 1535; however, the name *Mexico*, which came from "Mexica," the Aztecs' name for themselves, was already being applied to the territory. Exploration of the territory of Mexico soon commenced, and explorers crossing north of the Rio Grande eventually referred to that area as Nuevo (New) Mexico. In 1539, in what is today the northwestern part of the state of New Mexico, those explorers stumbled upon the pueblo of Zuñi. They were searching for the fabled Seven Cities of Cíbola, which were rumored to be fabulously wealthy with riches of gold and silver. A more organized expedition under Francisco Vasquez de Coronado returned to Zuñi on February 22, 1540, and a thorough exploration revealed six "cities" at Zuñi (not seven), and they were made of adobe (not gold). This could not be Cíbola, so Coronado sent an advance exploration party under Hernando de Alvarado to continue exploration. It followed tributaries of the Rio Grande eastward and then northward, reaching Taos Pueblo in the summer of 1540.

Discouraged by not finding the cities of gold, Spanish exploration of New Mexico lagged for the next five decades. Finally, in early 1598, Don Juan de Oñate led an expedition north along the Rio Grande. Oñate had been granted the titles of governor of New Mexico and captain-general of New Mexico by the king of Spain. Oñate's mission was to pacify and Christianize the Indians and build Spanish homes along the Rio Grande. Oñate took soldiers and their families, livestock, and supplies in order to accomplish his mission. After a journey of six months, they reached a pueblo that Oñate named San Juan (known today by its native name, Ohkay Owingeh). Using sometimes brutal methods and forced labor of the natives, Oñate established New Mexico's first capital city, named San Gabriel, on the west bank of the Rio Grande, opposite San Juan Pueblo on the east side. Almost immediately afterwards, Oñate began visiting the far-flung outposts of his province, reaching Picurís Pueblo on July 13 and Taos Pueblo on July 14, 1598.

Throughout the 1600s, Spanish settlement along the Rio Grande continued. Some pueblos were subdued by force, and all pueblos suffered from forced labor and heavy taxation by the Spaniards, as well as curtailment of their "pagan" religious activities. Matters reached a turning point in 1680 when the pueblos united under the leadership of Po'Pay (also spelled Pope'), a medicine man from San Juan Pueblo. After extensive secret planning with other pueblo leaders, Po'Pay led an armed revolt of the pueblo people against the Spanish in August 1680. The Puebloans were successful in their attacks, with as many as 1,000 Spaniards killed. In Taos, some 70 Spaniards were killed, including two Franciscan priests. Most Spanish mission churches were destroyed, along with all vestiges of Christianity. The attacks were so successful that all surviving Spaniards fled south along the Rio Grande to Mexico. For the next dozen years, the Spanish were gone from New Mexico. Then, in 1692, Don Diego de Vargas marched with troops north from Mexico and eventually completed the reconquest of New Mexico by the Spanish in 1696.

The first recorded date of a Taos trade fair was 1723; various Indian tribes met at Taos Pueblo to exchange goods. Spaniards eventually joined in the trade fair and, in the 1820s, were joined by French and American fur traders for a periodic rendezvous. The year 1821 saw Mexico gain independence from Spain, and while governed only loosely by Mexico City, the province of New Mexico removed regulations against trade with foreigners. This opened the way for the Santa Fe Trail, which brought thousands of Americans to Santa Fe, the capital of New Mexico, which had been established in 1610 when San Gabriel was abandoned as the capital city.

The United States and Mexico went to war in 1846, and a US army led by Col. Stephen Watts Kearny successfully invaded Santa Fe without a shot being fired. The US invasion was not viewed favorably in Taos, however, and on January 19, 1847, a group of hostile New Mexicans and Taos Pueblo Indians joined forces in the Taos Revolt against the US invasion. The American provincial governor of New Mexico, Charles Bent, was killed in Taos by the insurgents, along with several other Americans. When word of this attack reached Santa Fe, Col. Sterling Price, with a force of 335 American soldiers, was sent north through deep mountain snow to quell the rebellion. Ever since, his route over the mountain has been called US Hill, and the High Road now crosses it on New Mexico Highway 518. In 1848, Mexico surrendered to the United States, and the Treaty of Guadalupe-Hidalgo gave the territory of New Mexico to America. New Mexico remained a territory until 1912, when it became the 47th state of the United States of America.

Although the Spanish had settled parts of northern New Mexico in the 1600s, the High Road villages were all abandoned during the Pueblo Revolt of 1680. After the Spanish reconquest of 1692, the villages were slowly reoccupied, only to be subjected to frequent attacks by hostile Comanche, Apache, and Ute Indians until the early 1800s. When the attacks finally stopped, the Hispanic families settled into a subsistence ranching/farming lifestyle. This lifestyle in the High Road villages was largely unchanged when photographers from the Farm Security Administration arrived in the 1930s and 1940s to document the villages. Those photographers helped preserve the legacy of a lifestyle that began rapidly disappearing after that time.

Formed on April 30, 1935, as the Resettlement Administration by Executive Order No. 7027 from Pres. Franklin D. Roosevelt, the agency was renamed in 1937 as the Farm Security Administration (FSA). In 1942, the Office of War Information (OWI) was established, consolidating many other agencies, including the FSA. The purpose of the FSA was to develop solutions to the crises faced by American farmers brought about by drought and the Great Depression. The Historical Section of the FSA, under the leadership of Roy E. Stryker, was created to document, through photographs, the conditions of rural life throughout the country. The idea was to generate sympathy for President Roosevelt's New Deal programs to aid poverty-stricken rural areas. Stryker hired famous photographers, such as Dorothea Lange and Arthur Rothstein, for this photographic documentation. In this book, Lange's 1935 images of Chimayó and Córdova are included, as well as Rothstein's 1936 images of Ranchos de Taos. The majority of the book's images come from photographers Russell Lee (hired by Stryker in 1936) and John Collier Jr. (hired by Stryker in 1941). Lee photographed Chamisal and Peñasco in the summer of 1940, and Collier photographed Truchas and Las Trampas in the winter of 1942–1943.

Russell Lee was born on July 21, 1903, at Ottawa, Illinois. He attended Lehigh University in Bethlehem, Pennsylvania, training as a chemical engineer. Lee was self-taught in photography, but he was well served by his background in chemistry, developing film by himself in dark bathrooms at hotels during his travels. Lee took more photographs than any other FSA photographer, traveling to all corners of the nation. In 1940, Lee and Stryker decided that it was a priority to photograph New Mexico before the other states of the Four Corners area (Colorado, Arizona, and Utah) because of the multicultural situation there and the problems faced by the rural, Hispanic population. Both Stryker and Lee realized how little the Hispanic culture was known to the rest of America but how fascinating that culture would be to those unfamiliar with it.

So in the summer of 1940, Lee and his wife, Jean, moved to Dixon, New Mexico, as a base camp for their work in Peñasco and Chamisal. Jean wrote most of the captions for Russell's photographs. Russell had a natural ability at putting the local residents at ease and coaxing them into allowing the photographs; however, he was hampered by his inability to speak Spanish. He was quoted by William Wroth in *Russell Lee's FSA Photographs of Chamisal and Peñasco, New Mexico*, as saying, "The people are really grand around here—but I sure wish I had a knowledge of Spanish."

John Collier Jr. was born in Sparkill, New York, in 1913, but his family moved to San Francisco in 1919. A childhood accident in California rendered him deaf and with severe learning disabilities. In 1920, the family was invited to Taos by socialite Mabel Dodge Luhan, and they were entranced by both the landscape and Taos Pueblo. Thereafter, they split their time between California and Taos. Collier's parents were determined to help him overcome his disabilities, and when he was 12 years old, he was apprenticed to artist Maynard Dixon in California. Collier lived in the Dixon home, along with Maynard's wife, Dorothea Lange, who in 1935 became one of the first FSA photographers. So John was immediately exposed to an art and photography background, and he did well in both fields. He was also taught by artist Nicolai Fechin in Taos, and he learned commercial photography from Robert Mack and his wife, Sara Higgins (daughter of Taos artist Victor Higgins), in San Francisco.

John Collier Jr. established a home in Talpa (just south of Taos) on the Rio Chiquito in 1936. He operated a photography studio in Taos and was heavily influenced by his father, John Sr., who served as US commissioner of Indian Affairs from 1933 to 1945. John Sr. was very involved with the struggles of Taos Pueblo Indians to retain their rights. John Jr.'s local connections served him well in empathizing with the Hispanic and Indian subjects of his photographs. His New Mexico FSA photographs include subjects in Questa, Ranchos de Taos, Peñasco, Las Trampas, and Truchas.

By presidential executive order in 1944, the approximately 172,000 film negatives and transparencies of all the FSA photographers were transferred to the care of the Library of Congress. Thanks to this action, these valuable historic photographic records are available to the public. The photographs of the Hispanic villages along the High Road to Taos illustrate, according to William Wroth, "a way of life in which to this day, values and practices brought during the colonial period from Mexico and ultimately from Spain, have been preserved."

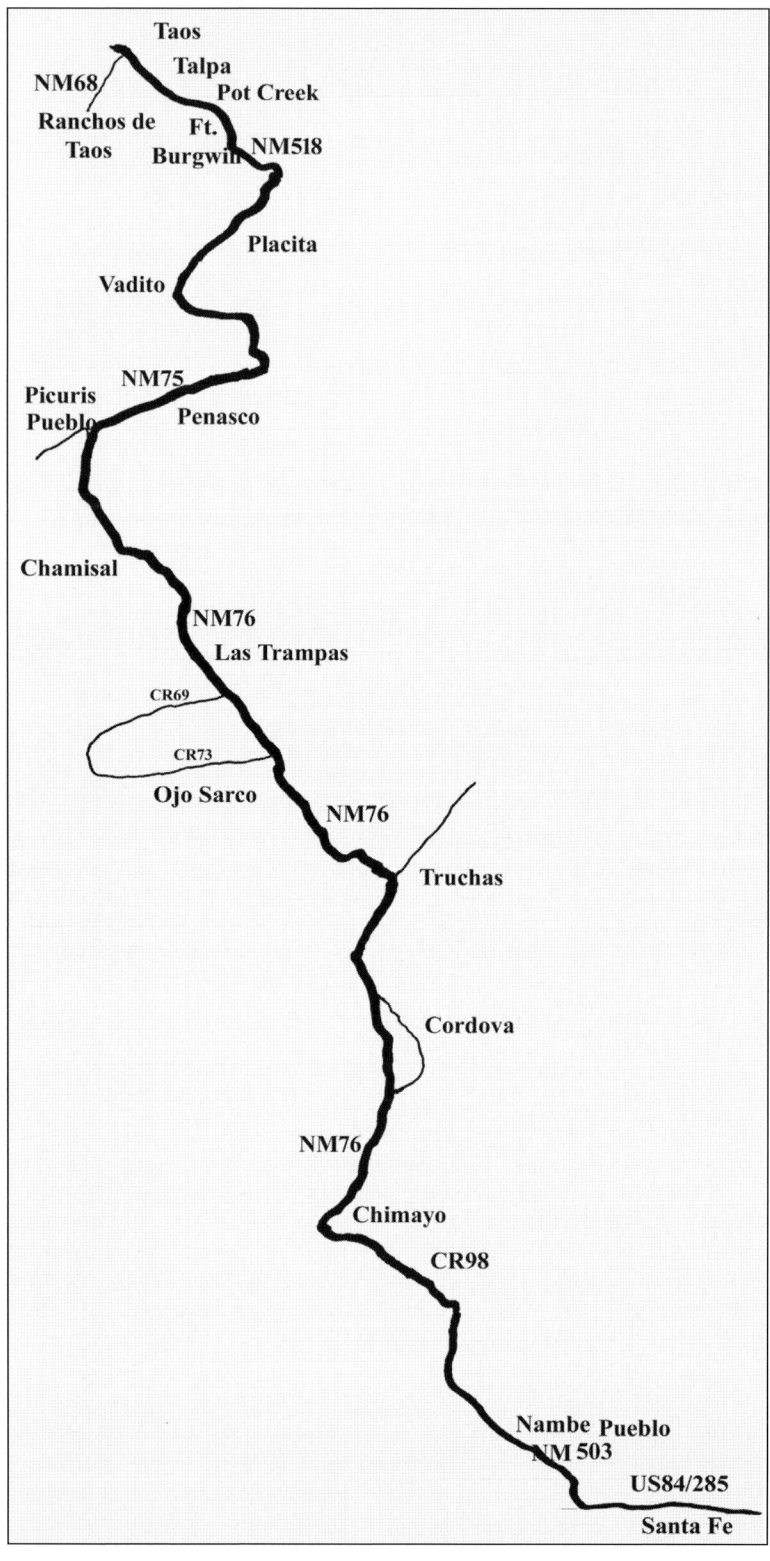

MAP OF THE HIGH ROAD TO TAOS. The High Road from Santa Fe to Taos begins at the intersection of US Highway 84/285 and New Mexico Highway 503. The High Road is well marked by signs, but it is easy to miss a turn. The following is the route that travelers should follow in sequence heading from south to north (if one starts in Taos and heads south, simply reverse this order): (1) Take New Mexico Highway 503 to Nambé and on north to the intersection of Santa Fe County Road 98; Turn left on Santa Fe County Road 98 to Chimayó; (2) at Chimayó, turn right on New Mexico Highway 76; (3) follow New Mexico Highway 76 all the way north to the intersection with New Mexico Highway 75; (4) take New Mexico Highway 75 left to Picurís Pueblo or right to Peñasco; (5) from Peñasco take New Mexico Highway 75 to the intersection of New Mexico Highway 518; (6) turn left on New Mexico Highway 518 to the intersection of New Mexico Highway 68; and (7) turn left on New Mexico Highway 68 to Ranchos de Taos.

One
Nambé, Chimayó, and Córdova

Heading northeast on New Mexico Highway 503, the traveler arrives at the small village of Nambé and, a little farther, at Nambé Pueblo. The first settlement date of the pueblo is unknown, but historians now generally date it to 1300, or perhaps earlier. Nambé served as a cultural and religious center for Tewa-speaking Pueblo peoples, who participated in the Pueblo Revolt in 1680. In the Tewa language, Nambé means "place of bowl-shaped (or rounded) earth." The Rio Nambé rises in the Sangre de Cristo Mountains and flows west, creating a deep canyon with the spectacular Nambé Falls therein. Today, the Nambé Falls Recreation Area is a source of income for Nambé Pueblo, which collects fees for picnic sites, camping, and fishing.

Chimayó is the next stop north on the High Road. With Chimayó's long tradition of weaving, travelers will want to stop at the beautiful weaving shops in the area. Chimayó was founded around 1598 by settlers from Santa Fe, near the site of an old Tewa settlement called Tsimayo. Chimayó was abandoned during the Pueblo Revolt and resettled sometime after the Spanish reconquest in 1692. Besides weaving, it is perhaps best known for its church, El Santuario de Chimayó, finished in 1816 by Don Bernado Abeyta. Local legend has it that Abeyta unearthed a Guatemalan priest's crucifix, and by touching the soil surrounding it, he was healed of his afflictions. Abeyta built El Santuario on the site of the holy soil, and today, thousands of pilgrims come annually to Chimayó to visit the church and receive a sample of the healing soil from a room adjoining the church.

Farther north on the High Road is Córdova, which *The WPA Guide to 1930's New Mexico* (published in 1940) states is along "a dirt road tortuously winding across low spurs of hills." Today, one can drive easily along paved New Mexico Highway 76, still covering an abundance of hills. Take the side road loop off New Mexico Highway 76 to see Córdova, which is home to the famous Lopez family of wood-carvers.

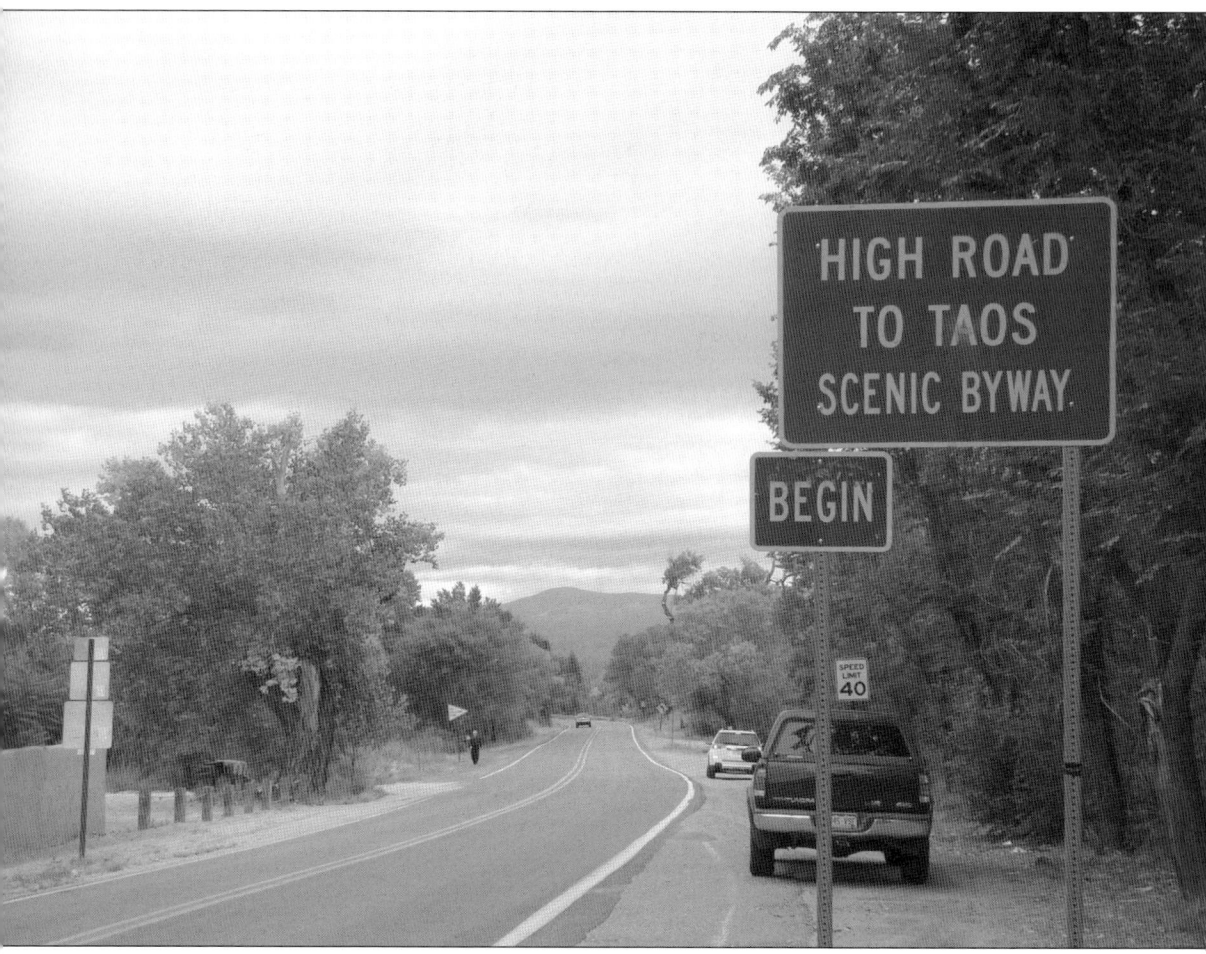

BEGIN THE HIGH ROAD TO TAOS. Sixteen miles north of Santa Fe, the traveler will reach the intersection of US Highway 84/285 and New Mexico Highway 503. A right turn on New Mexico Highway 503 marks the beginning of the High Road to Taos. Total mileage on the High Road varies from 52 to 60 miles, depending on various side roads taken. The entire length can be driven in an hour and a half, but why would anyone want to do so? The road traverses deserts, hills, canyons, and mountains while curving, climbing, and descending. The scenery is spectacular, and the towns along the way offer glimpses of the past, with Pueblo Indian villages dating to the 1300s and Hispanic villages dating to the 1600s. Take the time to venture into each village. View adobe churches and homes. Wander into art galleries featuring weavings, carvings, paintings, and pottery. Sample life from a bygone era, and enjoy the aromas of sage, pine, and roasting chile peppers along the High Road to Taos.

SAGRADO CORAZON (SACRED HEART) CHURCH, NAMBÉ, 2014. This church is located next to New Mexico Highway 503 in the village of Nambé, prior to reaching Nambé Pueblo. It was designed by architect Urban Weidner and constructed in 1947 after the original church burned down. It has twin bell towers with a cross perched on top of each.

SAN FRANCISCO DE ASIS CHURCH, NAMBÉ PUEBLO, 2014. On New Mexico Highway 503, turn right at the sign for Nambé Falls and in about a mile turn right again into the pueblo. Please observe all posted regulations at the pueblo. This church was built in 1974. The original church was destroyed in the Pueblo Revolt of 1680. A replacement church was built in 1725, and it was succeeded by the 1974 church.

NAMBÉ FALLS, 1927. A Nambé native is placing a prayer feather in the stream. Today, Nambé Falls Recreation Area is usually open to visitors from March through September, and visitation fees provide income to the pueblo. (Edward S. Curtis, LC-USZ62-101264.)

NAMBÉ PUEBLO, C. 1910. Pottery making has long been a tradition at Nambé Pueblo, and visitors today can often purchase pottery from vendors in the main plaza of the pueblo. (Photographer unidentified, LC-USZ62-119347.)

NAMBÉ PUEBLO KIVA, MARCH 17, 1934. The kiva is located in the central plaza of the pueblo. It is the traditional religious ceremonial center of the tribe. Ceremony participants climb the stairs to the right, and then at the top, they climb the ladder down through an opening in the roof to the floor of the kiva below. (James M. Slack, HABS NM, 25- NAMP, 2.)

NAMBÉ PUEBLO KIVA, SEPTEMBER 2014. The kiva still stands, appearing much as it did in 1934. It must be replastered with adobe mud every year or so to preserve the structure. Note a more modern addition to the kiva at the top rim—a notch to drain water off the flat rooftop.

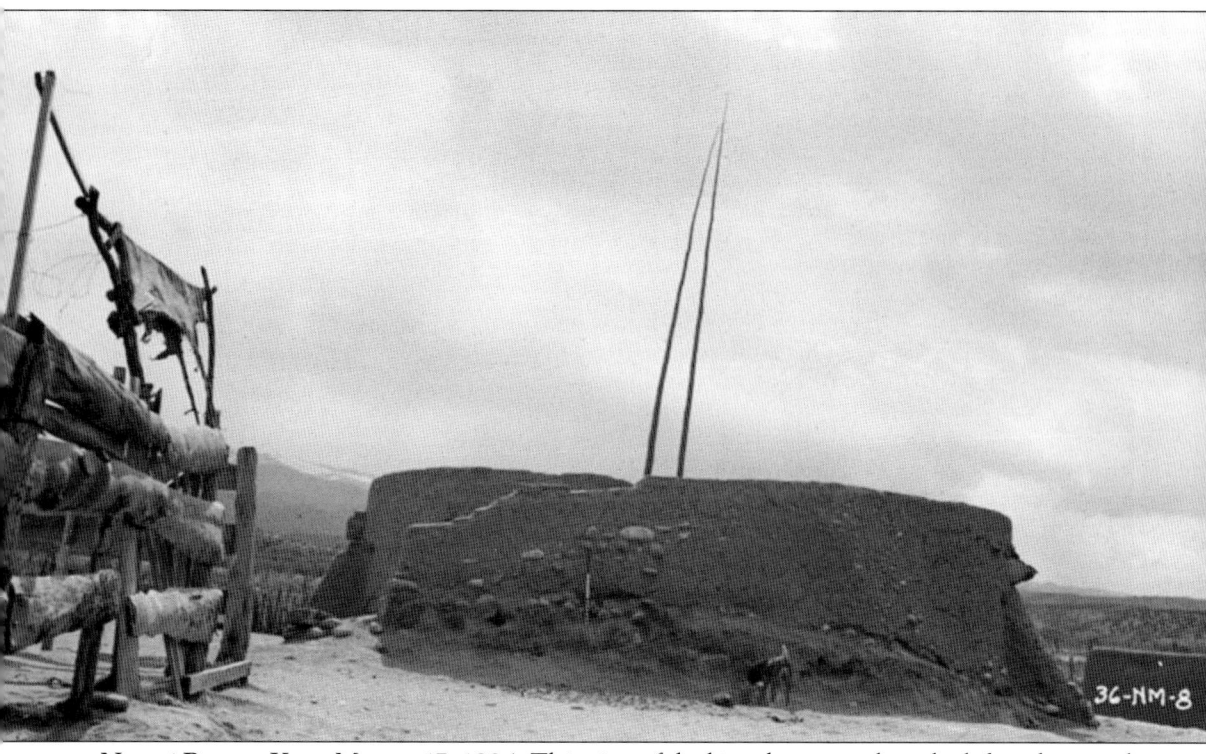

NAMBÉ PUEBLO KIVA, MARCH 17, 1934. This view of the kiva shows a rack to the left with animal skins drying on it. These appear to possibly be cow hides. The bright New Mexico sun and high elevation provide excellent conditions for drying hides. Today, Nambé Pueblo maintains a buffalo herd of some two dozen animals for ceremonial purposes. James M. Slack, who took this image, was a photographer for the Historic American Buildings Survey (HABS), which is administered by the National Park Service. HABS provides photographic documentation, architectural drawings, and historical research for important historic structures across the nation. (James M. Slack, HABS NM, 25-NAMP, 3.)

NAMBÉ PUEBLO, MARCH 17, 1934. This view toward the kiva shows adobe homes on the plaza square surrounding it. The homes are all one story. The style differs from Taos Pueblo, which has multistory adobe homes rising as high as five stories. (James M. Slack, HABS NM, 25-NAMP,1.)

NAMBÉ PUEBLO, SEPTEMBER 2014. Many of the original one-story pueblo homes remain, though a more modern, higher structure is at the rear. The pueblo style of architecture with its adobe brick walls, *canales* (flat roof drain spouts), kiva fireplaces, and viga (log)-supported ceilings has highly influenced modern home building in northern New Mexico. Homes in this style can be seen throughout High Road towns from Santa Fe to Taos.

EL SANTUARIO DE CHIMAYÓ, MARCH 19, 1934. Spanish colonists from Santa Fe resettled in Chimayó after the Pueblo Revolt was over in 1692. The valley, watered by the Rio Quemado and the Rio Santa Cruz, was an oasis in the desert, offering colonists fertile land for farming. Crops included fruit, beans, corn, and wheat. Permission to build El Santuario was not granted until 1814. (James M. Slack, HABS NM, 25-CHIM, 2.)

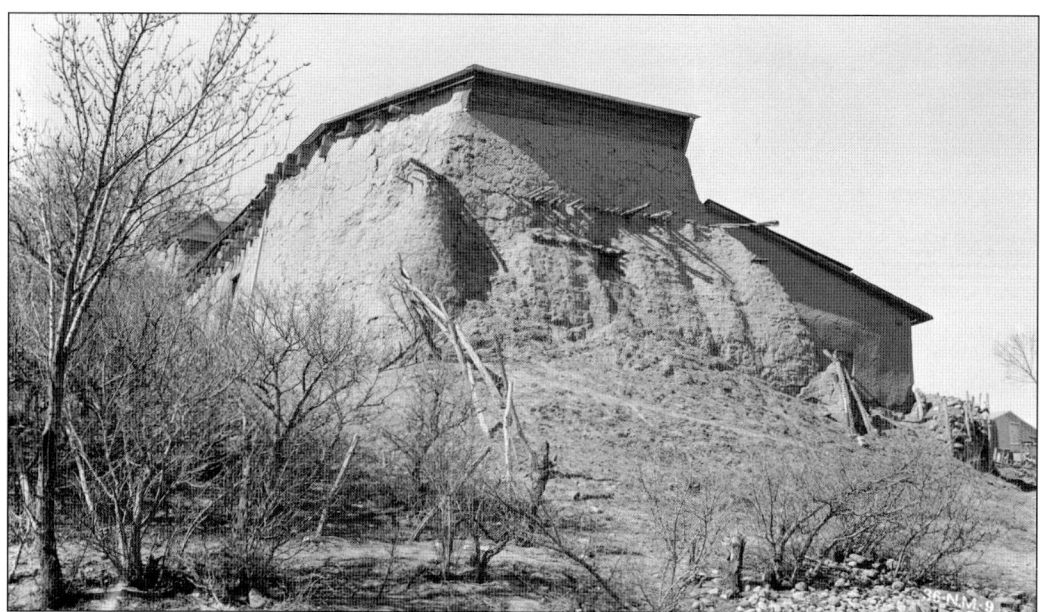

REAR ELEVATION, EL SANTUARIO DE CHIMAYÓ, MARCH 19, 1934. In 1814, residents of Chimayó were given permission to build a chapel by the Reverend Father Francisco de Otocio, the pastor in charge of all missions in New Mexico. The rear of the church faced a downhill slope, and it was fortified by buttresses of adobe brick, as seen in the photograph. (James M. Slack, HABS NM, 25-CHIM, 4.)

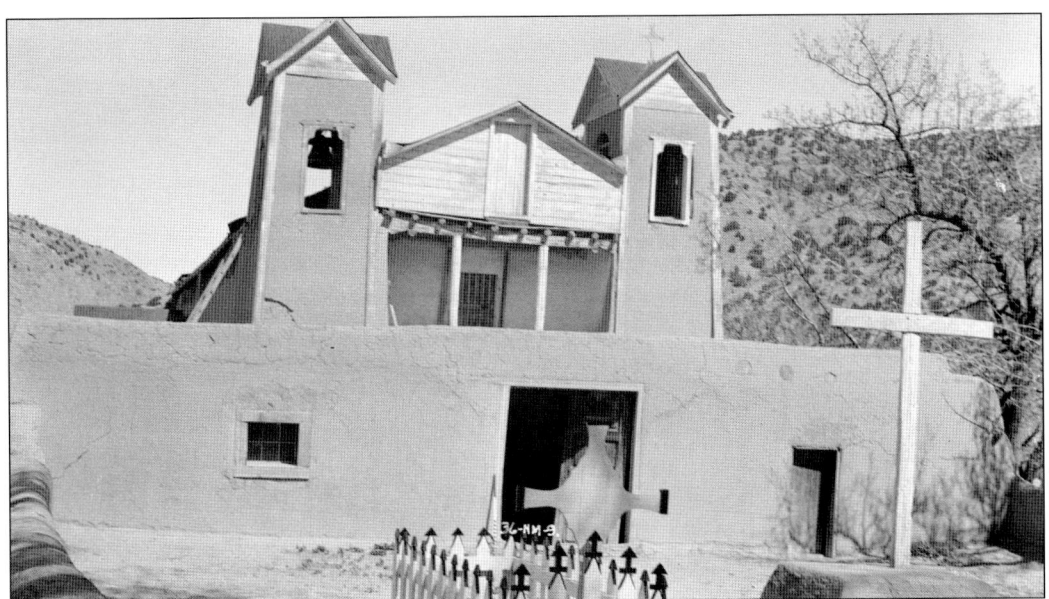

EL SANTUARIO DE CHIMAYÓ, FRONT ENTRANCE, MARCH 19, 1934. Construction of the church was begun in 1814 by Don Bernardo Abeyta on the site of the healing soil he discovered. The church was built of adobe brick, 90 feet long by 30 feet wide, with walls three feet thick. Entrance to the church is through a gate in the wall that surrounds the front of the church. (James M. Slack, HABS NM, 25-CHIM, 3.)

EL SANTUARIO DE CHIMAYÓ, FRONT ENTRANCE, SEPTEMBER 2014. Through careful restoration and upkeep, the church today looks much like it did in 1934. The healing soil is located in a room seen off to the left of the main chapel (in the upper photograph on page 18). The healing soil is found in a shallow well called *el posito* (variously spelled *pocito* and *pozito*), which is a hole in the ground about 16 inches wide and 6 inches deep.

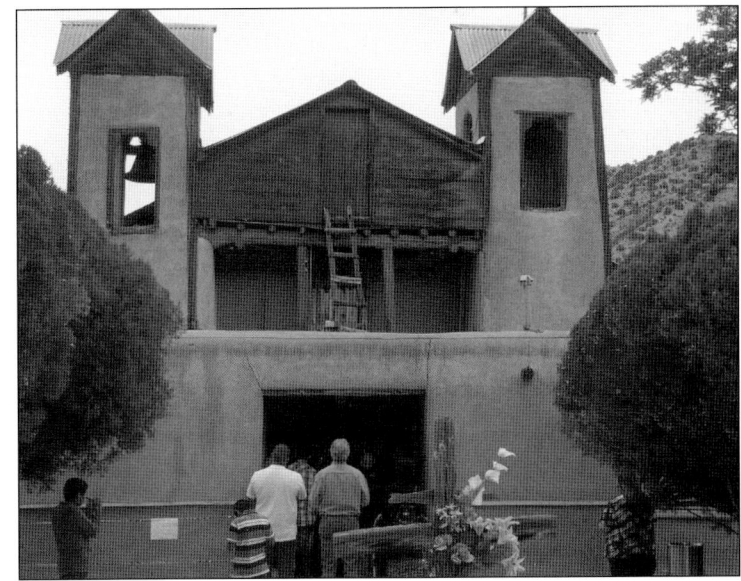

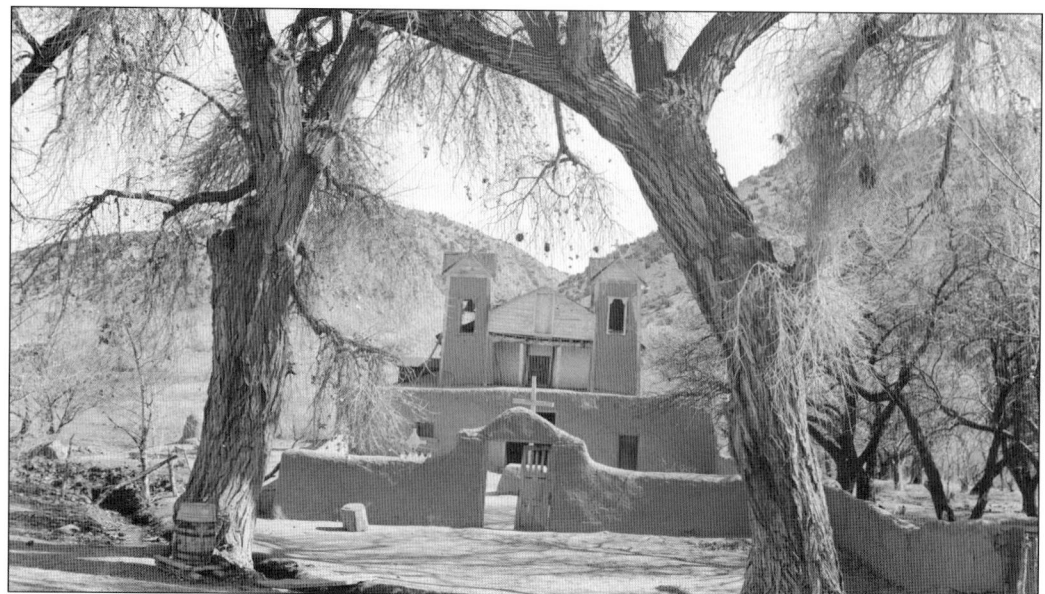

El Santuario de Chimayó, Arched Gateway, March 19, 1934. The church front is surrounded by an inner wall with a gate and by this outer wall with an arched gateway. The Abeyta family owned the church from 1814 until 1929. Financial difficulties prompted the family to start selling off the historic Spanish Colonial artwork that decorated the inside of the church. (James M. Slack, HABS NM, 25-CHIM, 1.)

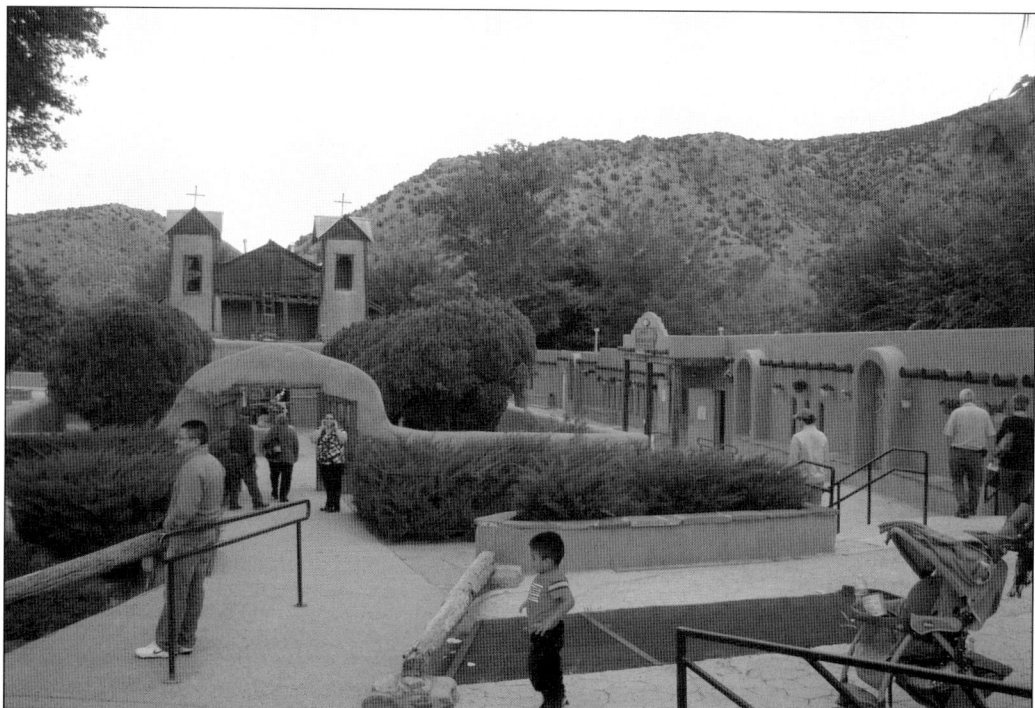

El Santuario de Chimayó, Arched Gateway, September 2014. Visitors still enter through the arched gateway today. The building at right is a modern addition and houses an excellent museum and gift shop.

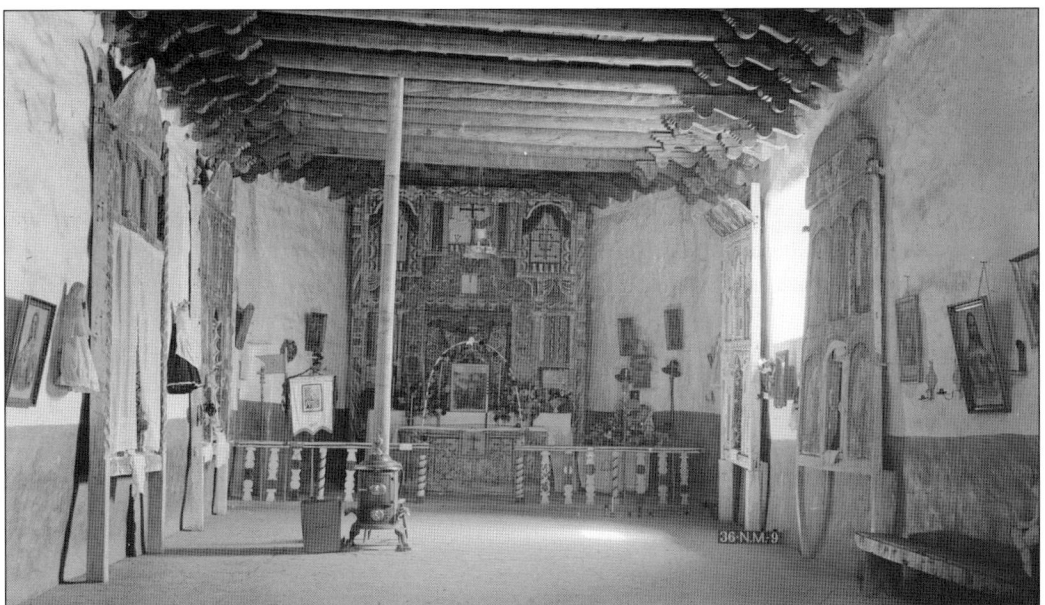

EL SANTUARIO DE CHIMAYÓ, INTERIOR, MARCH 19, 1934. Seen is Spanish Colonial artwork that the Abeyta family began selling in 1929. Alarmed by this, the Spanish Colonial Arts Society of Santa Fe (including writer Mary Austin, architect John Gaw Meem, and artists Gustave Baumann and Frank Applegate) began a fundraising campaign to purchase the church (and all of its artifacts), donating it to the Archdiocese of Santa Fe. (James M. Slack, HABS NM, 25-CHIM, 9.)

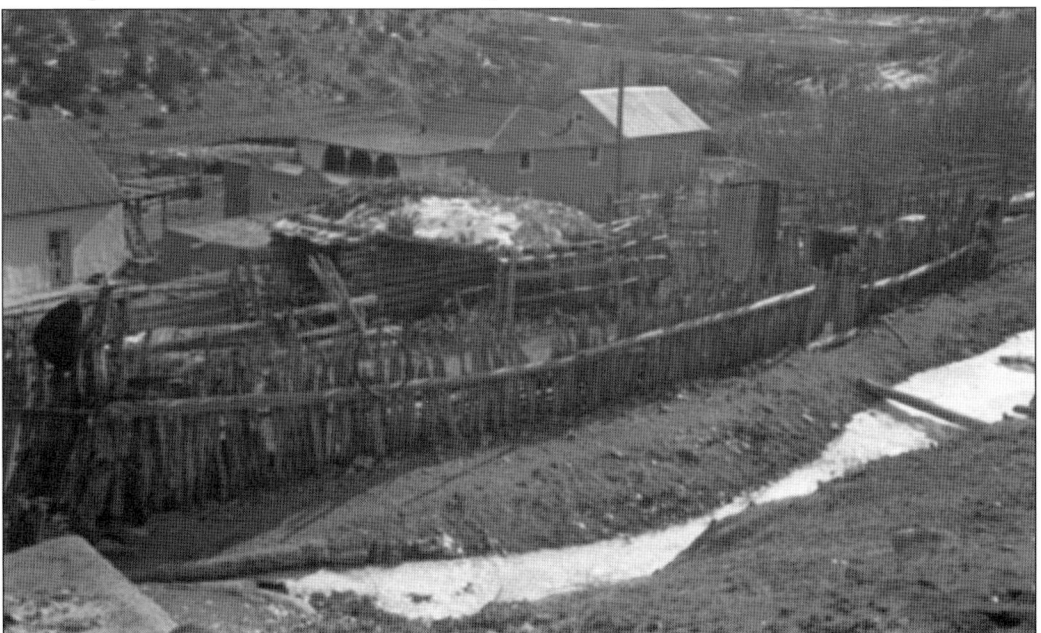

CHIMAYÓ, VILLAGE VIEW, DECEMBER 1935. Dorothea Lange was one of the first photographers hired by the Farm Security Administration's Historical Division. Lange took this photograph of a Chimayó ranch showing water frozen in an acequia (irrigation ditch), with houses, a barn, and a corral enclosed by "coyote" (wood sticks) fencing to keep coyotes out. (Dorothea Lange, LC-USF34-018338-D.)

CÓRDOVA STREET SCENE, DECEMBER 1935. Melting snow next to the adobe homes is causing this stream of water to flow down the street next to the church at right. Córdova was founded in approximately 1750 by settlers moving in from Chimayó, including the Córdoba family, who were descendants of Antonio de Córdoba of Santa Cruz, located between Española and Chimayó. (Dorothea Lange, LC-USF34-018339-D.)

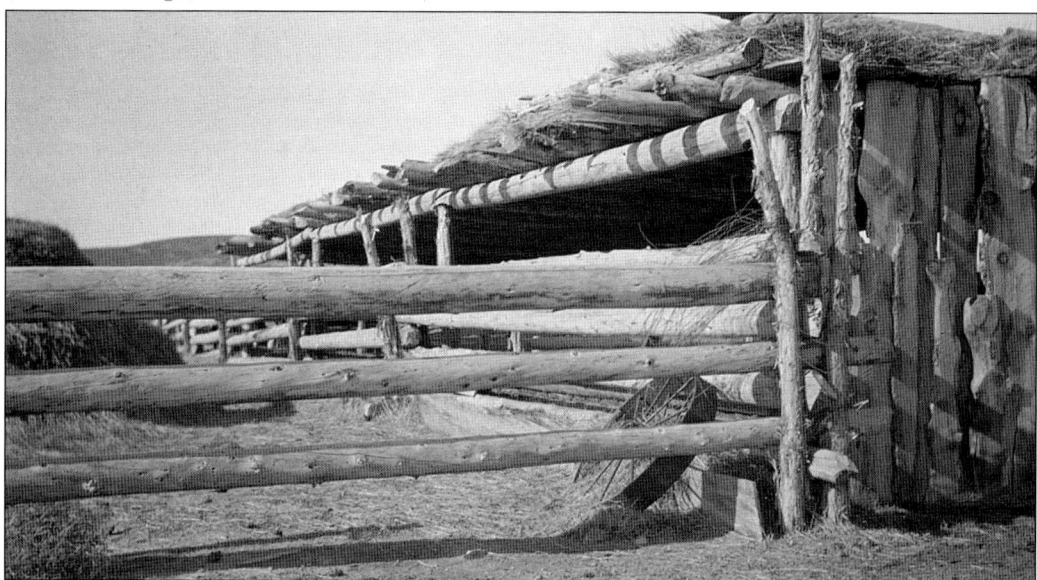

CORRAL NEAR CÓRDOVA, DECEMBER 1935. High in the mountains north of Chimayó, Córdova residents were more dependent on raising livestock (cattle, sheep, and goats) than on farming. Córdova was originally named San Francisco Xavier de Pueblo Quemado after an abandoned Indian pueblo. The name was changed to Córdova in 1900 when the post office was established. (Dorothea Lange, LC-USF34-018340-E.)

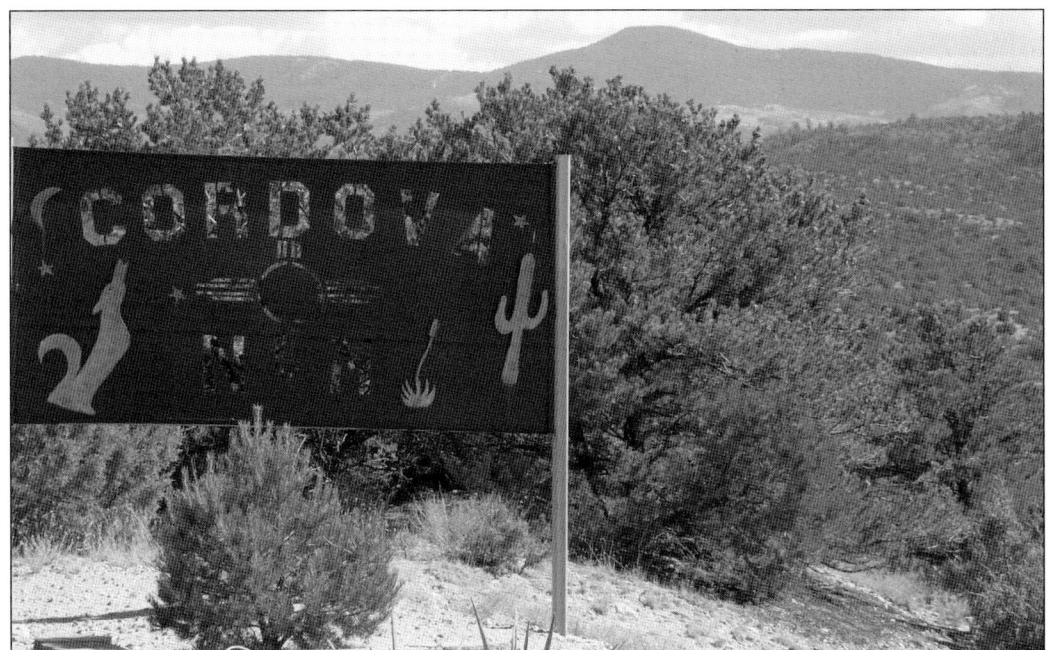

CÓRDOVA, SEPTEMBER 2015. This metal sign greets travelers heading north into Córdova, with the majestic Sangre de Cristo Mountains rising in the background. Córdova is the home of the Lopez family, who were wood-carvers; Jose Delores Lopez started carving in 1917. The tradition is still carried on by his son George Lopez and George's adopted daughter Sabinita Lopez Ortiz.

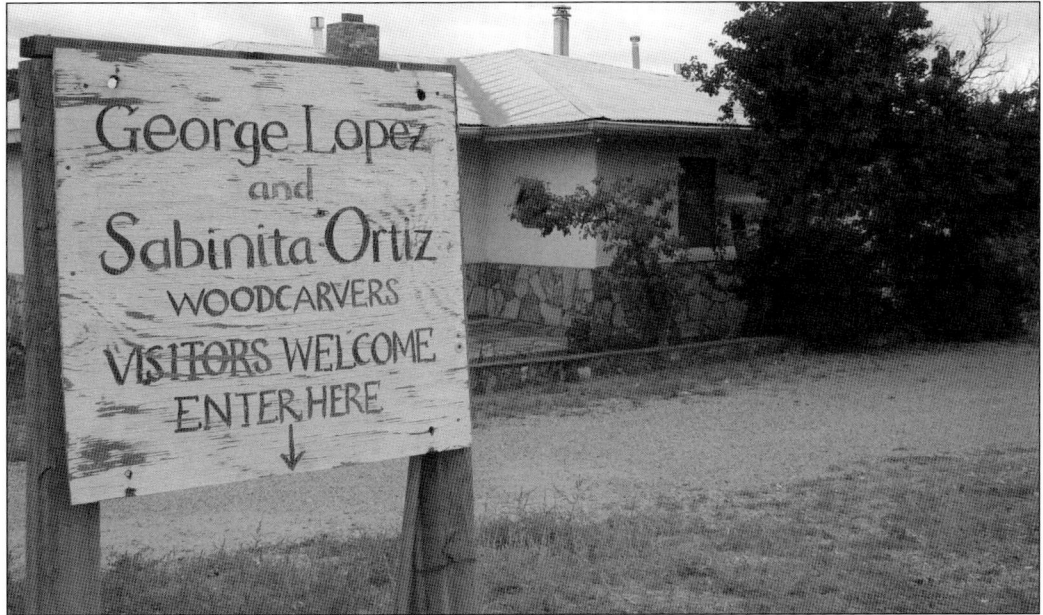

CÓRDOVA, SEPTEMBER 2014. Travelers to Córdova can visit the gallery of wood-carvers George Lopez and Sabinita Lopez Ortiz. They still carve santos (saints) much like their ancestor Jose Delores Lopez, "who fashioned with his penknife from juniper and piñon firewood—birds, squirrels, and beavers, as well as the figures of Adam and Eve in dejection leaving the garden," according to the *WPA Guide to 1930s New Mexico*.

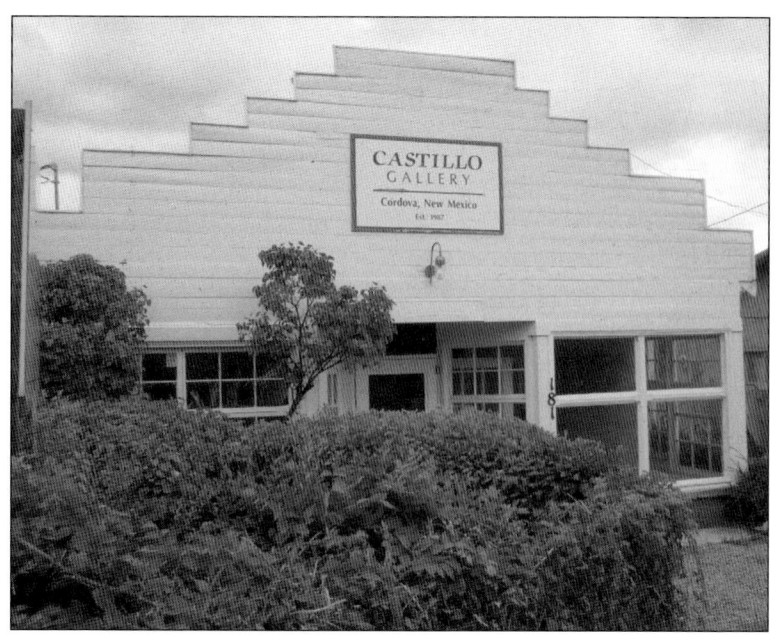

Castillo Gallery, Córdova, September 2014. Besides the Lopez wood carvings, Córdova houses other art galleries featuring paintings, photographs, and sculptures. Castillo Gallery on Main Street was established in 1987. It was open when the author visited in 2014 but closed for business on the author's visit in September 2015. Like art galleries everywhere, the ones here tend to come and go with the times.

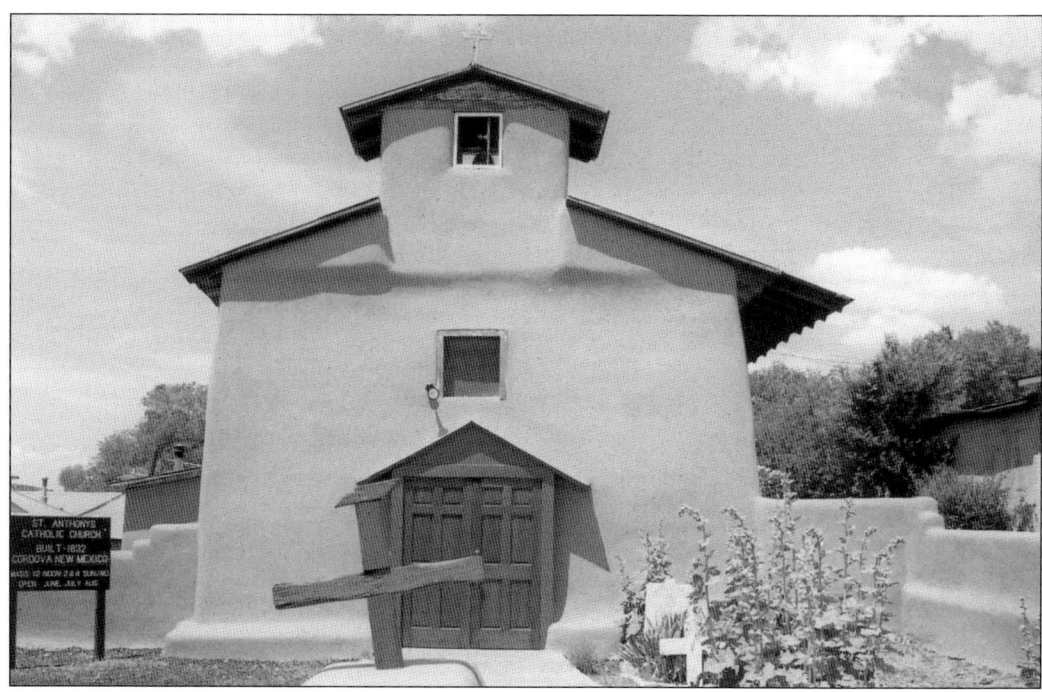

St. Anthony's Catholic Church, Córdova, July 5, 2007. This adobe church was built in 1832 using funds donated by Don Bernardo Abeyta, who built El Santuario de Chimayó in 1814. The metal roof was added in the 1940s. The church is somewhat difficult to find, but it can be located by driving a few blocks past the Castillo Gallery and turning left.

Two

Truchas and Ojo Sarco

Five miles north of Córdova, Truchas sits on an 8,000-foot-high plateau, overlooking desert to the west and the towering Truchas Peaks (13,000 feet) to the east. Named after the nearby Rio de las Truchas (River of Trout), Truchas was established by the Spanish viceroyalty as a northern outpost of defense against raiding Indian tribes, such as the Comanche, Navajo, and Apache. In 1752, families settling in Truchas were promised a land grant if they lived on the land for two years. In 1754, the grant was awarded to members of the Romero family from Santa Cruz and the Espiñosa family from Chimayó. The plan backfired somewhat, as the families from Truchas and nearby Las Trampas had to be evacuated due to Comanche raids in 1762, taking refuge behind the walls of Picurís Pueblo to the north.

The adobe Catholic church in Truchas is Nuestra Señora del Rosario (Our Lady of the Rosary). A sign outside the church indicates that it was built in 1764, but that was probably the first attempt to start the church, which was likely put on hold due to Indian raids on the settlement. Truchas is featured in Robert Redford's 1988 film *The Milagro Beanfield War*, based upon Taos author John Nichols's novel of that title.

Winding and climbing north another six miles from Truchas, the High Road reaches the village of Ojo Sarco. The town is really a string of villages established in the 1880s, most likely by settlers from Las Trampas in search of more farmland. The name *Ojo Sarco* literally means "blue or clear eye" and probably refers to the clear waters of nearby Ojo Sarco Creek, which flows north to the Rio Embudo. The village is strung out along Rio Arriba County Road 73 on the south, which then curves west and north to meet Rio Arriba County Road 69, together forming a four-mile loop leading back to New Mexico Highway 76. Both Truchas and Ojo Sarco were photographed in January 1943 by John Collier Jr. for the Farm Security Administration.

Truchas Overview, September 2007. This view illustrates the rugged terrain at Truchas, perched on the edge of an 8,000-foot-high plateau. The 13,000-foot Truchas Peaks can be seen in the distance to the east. With plenty of timber available in the nearby mountain forests, many Truchas buildings were constructed of logs.

Truchas, September 2014. Log structures are still seen along the edge of the plateau, as well as adobe homes along the rim. Logs were used mainly for building corrals and barns, while adobe was used for constructing homes.

Truchas Close-up, September 2014. Residents have spelled out the name "Truchas" with whitewashed rocks at the edge of the plateau. The town was built right along the edge of the plateau, thus affording additional protection from Indian attacks on that side of the village. All sides of the original village were enclosed with a defensive wall.

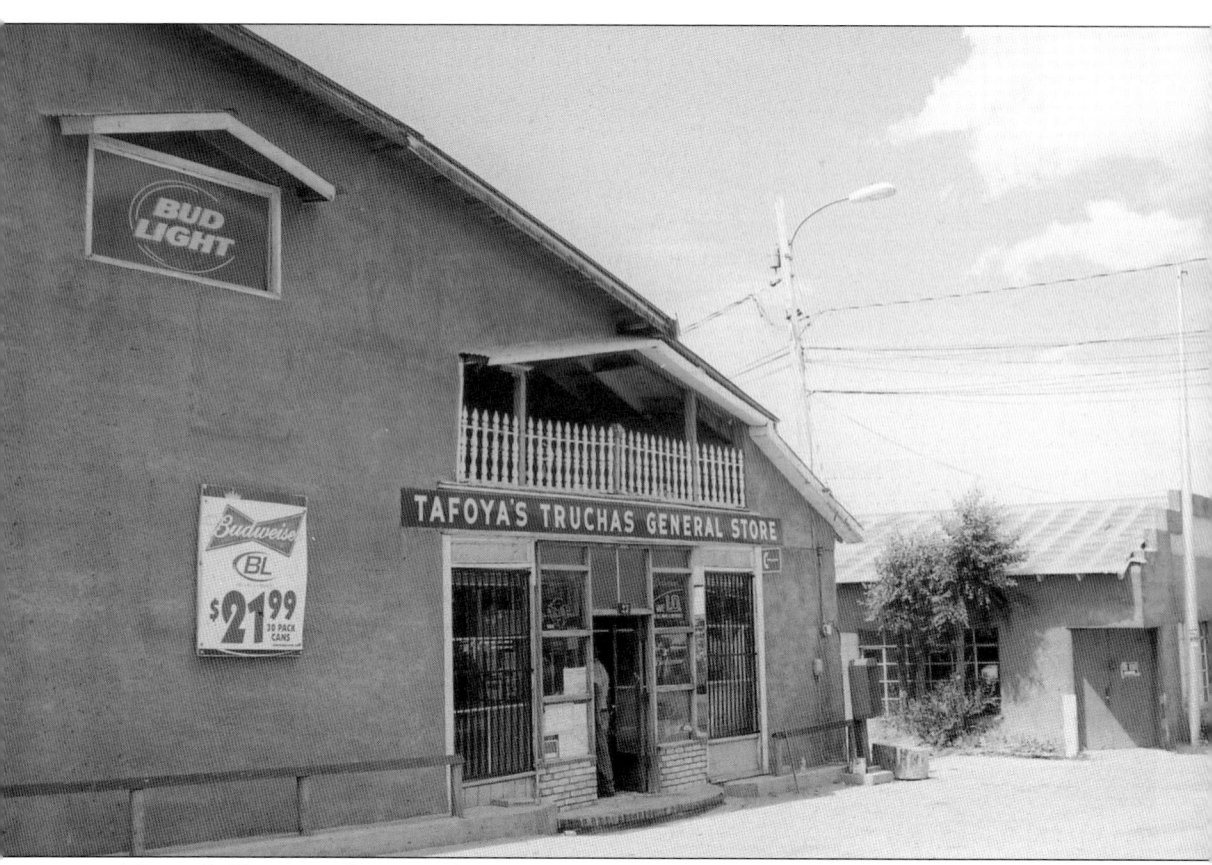

Tafoya's Truchas General Store, July 2007. During the author's 2015 visit, this building was still standing, but the store had gone out of business. Truchas did not have a store or café in 2015. The town is now largely a tourist destination, with art studios and galleries lining the main street.

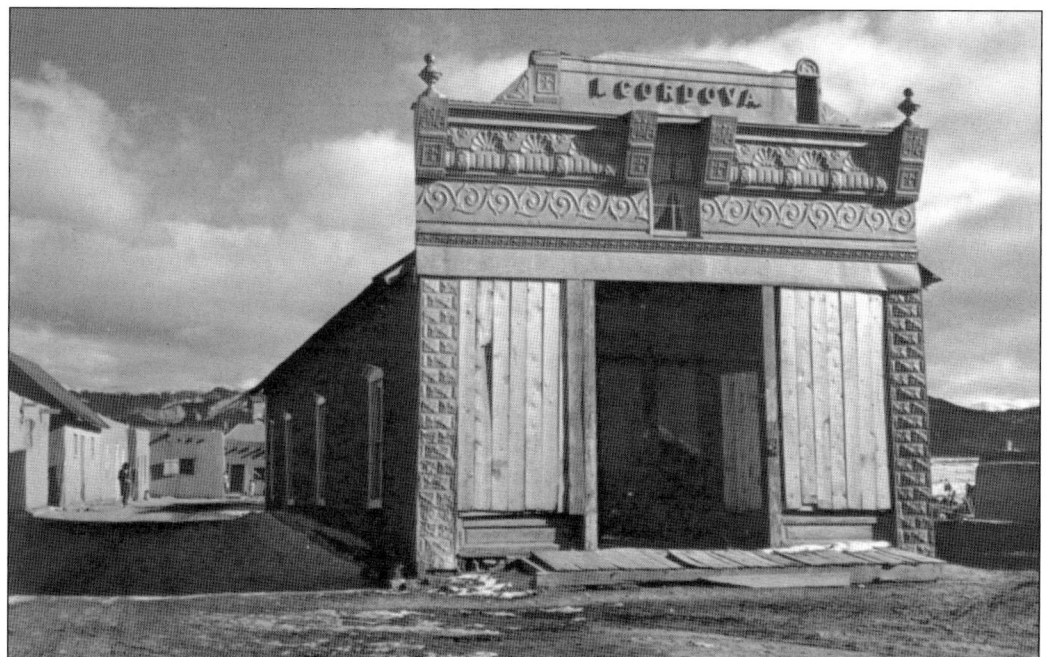

ABANDONED STORE IN TRUCHAS, JANUARY 1943. John Nichols's 1974 novel *The Milagro Beanfield War* was transformed into a feature film in 1988 by director Robert Redford. Much of the movie was filmed in Truchas because of the historic buildings; however, beans do not grow well at Truchas's altitude. Bean plants were grown in greenhouses and transplanted to fields in Truchas for the movie. The plants were promptly killed by an early frost during filming in August. (John Collier, LC-USW3-013665-C.)

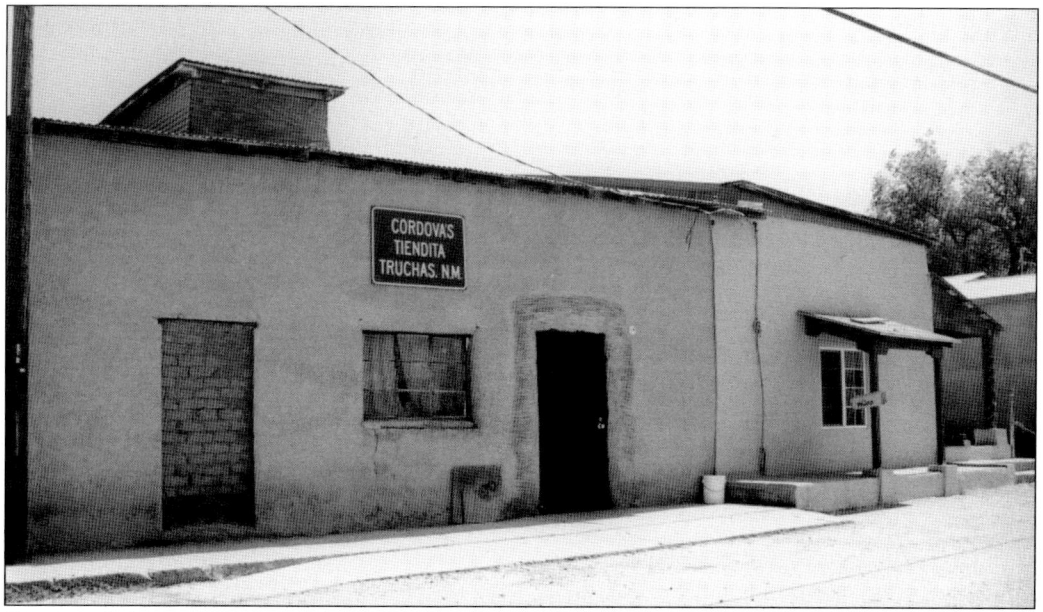

CORDOVA'S TIENDITA, JULY 5, 2007. This *tiendita* (little store) was probably owned by relatives of the Cordova family, who had also owned the abandoned store shown above. When the author revisited Truchas in 2015, this store was no longer there.

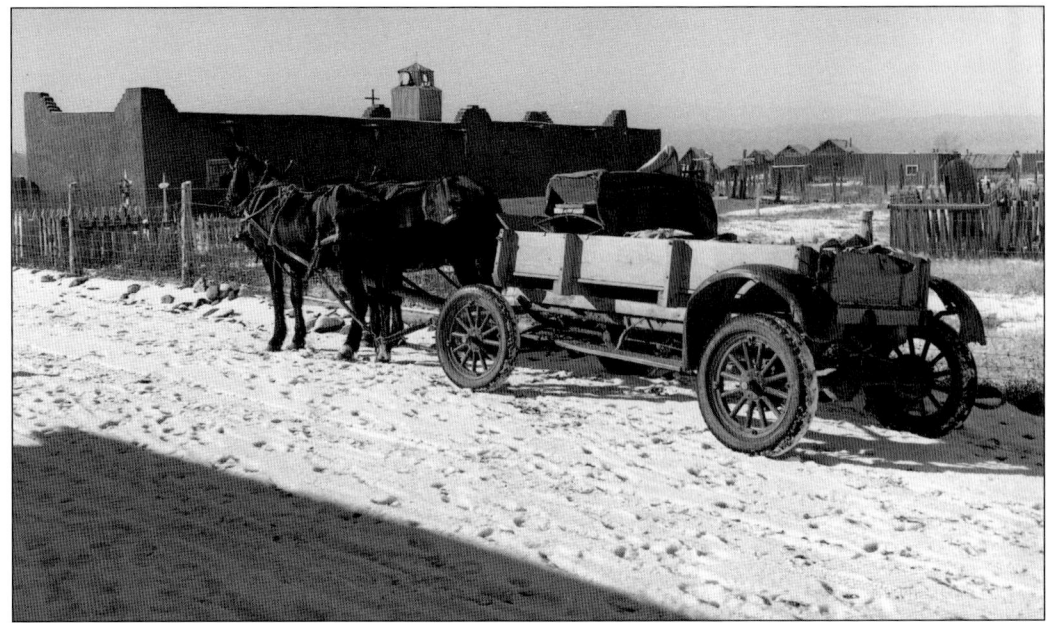

UNIQUE TRANSPORTATION, TRUCHAS, JANUARY 1943. Automobiles and trucks were still very rare in Truchas in the early 1940s. An enterprising resident converted an old automobile chassis into a wagon drawn by two horses. The building in the background is a morada (chapter meetinghouse) of the local chapter of Los Hermanos Penitentes (the Penitent Brotherhood). (John Collier, LC-USW3-013812-C.)

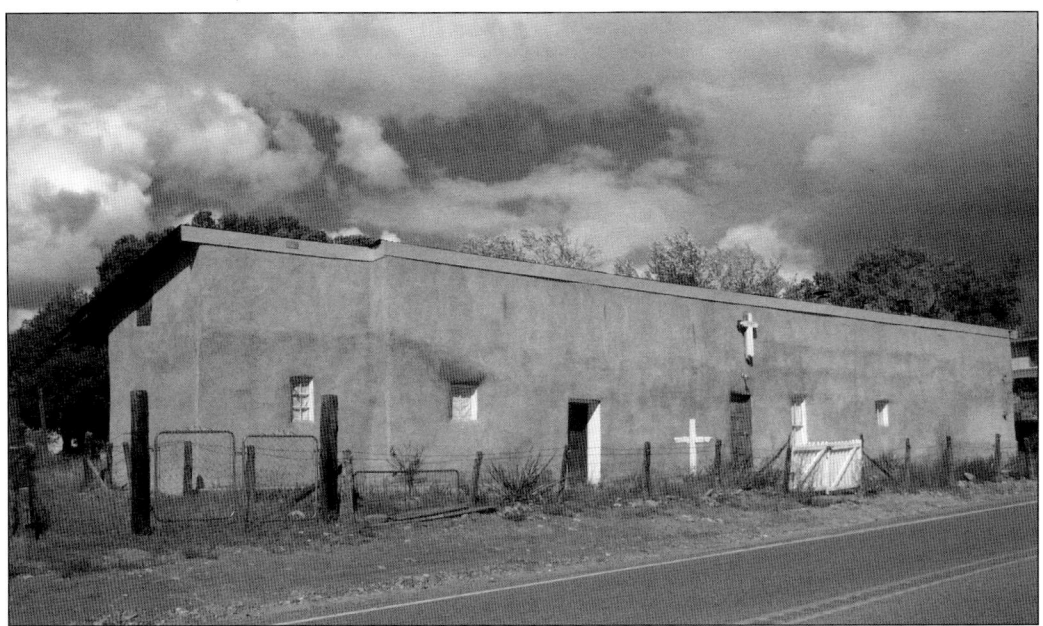

TRUCHAS MORADA, SEPTEMBER 2014. The High Road passes directly in front of the morada. Throughout the far-flung Spanish empire in Mexico and New Mexico, there were never enough Catholic priests to serve the congregation of each village. Lay groups of devout local men (Penitentes) were formed to fill in for priests, conducting prayer services, saying the rosary, tending the sick, and burying the dead.

Truchas Morada Rear, September 2014. Note the bell tower on the roof, also seen in the upper photograph on the previous page. The original flat roof of the morada has been slanted and covered with metal to provide better drainage. From the 1700s, Penitente groups practiced self-flagellation during Holy Week. Because of this, in the 1850s, Archbishop Lamy of Santa Fe wanted the brotherhood banned.

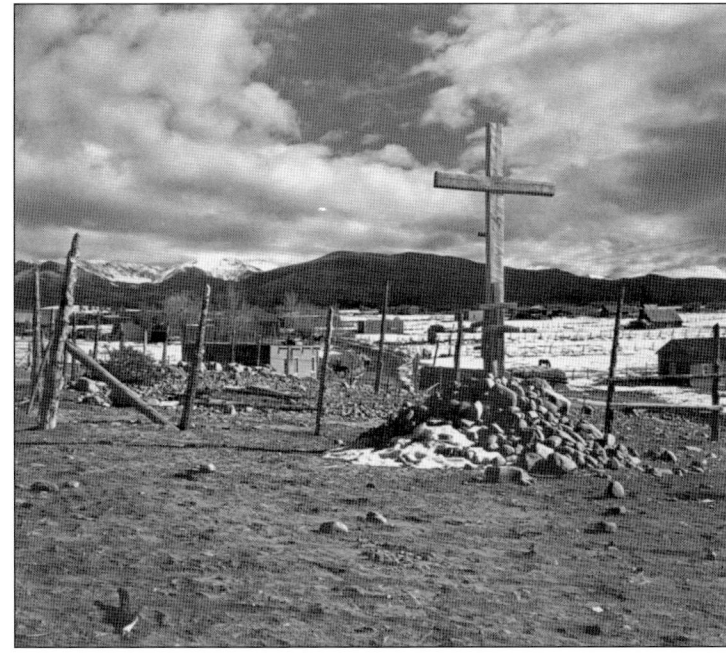

Penitente Cross, Truchas, January 1943. Due to the self-flagellation practices of the Los Hermanos Penitentes and actual reenactment of Christ's crucifixion on the cross, the Vatican banned the brotherhood in 1889. The brotherhood then became even more secretive. It was finally recognized again in 1947, when Archbishop Edwin Byrnes of Santa Fe allowed the group to continue, as long as members promised to stop the rite of self-flagellation. (John Collier, LC-USW3-013664-C.)

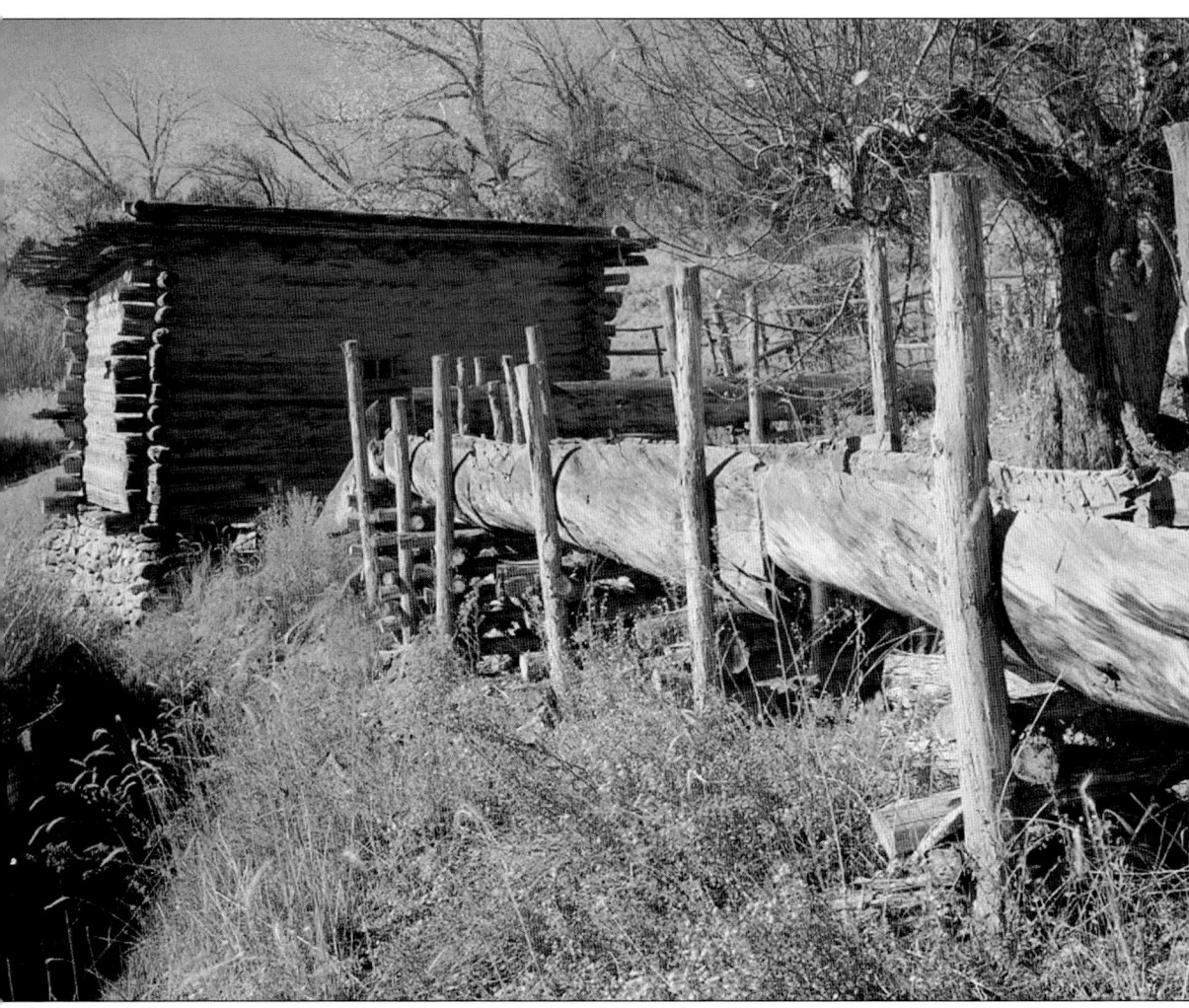

TRUCHAS MOLINO, 2007. This *molino* (grinding mill) was originally located on the Jose de la Luz Barela ranch in Truchas. It dates from 1873, and it was moved in 1968 to the living history museum at El Rancho de Las Golondrinas, near Santa Fe. It was restored to operating condition in 1991 at the museum. The slanting log flume brought water to drive the waterwheel on the lower level, seen on the next page. (Martin Stupich, LC-HAER NM-14-A.)

HORIZONTAL WATER WHEEL, TRUCHAS MOLINO, 2007. Water from the log flume turned the waterwheel, which turned the vertical shaft connecting to the upper level grinding stones. The Barela Molino ground wheat, corn, and chiles for some 25 to 40 families in Truchas until 1940. Once the water passed over the wheel, it flowed out the other side of the structure and back into the irrigation ditch. (Martin Stupich, LC-HAER NM-14-A.)

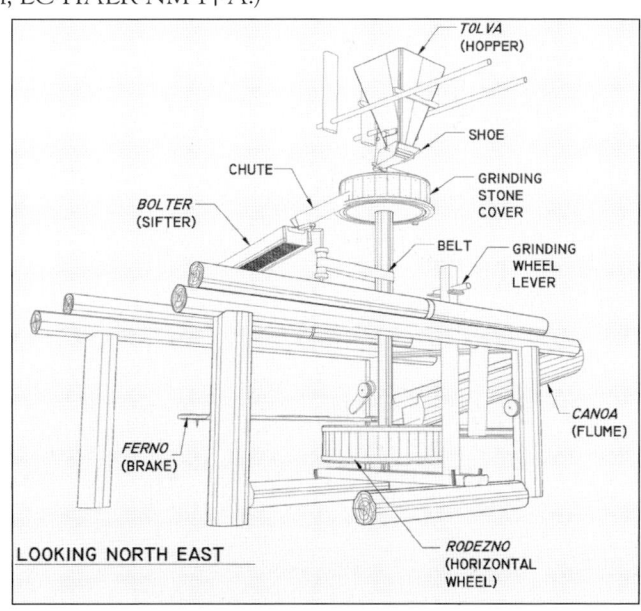

TRUCHAS MOLINO DIAGRAM. The *molino* technology brought over from Spain served New Mexico farmers very well, using the limited amount of water available from an acequia (irrigation ditch) and returning the water to the acequia after flowing over the *rodezno* (horizontal wheel). On the upper level, grain was poured into the hopper, ground by the stones, sent down the chute, and sifted in the bolter, where the fine flour dropped into collection barrels. (Diagram from LC-HAER NM-14-A.)

33

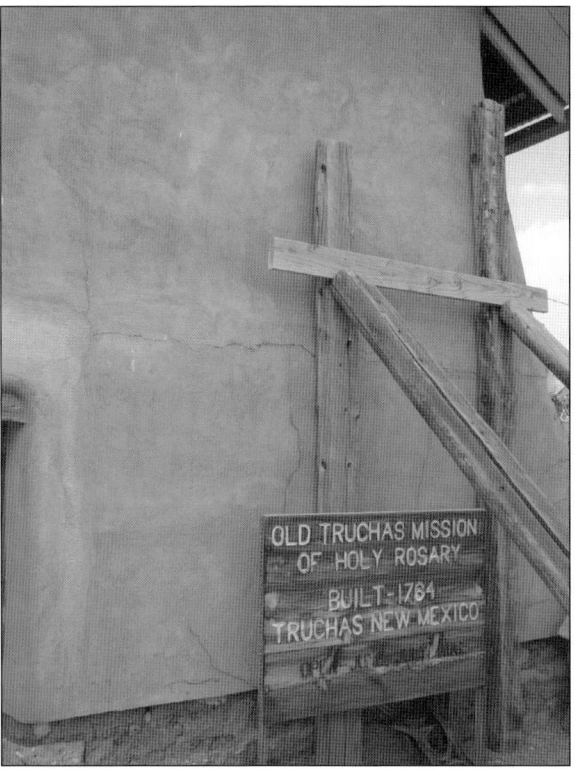

Nuestra Señora del Rosario Church, Truchas, September 2014. Our Lady of the Rosary was built in 1764, according to the sign in front of the church (photograph at left), but other texts date construction to the early 1800s. The adobe church underwent massive restoration in 2013 when it was noticed that moisture was causing the walls to collapse.

Front Entrance, Nuestra Señora del Rosario, September 2014. Framing holds up walls that were beginning to collapse. Hard stucco on the exterior and wallpaper and burlap on interior walls trapped moisture and caused decomposition of the adobe bricks. Restoration involved removing interior and exterior wall coverings, allowing the bricks to dry.

Front Entrance Adobe Bricks, September 2014. Decomposition of the church's adobe bricks is readily apparent. Once the bricks dried, and many were replaced, a new layer of adobe mud stucco was placed on the exterior walls and a traditional lime plaster was applied to the interior walls.

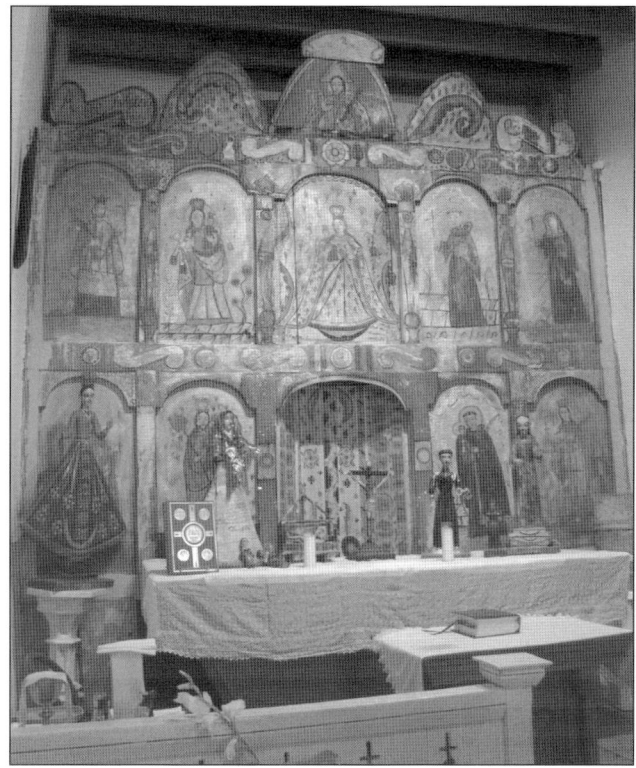

Main Altar Screen, Truchas Church, September 2014. At the interior front of the church, the beautiful reredos (altar screen) was protected by drop cloths when the side walls were recoated. The reredos itself is still in need of restoration and is one of many items on the wish list for the Nuestro Señora del Rosario Foundation, which is restoring the church.

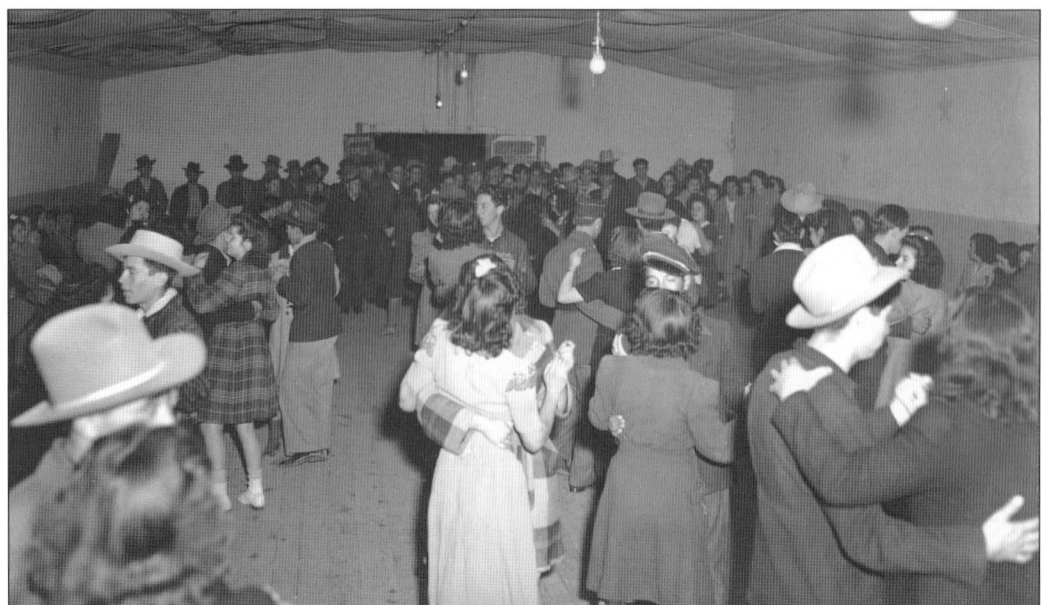

TRUCHAS DANCE, JANUARY 1943. Residents enjoy a respite from the cold winter winds inside the dance hall. High Road communities were very close-knit, having descended from a few families who settled each community. Social events brought families and friends together from the scattered farms. (John Collier, LC-USW3-013771-C.)

HAND ARTES GALLERY, TRUCHAS, SEPTEMBER 2014. Like other High Road communities, Truchas in the 1970s and 1980s became home to a number of artists inspired by the New Mexico landscape. Galleries in Truchas participate in the annual High Road Studio Tour the last two weekends in September, drawing hundreds of visitors.

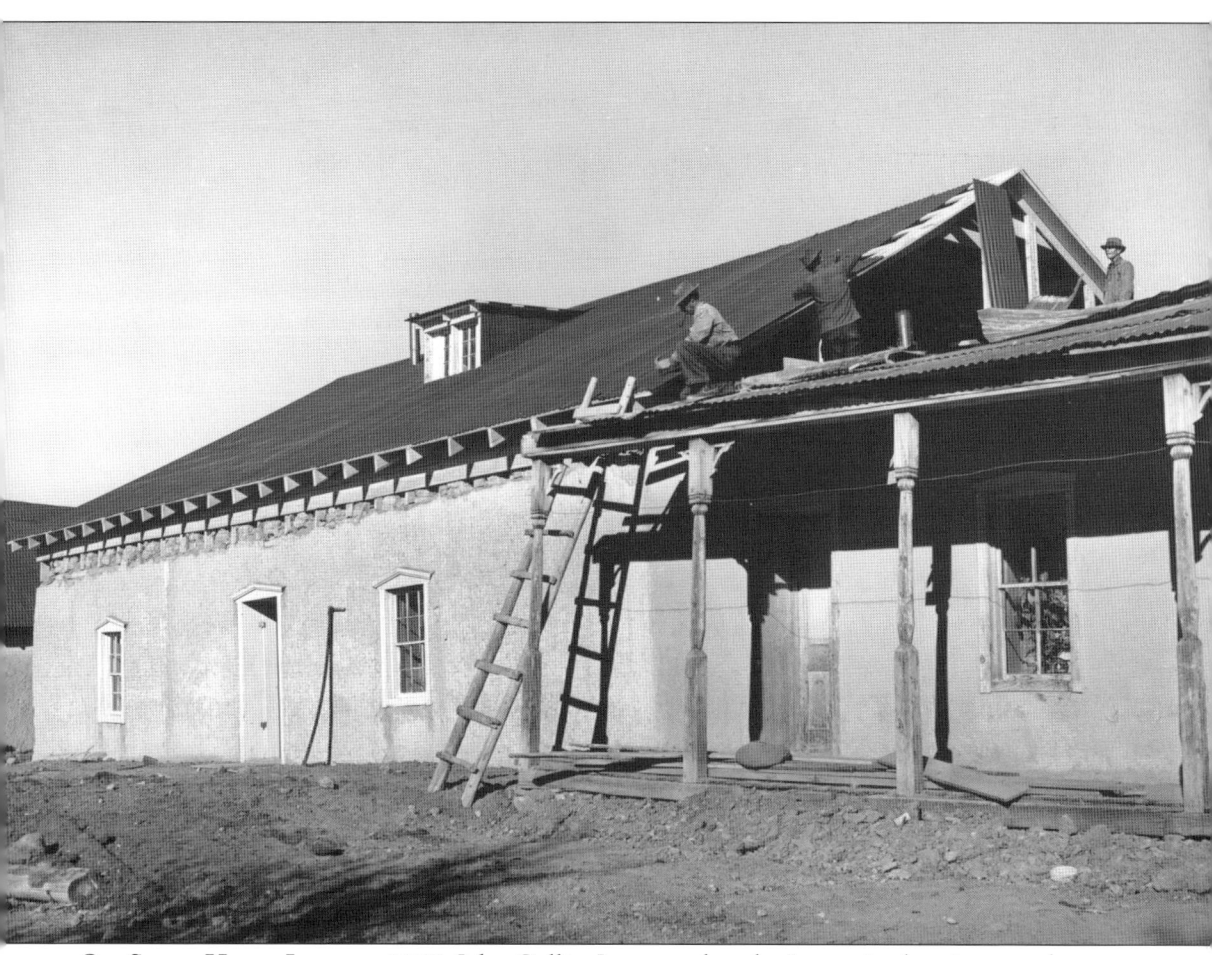

Ojo Sarco Home, January 1943. John Collier Jr. wrote that the "snows in the winter are heavy in this mountain region and flat adobe roofs leak continuously in the thaws, so pitched tin roofs are built by all who can afford them." Timbers harvested in the nearby mountains provide support for building the pitched roof on top of the adobe home. (John Collier, LC-USW3-014715-C.)

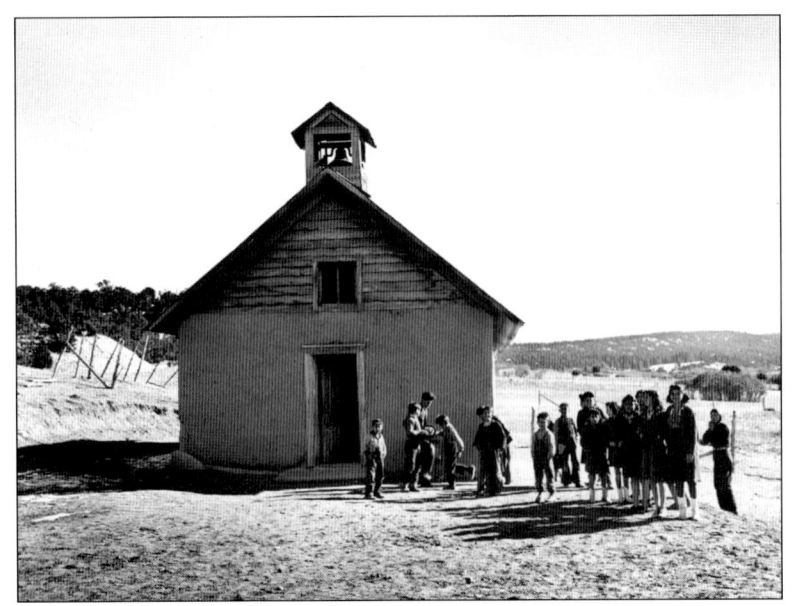

OJO SARCO SCHOOL AFTERNOON RECESS, JANUARY 1943. Students line up to reenter the school after recess. Note the various heights of the children; the school housed eight grades. The younger children were taught in the front half of the school, and the older children were taught in the back half. (John Collier, LC-USW3-014635-C.)

OJO SARCO BOYS, SCHOOL RECESS, JANUARY 1943. The boys smile for John Collier's camera as they enjoy the warm afternoon sun of an atypically mild January afternoon. Ojo Sarco's population was almost entirely Hispanic in the 1940s. The town was very isolated in a mountain valley, with only rough dirt roads for access. (John Collier, LC-USW3-014727-C.)

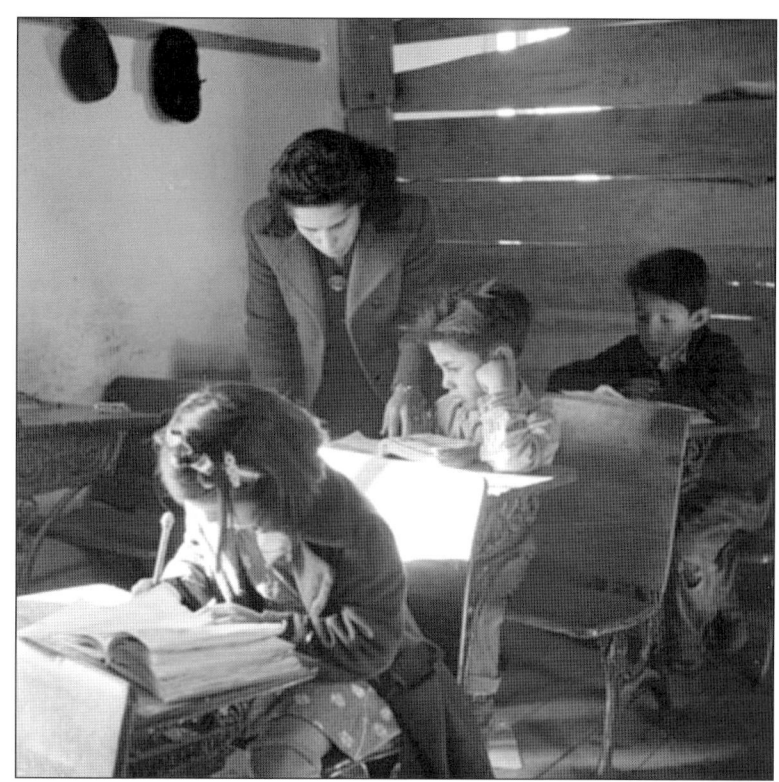

OJO SARCO TEACHER, JANUARY 1943. Students received individual attention from their teacher when needed. Farm Security Administration (FSA) photographs were originally intended to alert Americans to the needs of small farm communities suffering through drought and the Great Depression, but by 1943, the FSA had become part of the Office of War Information, and the photographs were used for patriotic propaganda purposes instead. (John Collier, LC-USW3-014508-E.)

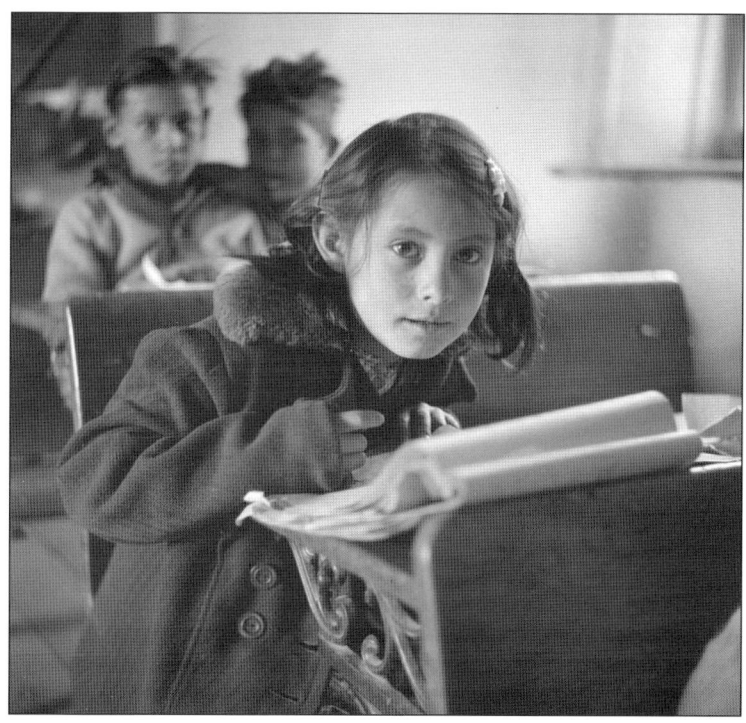

OJO SARCO SCHOOLGIRL, JANUARY 1943. The school was built around 1940 and housed grades one through eight. Note the two boys behind the girl; they are featured in the photograph on the next page. Ojo Sarco was originally named Diamante (diamond), but the name was changed in 1912. (John Collier, LC-USW3-014522-E.)

OJO SARCO SCHOOL ROOM DIVIDER, JANUARY 1943. The upper and lower grades in this one-room schoolhouse were separated by the wooden divider seen behind these boys, who were in the lower grades. (John Collier, LC-USW3-014520-E.)

OJO SARCO SCHOOL BOOKCASE, JANUARY 1943. These books were donated by the Michigan Public School system. With titles such as *Widening Trails*, *Near and Far*, and *Book One: Elson Gray Basic Reading*, these books were probably of little use to Spanish-speaking students of Ojo Sarco until the upper grade levels. (John Collier, LC-USW3-014511-E.)

Ojo Sarco Teachers, January 1943. Older students were taught by the gentleman teacher in the back half of the schoolhouse, while the woman teacher taught younger students in the front section. Note the bookcase in the rear, which contains the books shown in the lower photograph on the previous page. (John Collier, LC-USW3-014735-C.)

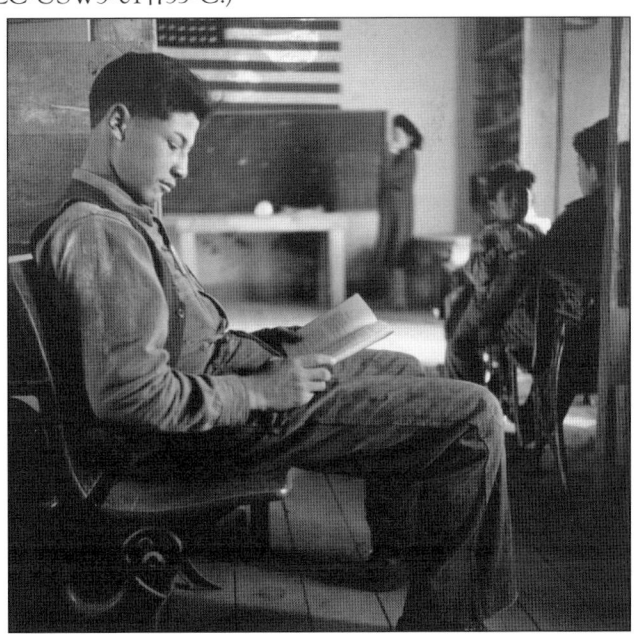

Ojo Sarco Older Schoolboy, January 1943. This boy is studying in the section of the schoolhouse reserved for the upper grades. In the background, the woman teacher is shown at the blackboard teaching the lower grades. (John Collier, courtesy of Maxwell Museum of Anthropology.)

Santo Tomas (St. Thomas) Church, Ojo Sarco, September 2014. This adobe church was built in 1886. It can be seen near the junction of Rio Arriba County Roads 73 and 69. The feast day on July 3 honors Santo Tomas, who is said to bless the acequias, fields, and animals to ensure prosperous crops and livestock.

Ojo Sarco Pottery, September 2014. Artists and craftsmen from Santa Fe and Taos discovered Ojo Sarco in the 1970s and 1980s, settling in homes and building studios and galleries. Here is the studio and gallery of potters Kathy Riggs and Jake Willson, who settled in Ojo Sarco in 1975. Each piece of their fine pottery is individually handcrafted, with patterns suggested by the local landscape of New Mexico.

Three

Las Trampas

Two miles north of Ojo Sarco, the High Road winds down into the valley of the Rio de Las Trampas (River of Traps). Las Trampas was settled in 1751 by 12 families from Santa Fe, led by 74-year-old Juan de Arguello, who had received a land grant from Gov. Tomas Velez Cachupin. The River of Traps was so named because of the trapping of beaver along the river. Las Trampas has historically been a very isolated place. The *WPA Guide to 1930s New Mexico* states that the road north of Truchas "runs over mountain trails and across canyons to Trampas—a very difficult and dangerous road, not to be undertaken except under the best conditions and then only by those experienced in mountain driving. It is safer as a pack trip." The 1968 National Survey of Historic Sites and Buildings states that "until the 1920s the Trampas area remained so isolated and its economy so retarded that it was unaffected by American fashions of the late 19th century."

Las Trampas citizens finally got their wish for a better road in 1967 when New Mexico State Road 76 was to be widened and paved. However, the new road threatened the destruction of Las Trampas's most famous historic site—the San Jose de Gracia Church, which was constructed from approximately 1760 to 1776. This soaring, 34-foot-high adobe church was one of the best remaining examples of Spanish Colonial church architecture in New Mexico. The new highway, as surveyed, would destroy the churchyard and come within six feet of the church itself. Alarmed local residents, Santa Fe architects (including John Gaw Meem), and politicians pled their case in Washington, DC, for formation of a National Historic Landmark District in Las Trampas. Their efforts were successful, and the district was created on May 28, 1967, thus preserving the church. The highway was then located farther west of the church.

Russell Lee photographed Las Trampas in July 1940, and John Collier photographed it in January 1943. Images from both photographers are featured in this chapter.

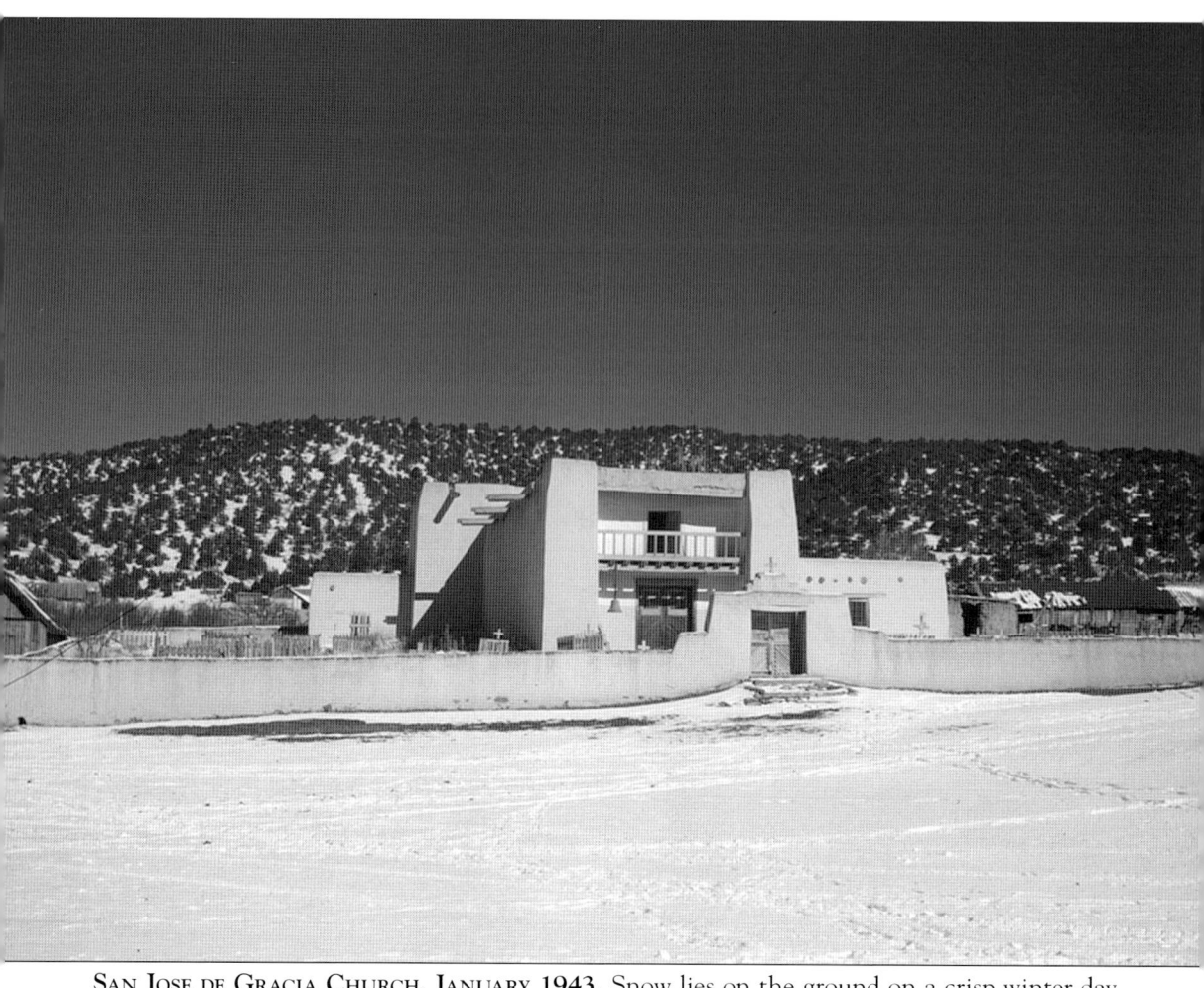

SAN JOSE DE GRACIA CHURCH, JANUARY 1943. Snow lies on the ground on a crisp winter day in Las Trampas. The sheer isolation of Las Trampas probably helped preserve the church, as the National Survey of Historic Sites and Buildings notes: "It is to this cultural and economic isolation that the remarkable unaltered state of the San Jose de Gracia Church is due." The 1967 highway expansion would occur to the left of the churchyard. (John Collier, LC-USW361-913.)

ROAD INTO LAS TRAMPAS, JANUARY 1943. This view north shows the road heading across a bridge into town. On the right side of the road is the adobe San Jose de Gracia Church. Just in front of the church, the building with the slanted roof and bell tower is the local school. (John Collier, LC-USW3-017821-E.)

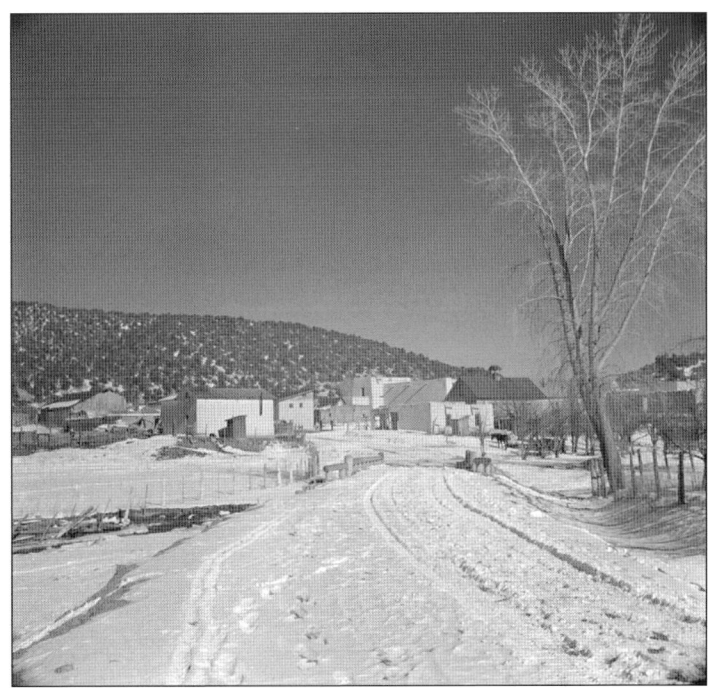

LAS TRAMPAS SCHOOL, SEPTEMBER 2014. The school is located directly across the plaza (south) from the church. The roof and bell tower appear much the same as in the 1943 photograph at the top of the page. The building is no longer used as a school.

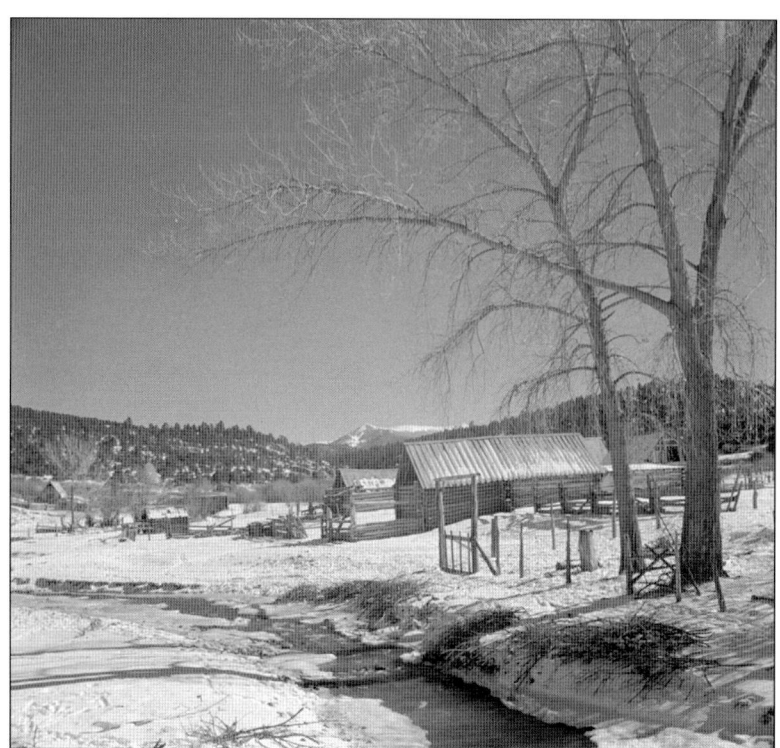

CREEK RUNNING NEAR TOWN, JANUARY 1943. John Collier did not identify this creek in his photograph, but it is probably the Rio de Las Trampas. The view is north toward the Sangre de Cristo peaks. The barns and outbuildings are constructed of logs. (John Collier, LC-0USW3-017820-E.)

LAS TRAMPAS VILLAGE SCENE, JANUARY 1943. This view toward the northeast shows an adobe home in the center with logs stacked to the left for construction of outbuildings. Las Trampas was very isolated, but an alternate road from the north (New Mexico Highway 75 from Dixon, east 15 miles to the Peñasco intersection, and then south five miles on New Mexico Highway 76) provided easier access than the road from Truchas. (John Collier, LC-USW3-017753-E.)

HORSES AND HOMES, JANUARY 1943. There were very few automobiles and trucks in Las Trampas in 1943. Horses provided the power needed by local farmers to pull plows and wagons. The large haystack at left provided feed for the horses. (John Collier, LC-USW3-017757-E.)

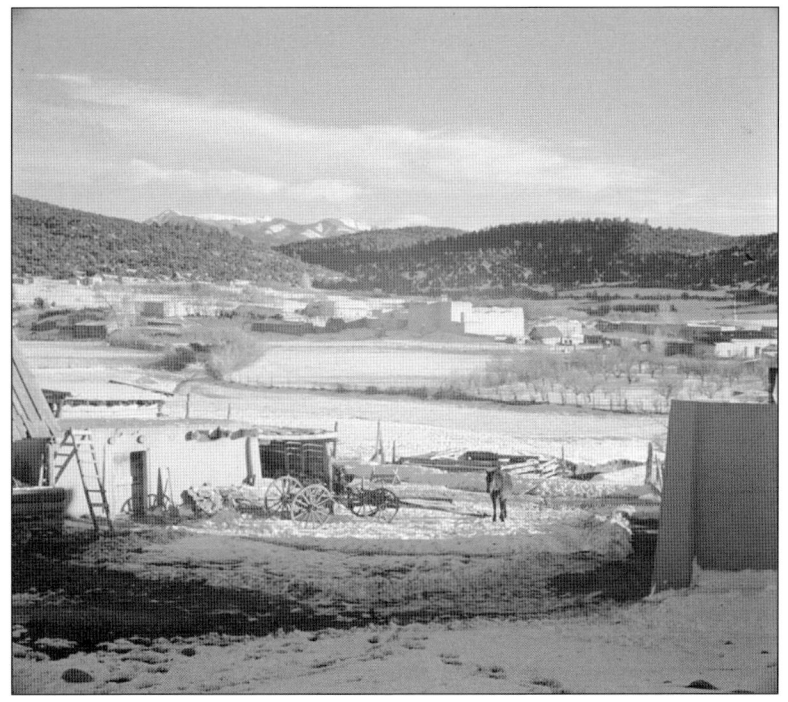

VIEW TOWARD THE CHURCH, JANUARY 1943. The church is the tall adobe building in the center of the photograph, and the town plaza is just to the right. In the foreground, a horse waits patiently to be hitched to a wagon or used for some other duty. (John Collier, LC-USW3-017779-E.)

SHEEP GRAZING NEAR TOWN, JANUARY 1943. This view is toward the northwest, with the church seen near the top right and the school to the left of the church across the plaza. Sheep provided wool and meat for the local farmers. (John Collier, LC-USW3-017824-E.)

WASHING ON THE LINE, JANUARY 1943. As in Truchas and Ojo Sarco, Las Trampas homes were generally made of adobe, and barns and outbuildings were made of logs cut in the nearby mountain forests. (John Collier, LC-USW3-017752-E.)

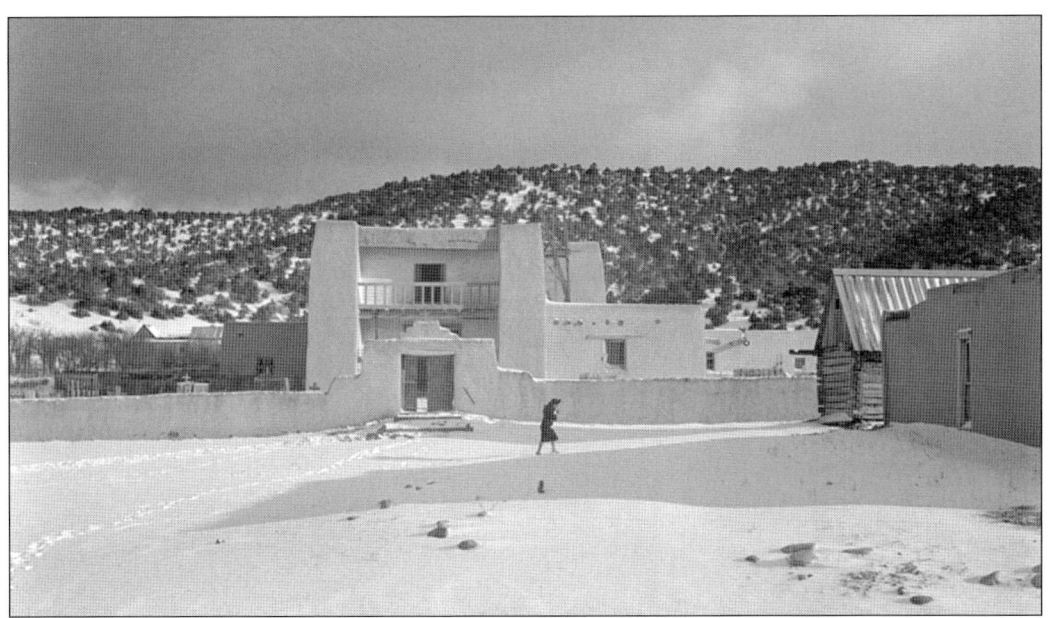

SAN JOSE DE GRACIA CHURCH, JANUARY 1943. A lone woman walks across the plaza on a bitter winter day. The church has a wall around it with an entry gate at the front. Note the complete lack of automobiles and trucks in the plaza. (John Collier, LC-USW3-015117-E.)

LEAVING CHURCH, JANUARY 1943. The women hold on to their hats as they leave the church service on this blustery January day. They have to walk through the snow in their high heels on the way out the gate to the plaza. (John Collier, LC-USW3-014643-C.)

SAN JOSE DE GRACIA CHURCH AND ENTRY GATE, JANUARY 1943. When Las Trampas was first settled in 1751, the villagers had to go nine miles north to the church at Picurís Pueblo if they wanted to attend Mass. They soon decided to build their own church, and construction began in 1760. Frequent Indian raids and periodic abandonment of the village delayed completion until about 1776. (John Collier, LC-USW3-015114-E.)

CHURCH WEST SIDE, JANUARY 1943. To build the church, the 12 original families decided to pool one-sixth of the profits from their cash crops every year until they had enough funds to begin construction. The adobe walls are 34 feet high and 4 to 6 feet thick. There is a buttress along the back left side. (John Collier, LC-USW3-017818-E.)

CHURCH FRONT, SEPTEMBER 2014. Note the wooden belfries atop the two towers. The belfries do not appear in the 1943 photograph at the top of the previous page. When the highway was built west of the church in 1967, a complete restoration of the church was begun, and an earlier photograph was discovered that revealed the church originally had belfries.

PENITENTE MORADA EAST OF CHURCH, SEPTEMBER 2015. A tall wooden cross stands directly in front of the morada. As in Truchas, the Penitent Brotherhood was very strong in Las Trampas. The San Jose de Gracia Church was visited only infrequently by a traveling priest, so the Penitents played an important role as lay pastors to the congregation.

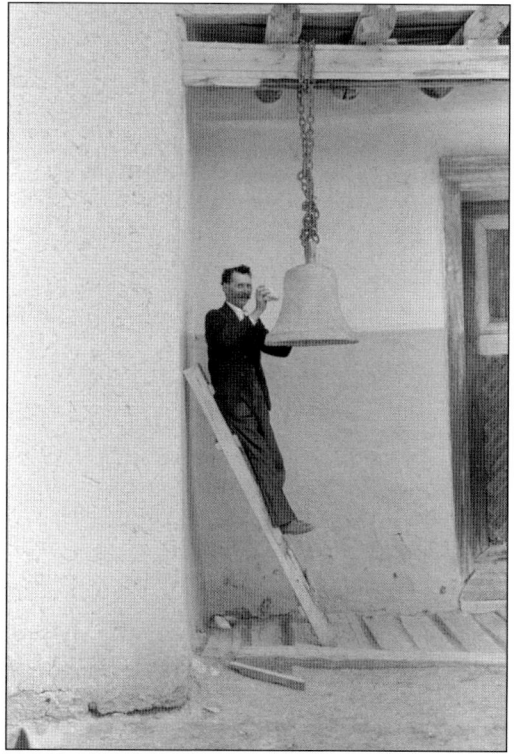

CHURCH BELL, JANUARY 1943. In 1943, the original belfries atop the towers were not in existence, so the bell was hung on a chain at the front entrance. The balcony above the bell was where the choir would stand and sing for outdoor processions. The door behind the balcony led to the interior choir loft. (John Collier, LC-USW3-013707-C.)

RINGING THE BELL WITH A ROCK, JULY 1940. Originally there were two bells, one for each belfry. But with no belfry in existence in 1940, this method was used to ring the bell. The two bells were nicknamed "Gracia" and "Refugio." The Refugio bell was stolen in 1909, so these photographs all show the Gracia bell. (Russell Lee, LC-USF33-012824-M2.)

CHURCH BELL GRACIA, JANUARY 1943. The two bells were cast from gold and silver metals from household items originally brought from Spain and donated by the parishioners. The Refugio bell had a deep, heavy tone and was rung for Masses for the dead or the death of an adult. The Gracia bell had a gentler, lighter tone and was rung for Mass or the death of an infant. (John Collier, LC-USW3-014580-E.)

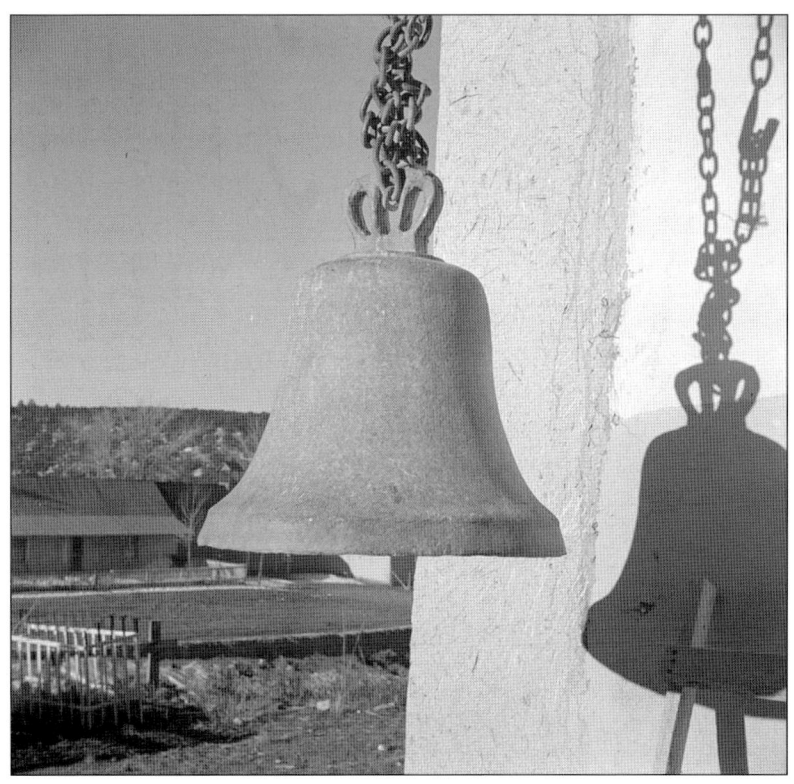

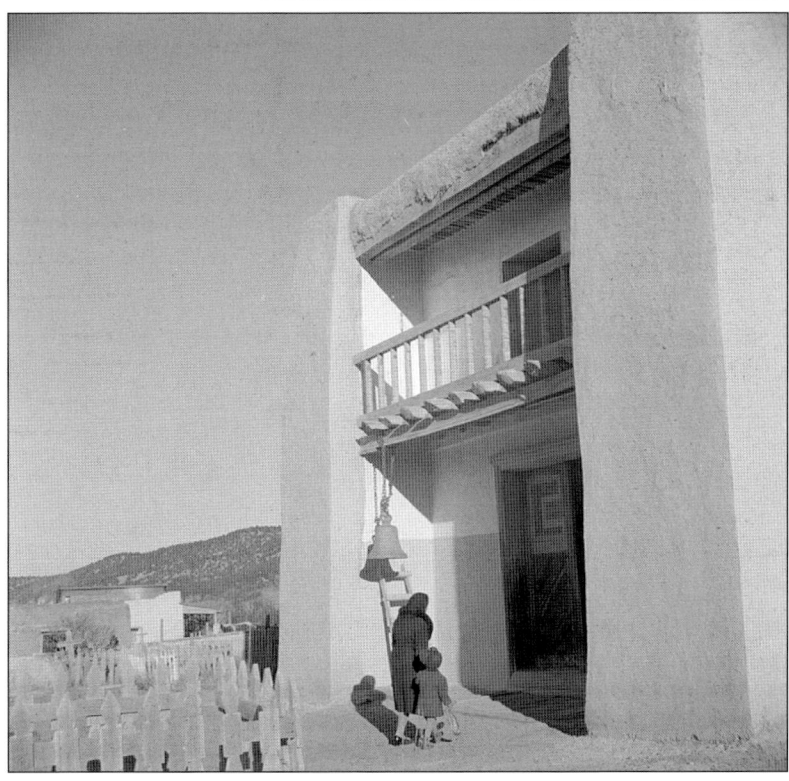

CHURCH ENTRANCE WITH GRACIA BELL, JANUARY 1943. The snow is gone, but the woman and child are bundled up against the cold weather. Some accounts state that the Gracia bell was stolen and the Refugio bell remains, but John Collier labeled this bell "Gracia" in his photographs. In September 2015, the author spoke to a church caretaker who confirmed that only the Gracia bell remains. (John Collier, LC-USW3-014582-E.)

Leaving after Mass, January 1943. Parishioners greet each other after Mass. The women are still clothed in heavy winter coats and hats, while the men have only suit jackets for warmth on this sunny January day. The picket fence in the left background surrounds graves, as shown on the bottom of page 56. (John Collier, LC-USW3-014628-C.)

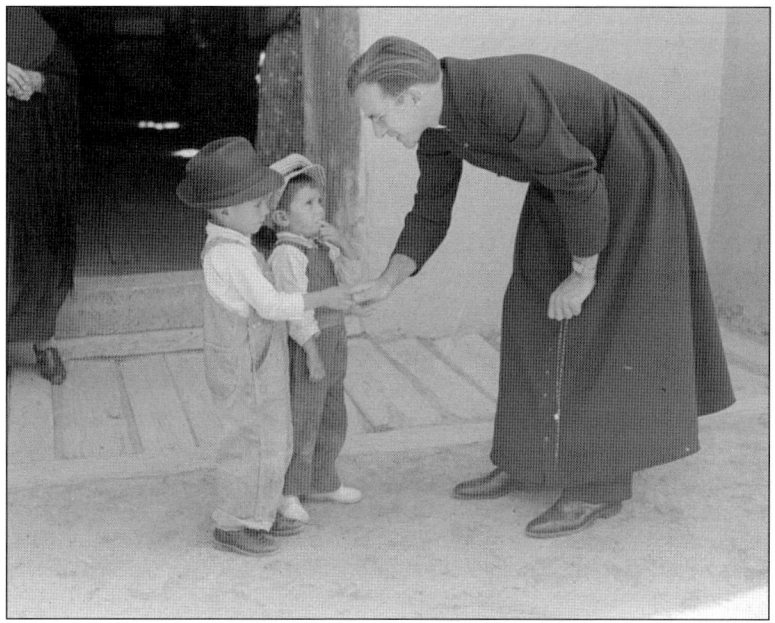

Priest Greeting Children, July 1940. San Jose de Gracia de Las Trampas Church was served by a visiting priest from Peñasco at this time. The young boys are well dressed for Mass. (Russell Lee, LC-USF33-012824-M4.)

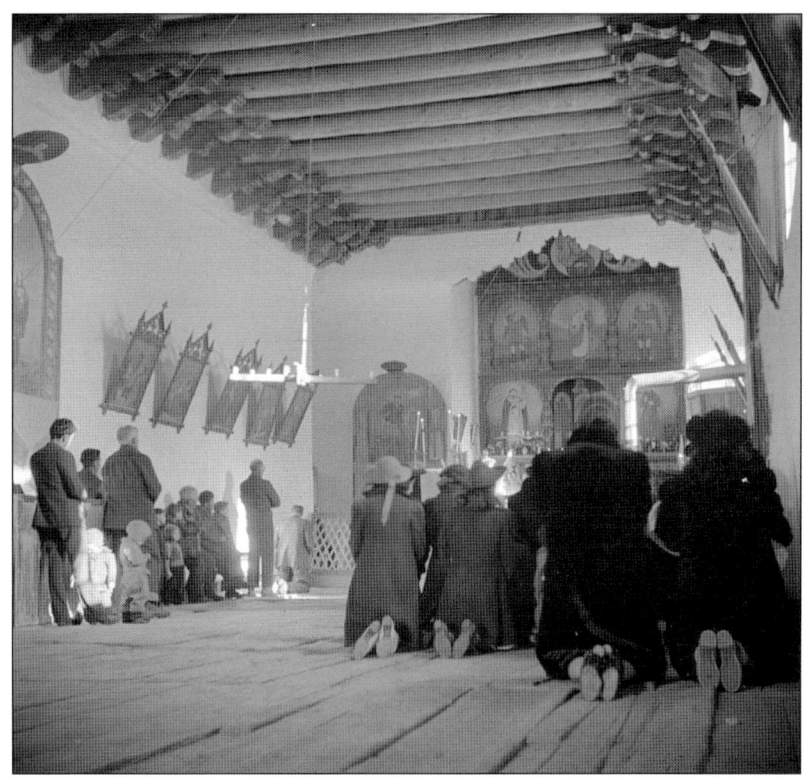

PRAYING ON THE FLOOR, JANUARY 1943. There were no pews in the San Jose de Gracia Church in 1943. Upon the author's visit in September 2015, the wood floor remained the same, but there were pews throughout the church. Note the vigas (log beams) supporting the roof of the church. Each viga was supported at both ends by a carved wooden corbel. (John Collier, LC-USW3-014602-E.)

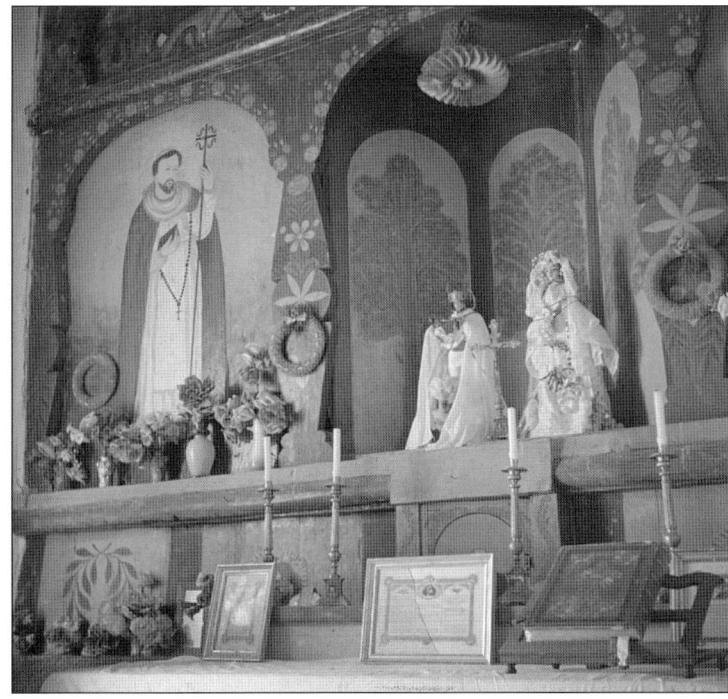

SAN JOSE DE GRACIA CHURCH ALTAR, JANUARY 1943. The main altar screen was probably built in the early 1800s. It was overpainted in 1860 by Jose de Gracia Gonzales, a Mexican *santero* (a painter or carver of images of saints). On the altar itself are two santos (carved images of saints). (John Collier, LC-USW3-014575-E.)

LADDER TO CHOIR LOFT, OCTOBER 1961. Just inside the front entry door to San Jose de Gracia Church is this ladder leading up to the choir loft. The choir could sing indoors from the loft in the sanctuary, or go outside through a door in the loft to the outer balcony to sing for outdoor processions. (Jack Boucher, LC-HABS NM, 28-TRAMP, 1-11.)

SAN JOSE DE GRACIA CHURCH GRAVEYARD, JANUARY 1943. The graveyard was on the west side of the church, while the morada was on the east side. Note the *canales* (drain spouts) on the roof, which drain water off the nearly flat, gently sloping roof. (John Collier, LC-USW3-013692-C.)

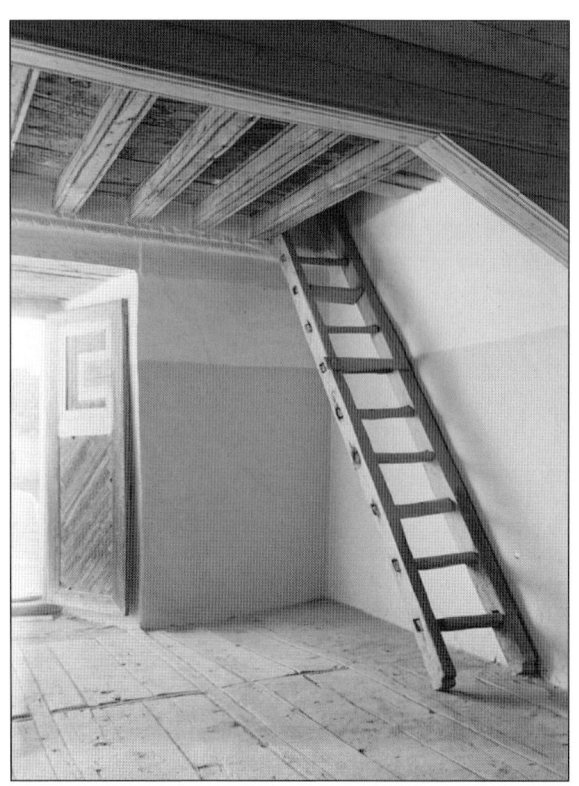

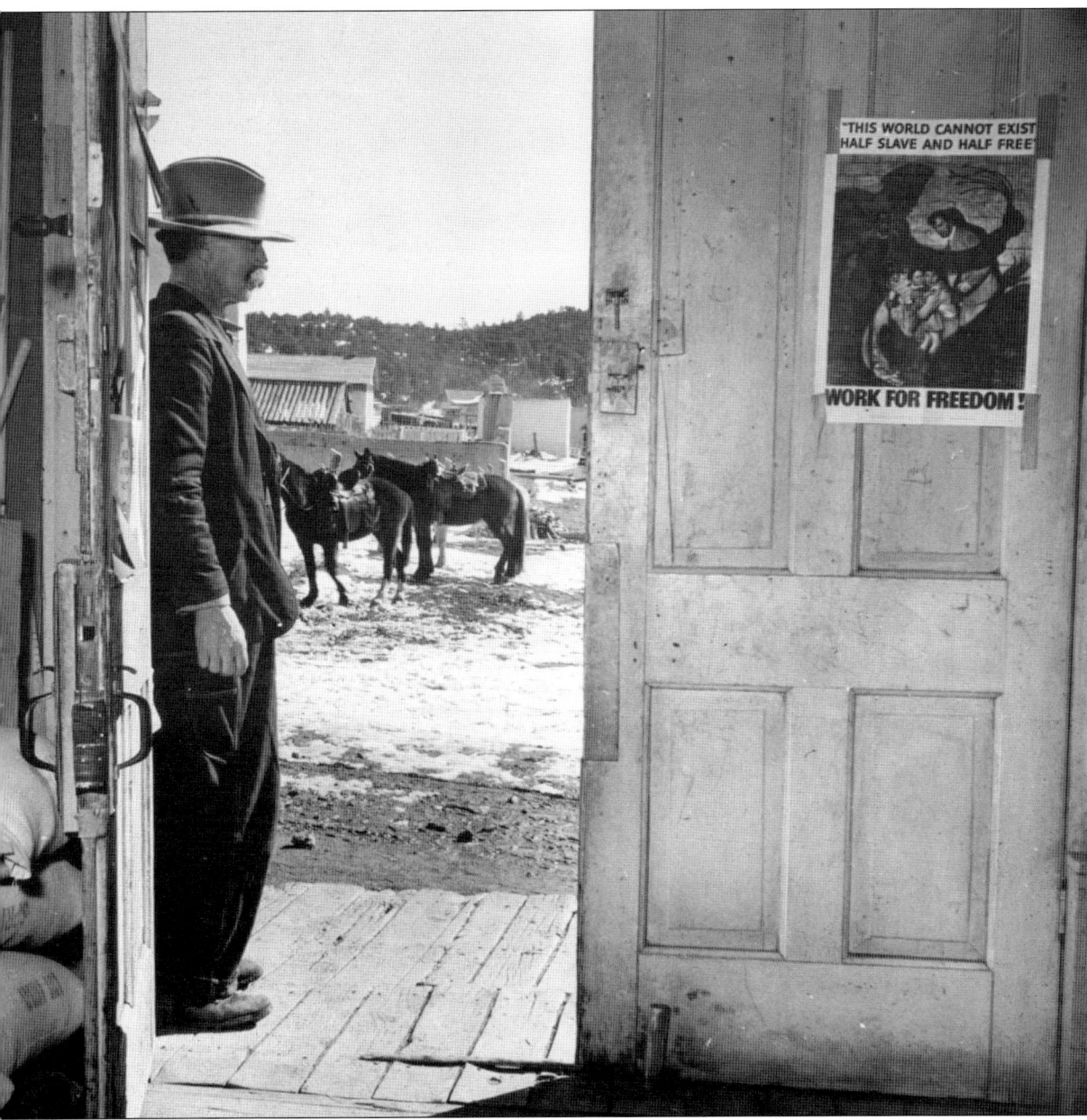

INSIDE LAS TRAMPAS GENERAL STORE, JANUARY 1943. Is this a scene from 1880 or 1943? The only clue is the poster on the door, which reads, "This world cannot exist half slave and half free—Work for freedom!" The poster was promoting civilian participation in the effort to defeat Nazism in World War II. Horses were a major source of transportation for Las Trampas citizens who owned very few automobiles in the 1940s. (John Collier, LC-USW3-018059-E.)

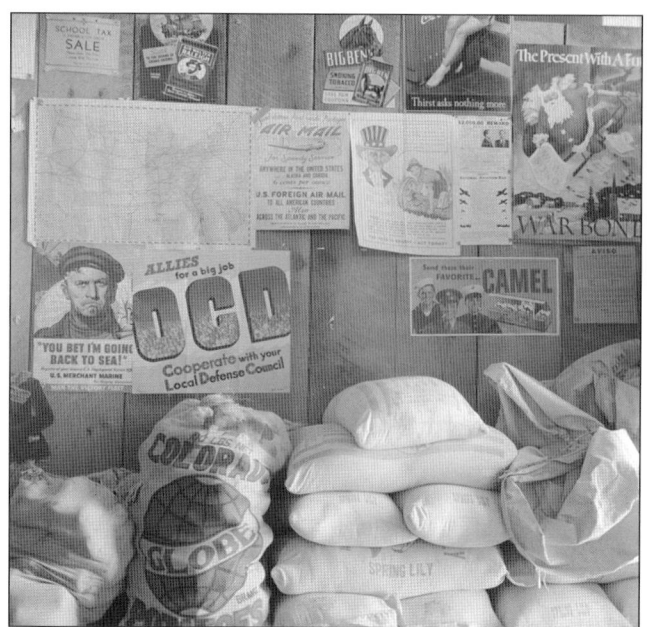

GENERAL STORE SUPPLIES, JANUARY 1943. Stacked and ready for purchase were bags of Colorado Globe potatoes (most likely from Colorado's San Luis Valley just north of the New Mexico border) and sacks of Spring Lily flour. Posters advertised war bonds, the US Merchant Marine ("You bet I'm going back to sea!"), Camel cigarettes, Big Ben Smoking Tobacco, and Sir Walter Raleigh tobacco. (John Collier, LC-USW3-018062-E.)

GENERAL STORE GATHERING PLACE, JANUARY 1943. The stove provided a warm respite from the cold January day as local men gathered to read newspapers and swap stories. (John Collier, LC-USW3-015212-C.)

Post Office, January 1943. The Las Trampas Post Office, located inside the general store, had a mail drop slot below the window with the iron bars. Several "Wanted" criminal posters hang next to the window. Other posters advertise "Postal Money Orders" and "United States Savings Bonds and Stamps." (John Collier, LC-USW3-018060-E.)

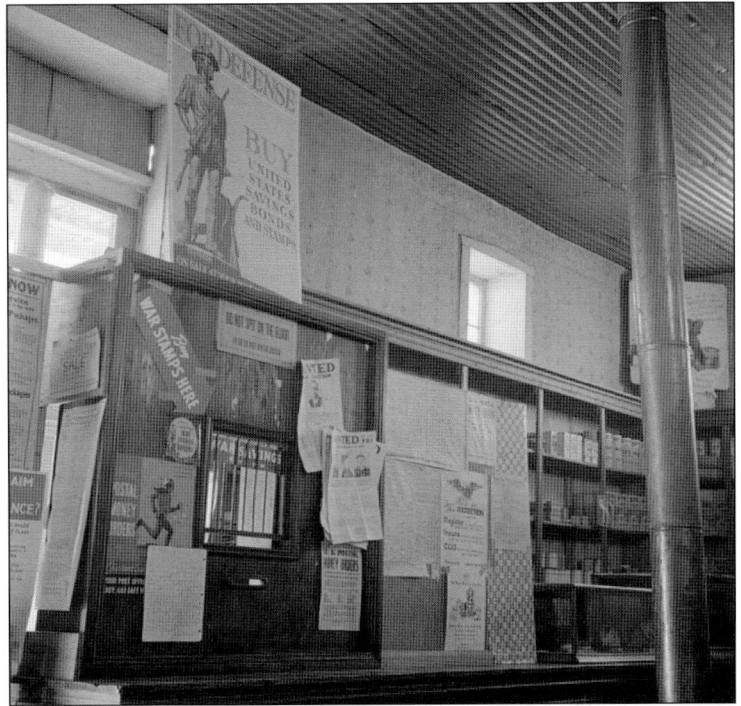

Las Trampas General Store, October 2014. Right across the plaza from San Jose de Gracia Church is a general store that had a take-out food counter. It is currently abandoned.

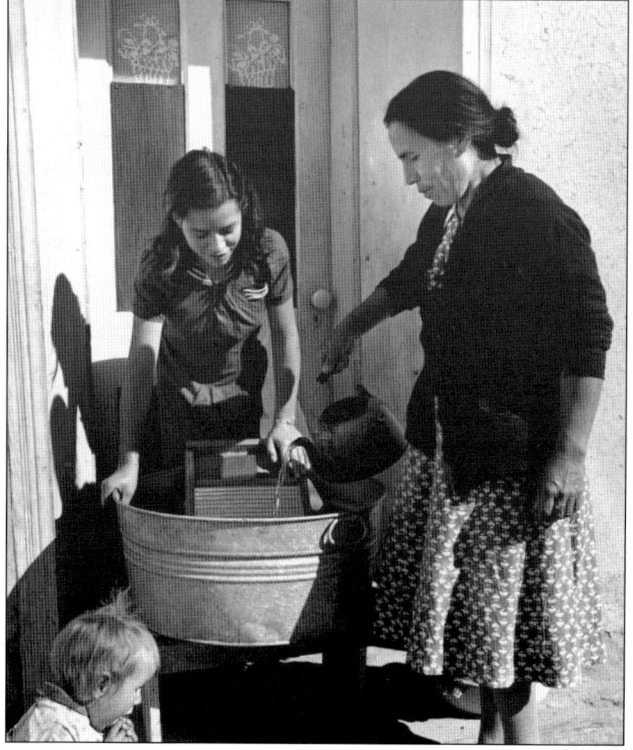

Portrait of Juan Lopez, January 1943. John Collier Jr. took an extensive series of photographs of the Juan Lopez family of Las Trampas and their daily activities. Collier identified Juan Lopez as mayordomo, which he defines as "mayor." However, mayordomo usually refers to one who is a member of the governing board of a parish church, or is the boss of an acequia (irrigation ditch). (John Collier, LC-USW3-T01-017941-C.)

Portrait of Maclovia Lopez, January 1943. Maclovia was the wife of Juan Lopez. Together they raised six children in their Las Trampas home. Maclovia's many household duties included cooking, washing, sewing, and spinning wool. (John Collier, LC-USW3-T01-018508-C.)

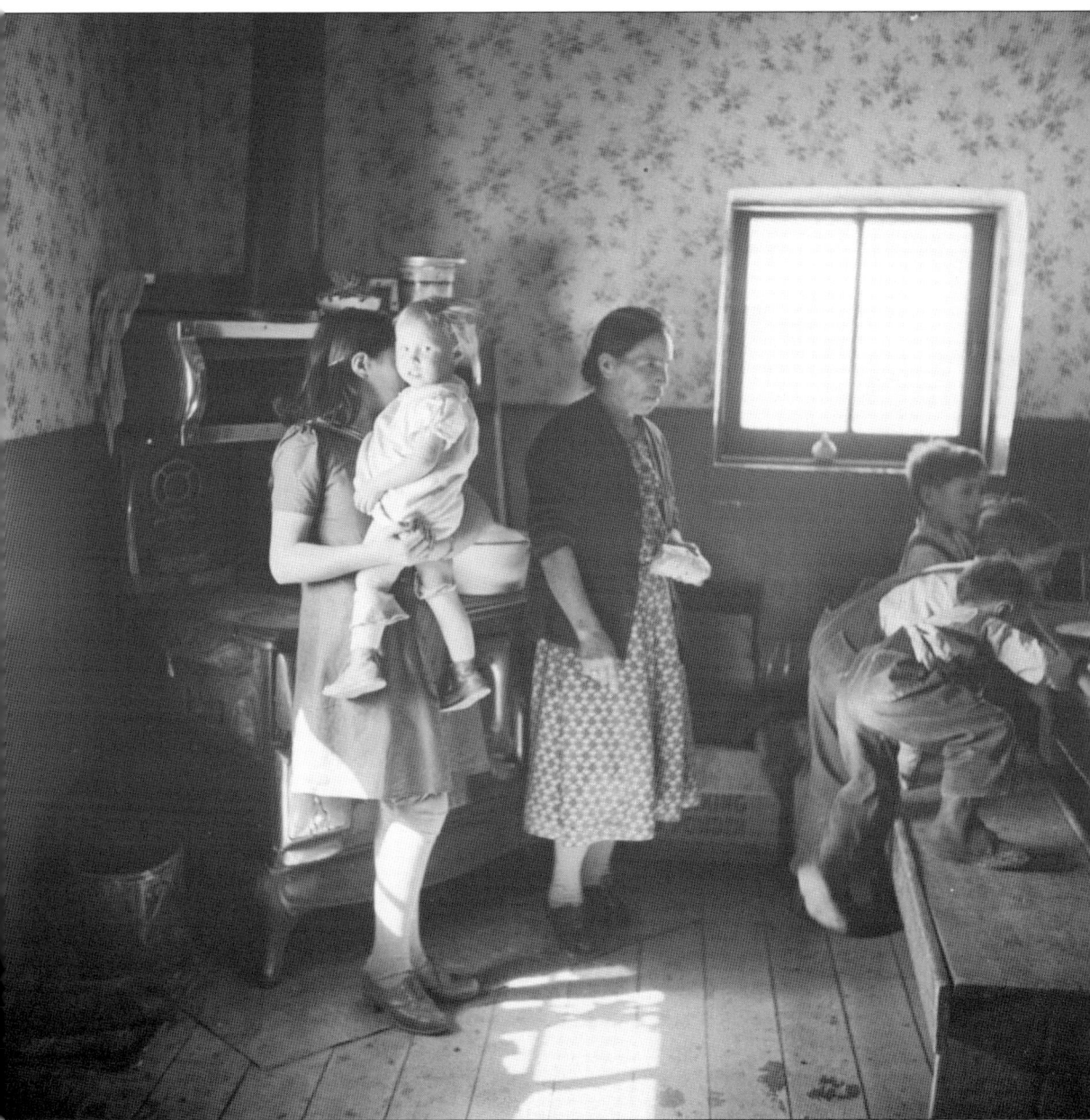

GATHERING FOR DINNER, JANUARY 1943. Dinner has been prepared on the woodstove in the left background. The Lopez boys are scrambling to their seats on the bench while Maclovia Lopez and her two daughters wait to be seated. (John Collier, LC-USW3-018168-E.)

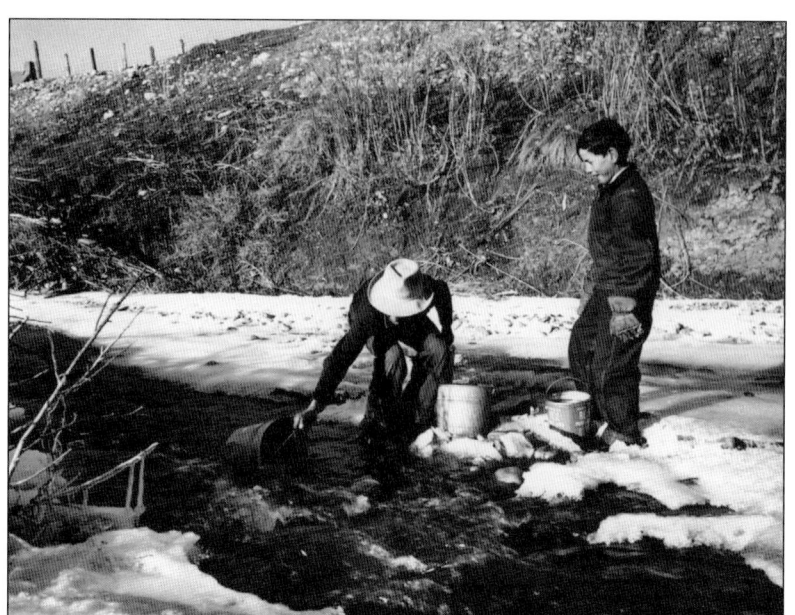

Drawing Water, January 1943. Juan Lopez and one of his sons fill buckets with water from the Rio de Las Trampas. There was no running water in their home, so they must make this trip to the river daily despite the snow, ice, and cold temperature of a January morning. (John Collier, LC-USW3-T01-017887-C.)

Washing Up, January, 1943. Two of the Lopez boys wash their hands and comb their hair using water gathered from the river. River water was also used for cooking, washing dishes, and washing clothes. (John Collier, LC-USW3-T01-015287-C.)

Lopez Boys Milking the Cow, January 1943. Early morning chores for the Lopez boys included drawing water from the river and milking the family cow. John Collier stated that the milk "is used on their mush and in coffee; rarely as a drink." (John Collier, LC-USW3-015298-C.)

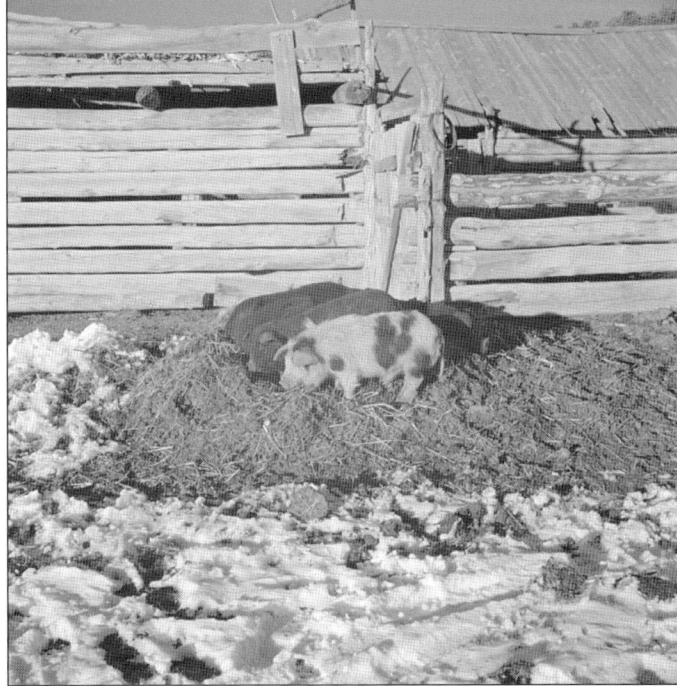

Pigs Feeding in the Lopez Corral, January 1943. The Lopez family raised cows, pigs, chickens, sheep, and horses on their small farm. Here, the pigs are feeding on hay harvested the previous summer. Pigs and chickens were a main source of meat for the family. (John Collier, LC-USW3-017761-E.)

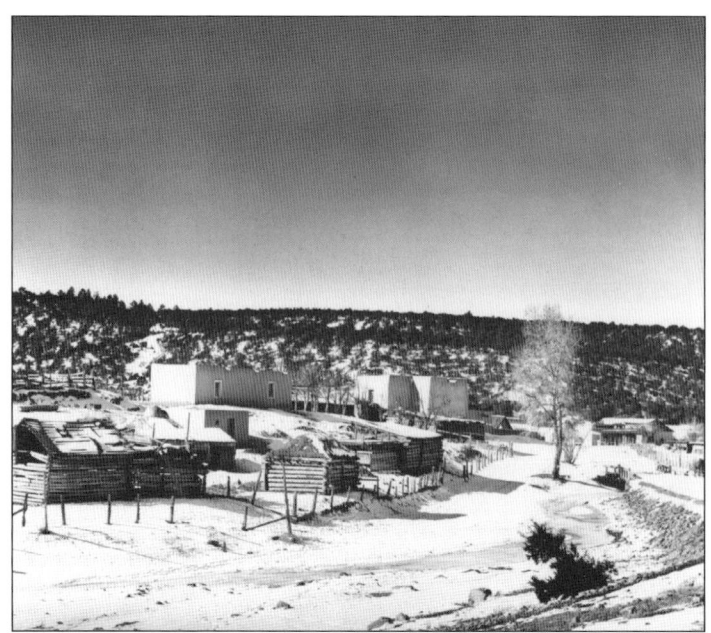

LOPEZ HOME, CORRAL, AND STORAGE SHED, JANUARY 1943. When the land grant was made to the original settlers of Las Trampas, it included three types of property: private parcels for each family (as seen here), public parcels for the church and plaza, and ejidos (common lands) consisting of woodlands and meadows for all the villagers to use for hunting, wood gathering, and grazing livestock. (John Collier, LC-USW3-T01-017884-C.)

HARNESSING HORSES, JANUARY 1943. Juan Lopez is harnessing horses to pull a wagon to the mountains to gather firewood. By 1943, common grazing lands and woodlands had almost completely disappeared. Many Spanish land grants were not recognized by the US government, and ejidos were given over to the care of the US Forest Service. (John Collier, courtesy of Maxwell Museum of Anthropology.)

HEADING OUT FOR FIREWOOD, JANUARY 1943. Juan Lopez and one of his older sons have harnessed the horses and hitched them to the wagon. They are heading higher up into the mountains to collect firewood, which they will bring back in the wagon. (John Collier, courtesy of Maxwell Museum of Anthropology.)

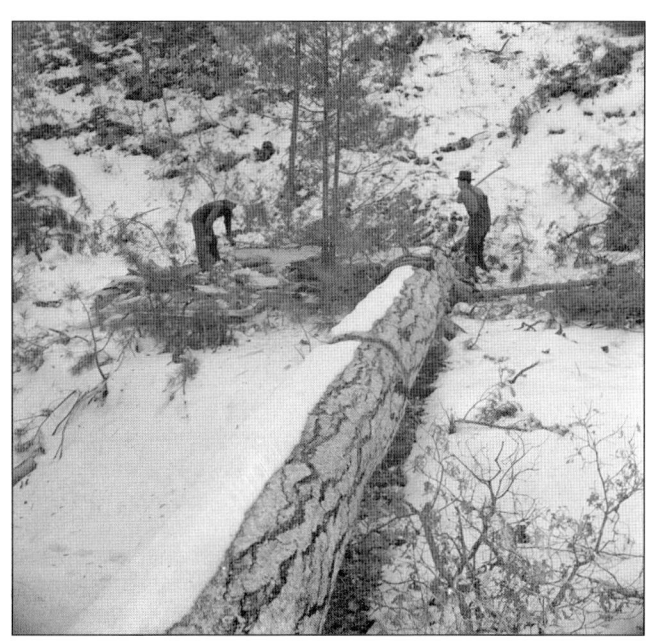

SPLITTING DOWNED TIMBER FOR FIREWOOD, JANUARY 1943. This is probably in what is now Carson National Forest. The *Taos News* reported on July 23, 2015, "To this day there is latent resentment among descendants of Hispano settlers who believe the agency (Forest Service) scooped up large portions of Spanish and Mexican land grants, depriving them of resources that were vital to their way of life." (John Collier, LC-USW3-015157-E.)

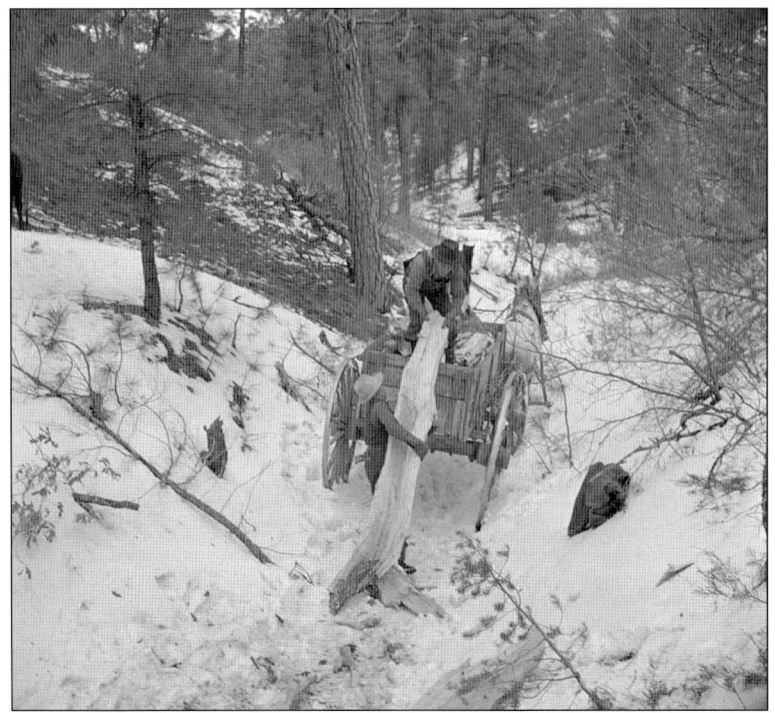

LOADING THE WAGON, JANUARY 1943. Juan Lopez and his son load dead timber into their wagon. This wood was essential for heating their home, cooking, and heating water for washing dishes and clothing. (John Collier, LC-USW3-015110-E.)

UNLOADING THE WOOD WAGON AT HOME, JANUARY 1943. Until about 1900, Hispanic villagers in northern New Mexico were virtually self-sufficient with their small farms and use of the communal lands. When the communal lands were taken away and property taxes levied on the farms, it spelled the end of a way of life that had worked successfully since the 1750s. (John Collier, LC-USW3-015223-C.)

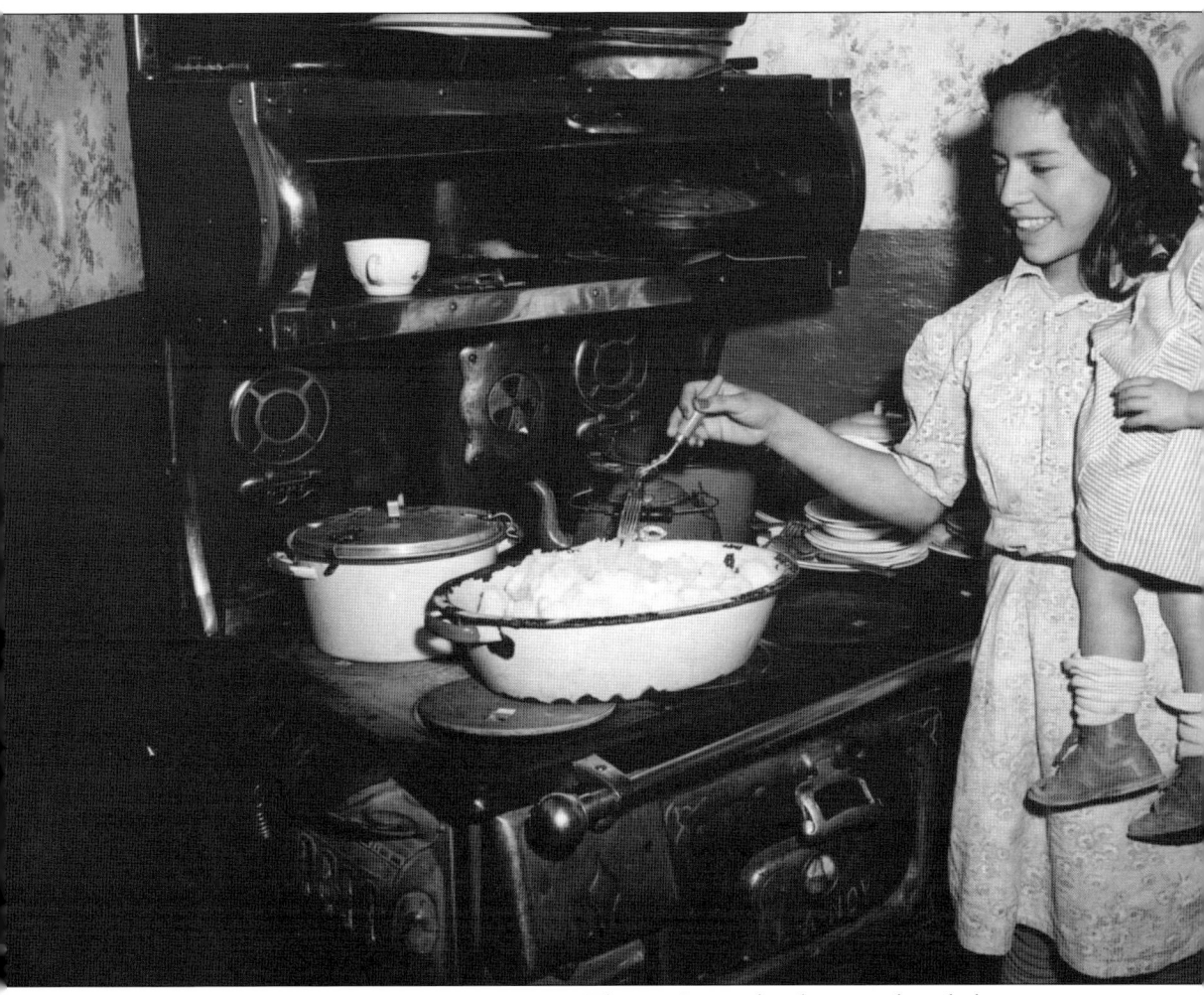

COOKING ON THE WOODSTOVE, JANUARY 1943. The two Lopez daughters are busy helping prepare the meal. The elder daughter tends to her younger sister while keeping an eye on the food. All family members helped with the chores, and the family unit was essentially self-sufficient. (John Collier, LC-USW3-015236-C.)

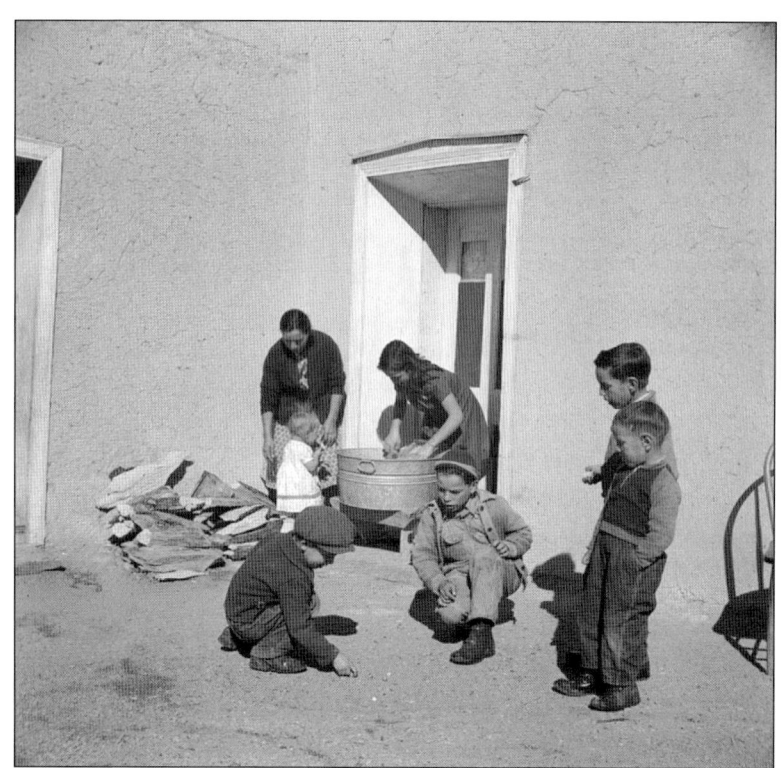

LAUNDRY DAY, JANUARY 1943. Maclovia Lopez and her two daughters are washing clothes in the tub with water drawn from the river and heated by firewood gathered by the men. The Lopez boys are playing a game of marbles. (John Collier, LC-USW3-017153-E.)

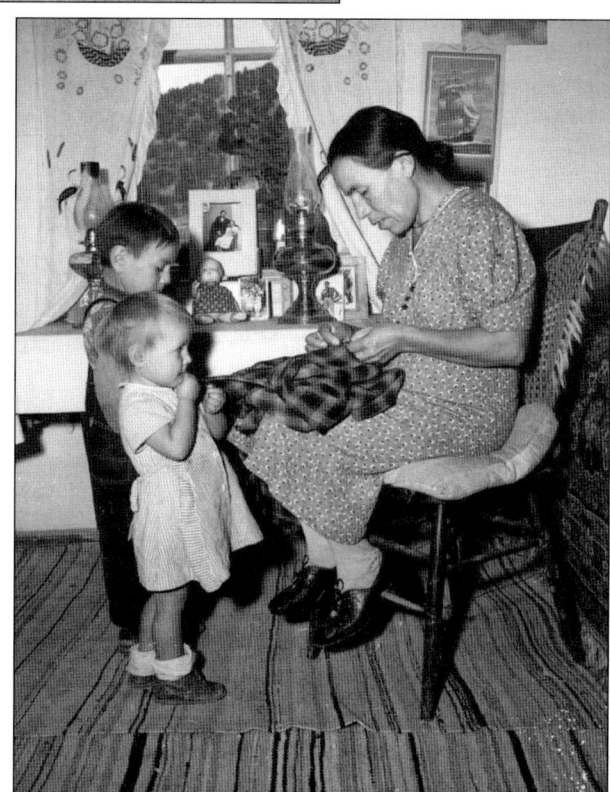

SEWING CLOTHES, JANUARY 1943. Maclovia Lopez is busy sewing clothes for the family. Maclovia was always busy with household chores. (John Collier, LC-USW3-017889-C.)

SPINNING WOOL, JANUARY 1943. Maclovia Lopez is shown spinning wool by the fireplace in the evening. It seems that her duties were never done. The Lopez family probably grazed a few sheep and used the wool to spin into thread for clothing and blankets. (John Collier, LC-USW3-T01-017814-E.)

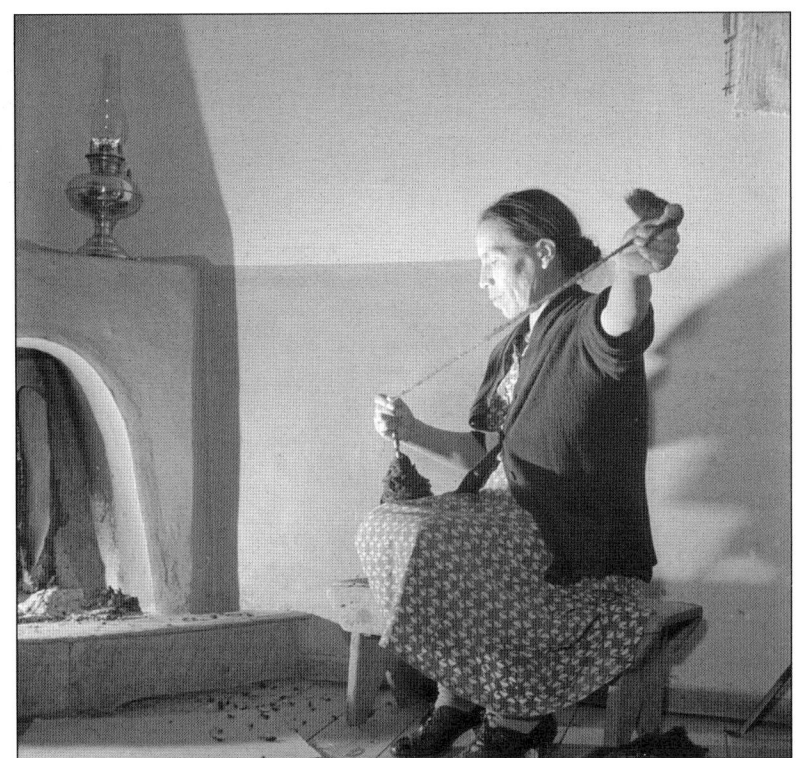

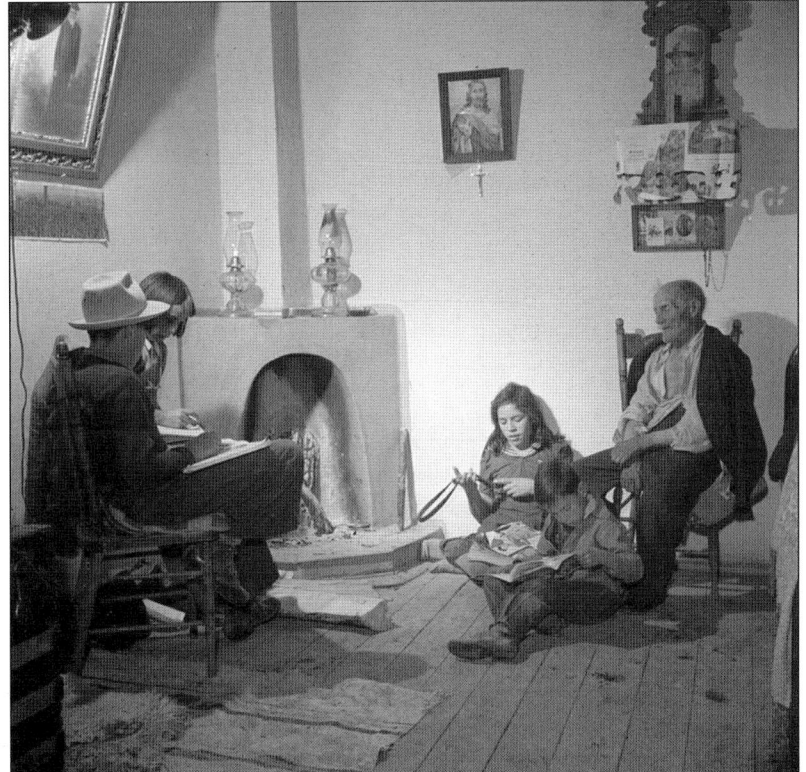

GATHERED AROUND THE FIREPLACE, JANUARY 1943. The fireplace is the kiva style, so familiar in homes across New Mexico. John Collier's caption for this photograph stated that Grandfather Lopez was telling tales of sheep herding in Las Trampas in the old days. The children are busy reading, possibly doing their homework. (John Collier, LC-USW3-T01-017809-E.)

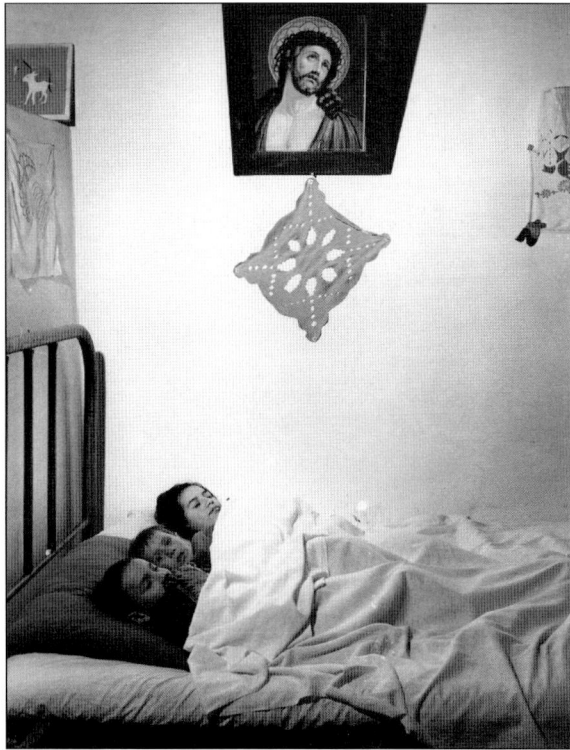

Relaxing by the Fireplace, January 1943. Juan and Maclovia Lopez are staying warm by the fireplace, relaxing after a long day of work. Juan appears to be carving or fixing a doll for the little girl, while Maclovia attends to her daughter. (John Collier, LC-USW3-015244-C.)

Bedtime in the Lopez Home, January 1943. Three of the Lopez boys are sleeping in one bed. The home probably had only two bedrooms, so space was at a premium. On the wall is a picture of Jesus, very appropriate for this Catholic family. (John Collier, LC-USW3-015260-C.)

LAS TRAMPAS CANOA, JANUARY 1943. The canoa is a log flume that carries irrigation water. It is supported by a sawn timber frame that carries the flume over an arroyo or intermittent stream. The Rio de Las Trampas flows southeast to northwest through town. Irrigation water from the river was distributed to two acequias—one serving farms north of the river and one serving farms south of the river. (John Collier, LC-USW3-017763-E.)

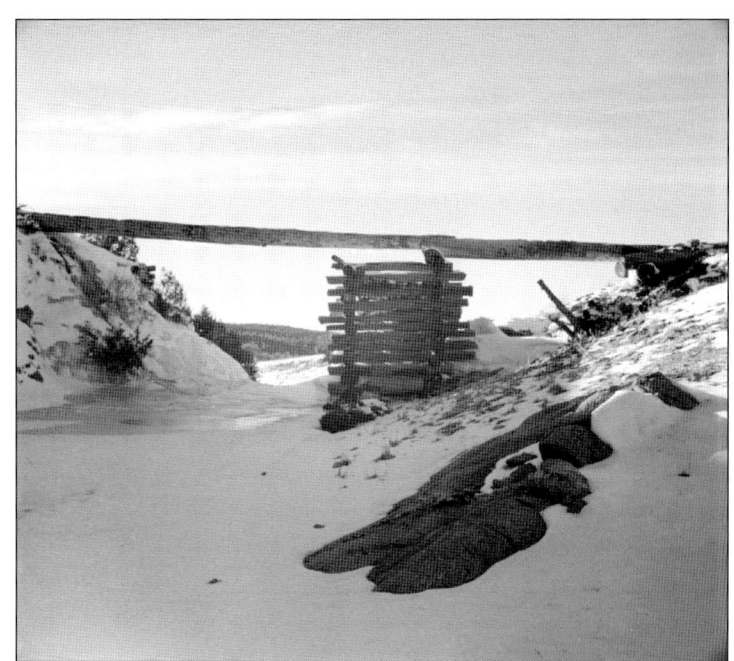

LAS TRAMPAS CANOA, SEPTEMBER 2014. Las Trampas is still served by a canoa today. The sawn timber frames support the canoa about 20 feet off the ground. For those heading north out of Las Trampas on New Mexico Highway 76 on the first curve, the canoa can easily be seen on the right side of the road.

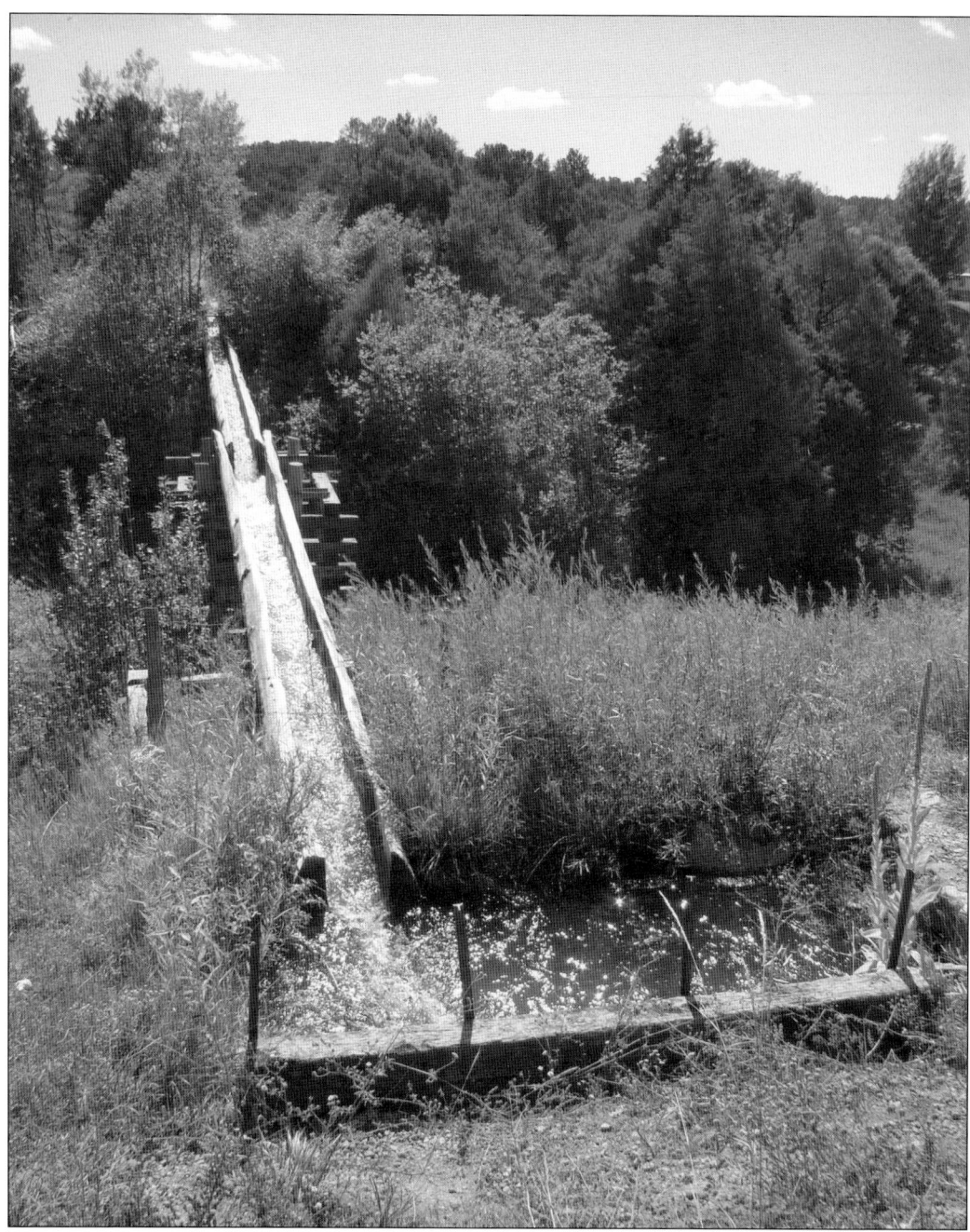

LAS TRAMPAS CANOA, SEPTEMBER 2014. Canoa literally means "canoe." The canoe shape of the hollowed-out logs can easily be seen in this photograph. The logs were hollowed out using an axe. Water flows from the acequia into the canoa, across the arroyo, and into the continuation of the acequia on the other side. Water flows about 30 feet across the two log flumes toward the viewer and empties into a culvert, which then carries the water under New Mexico Highway 76 to the other side. Each log is 12 inches wide inside and 6 inches deep. The canoa is estimated to carry one-half cubic foot of water per second, according to a study by the Historic American Engineering Record in 1972.

Four

CHAMISAL

The little village of Chamisal lies at an altitude of 7,474 feet, about three miles north of Las Trampas. It was settled in the late 1700s by people moving out from Las Trampas and other nearby areas in search of more farmland. It is located on the Picurís Pueblo land grant, and the incursion of the Spanish settlers was not welcomed by the Pueblo people. The name of the village comes from chamisa (rabbit brush), a form of sage that blooms bright yellow in autumn. In 2010, Chamisal had 310 residents, 87 percent of whom were Hispanic.

Russell Lee photographed Chamisal extensively in July 1940 for the Farm Security Administration. He set up his headquarters in Dixon, which is about a 16-mile journey from Chamisal. In *Russell Lee's FSA Photographs of Chamisal and Peñasco, New Mexico*, editor William Wroth notes that "Lee's work . . . was intended as a thorough, in-depth documentation of traditional Hispanic communities in northern New Mexico. The photographs he made there constitute an important visual document of a way of life that was and still is little known . . . by larger society." Lee states that he was "taking pictures of the history of today. By means of these pictures we were helping some parts of the country understand what the other parts were like."

While the effects of the Great Depression were devastating upon small villages like Chamisal, the negative effects were somewhat diminished by the self-sufficiency of the farm families, just as in Las Trampas. In 1981, an elderly man from Chamisal told Charles Briggs in an interview (from *Russell Lee's FSA Photographs of Chamisal and Peñasco*) that "the Depression hardly hit here at all. We had 4000 pounds of wheat, we had pigs, fat cows, beans. We didn't have any money, but why did we need money . . . We had a lot to eat, you see. And then we had sheep and we made wool mattresses, blankets to keep us warm, pants, socks of wool . . . If somebody was broke, the people helped him. Someone brought beans, a half sack of potatoes, some flour . . . we didn't suffer."

VALLEY OF CHAMISAL, JANUARY 1943. The High Road winds down from Las Trampas to Chamisal. A cluster of buildings in Chamisal can be seen in the center, left of the road. The Sangre de Cristo Mountains rise in the distance to the northeast. (John Collier, LC-USW3-015199-E.)

CHAMISAL MAIN STREET, JULY 1940. Main Street winds between adobe homes leading to a church whose steeple is at right toward the end of the road. (Russell Lee, LC-USF34-037009.)

Santa Cruz Church, July 1940. This adobe church in Chamisal was built in the 1930s to replace a 19th-century church that was in poor condition. The two-tier bell tower/steeple is a unique feature of its architecture. (Russell Lee, LC-USF34-036993-D.)

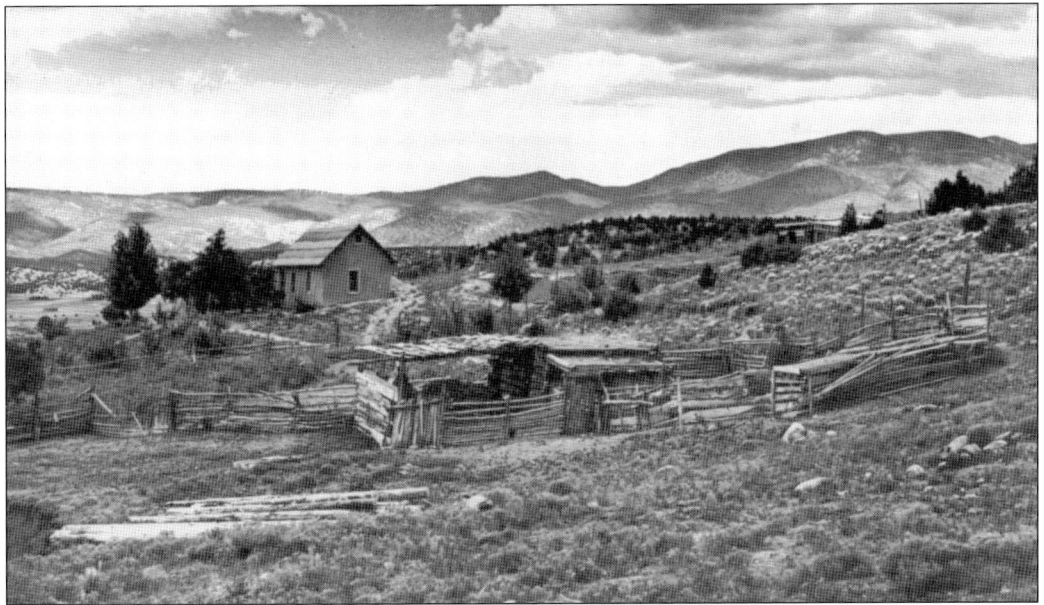

Chamisal Farmstead, July 1940. This beautiful scene illustrates the dispersed nature of many homes in the Chamisal area. Most homes had a small plot of land with a corral for animals and some land to grow a few crops. (Russell Lee, LC-USF34-37100.)

Iglesia Catolica de La Santa Cruz, September 2014. The sign on the church can be translated to "Catholic Church of the Holy Cross of Chamisal." This church was built in 1948, replacing the one seen on the previous page. To find the church today, take the Plaza Road loop west from New Mexico Highway 76 through the town.

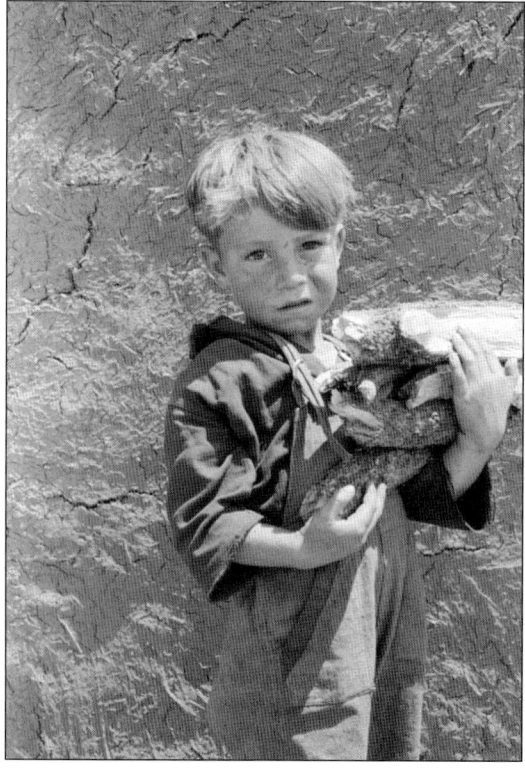

Carrying Firewood, July 1940. This young Chamisal boy is carrying firewood into his home for use in the woodstove for cooking. Children in Chamisal often did small chores such as this to help out their families. (Russell Lee, LC-USF33-012833-M5.)

WEEDING THE TOMATO PATCH, JULY 1940. Children had to help their families in Chamisal because of the shortage of men to work the farms. Many men had left Chamisal during the Great Depression to work as migrant laborers on the large farms in the San Luis Valley of Colorado or elsewhere. Their earned wages were sent back to their families. (Russell Lee, LC-USF33-012812-M4.)

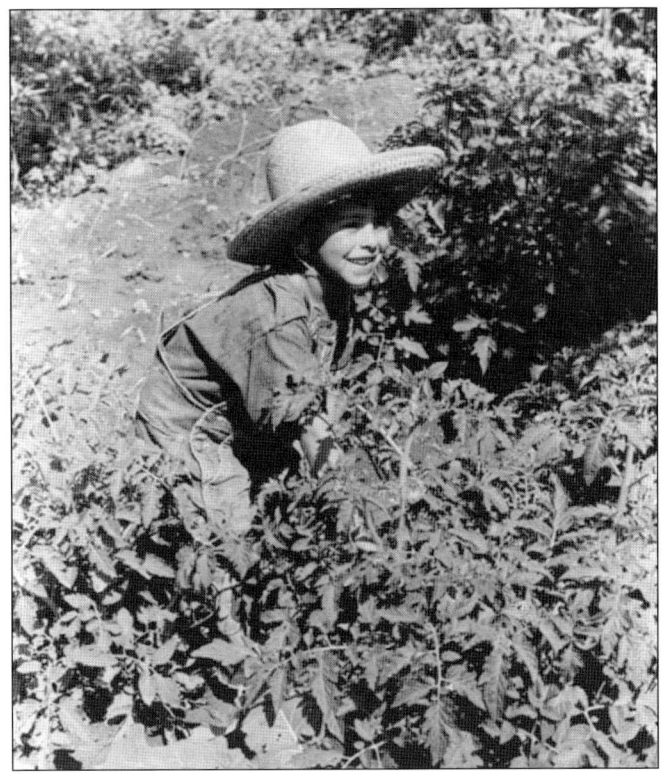

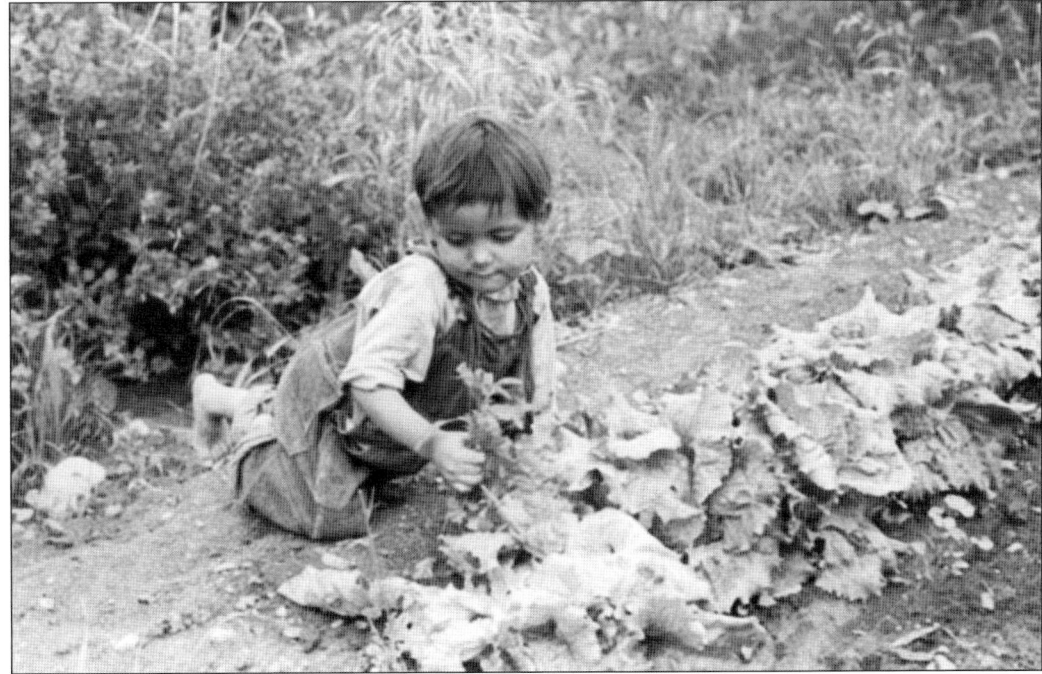

WEEDING THE CABBAGE PATCH, JULY 1940. On their small plots of land, Chamisal families grew tomatoes, cabbages, and other vegetables and fruits. After harvest, women canned the products for eating over the winter months. (Russell Lee, LC-USF33-012813-M4.)

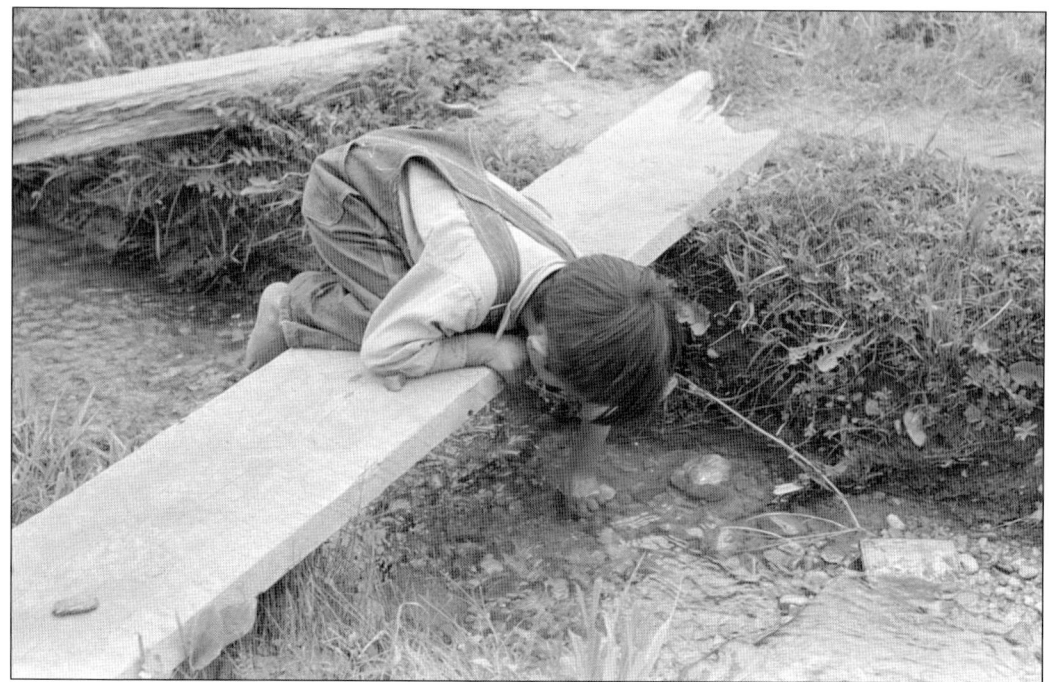

CHAMISAL BOY PLAYING IN IRRIGATION DITCH, JULY 1940. Children were not expected to work all the time. There was plenty of free time to explore the farm and look for frogs or lizards in the acequia. (Russell Lee, LC-USF33-012816-M3.)

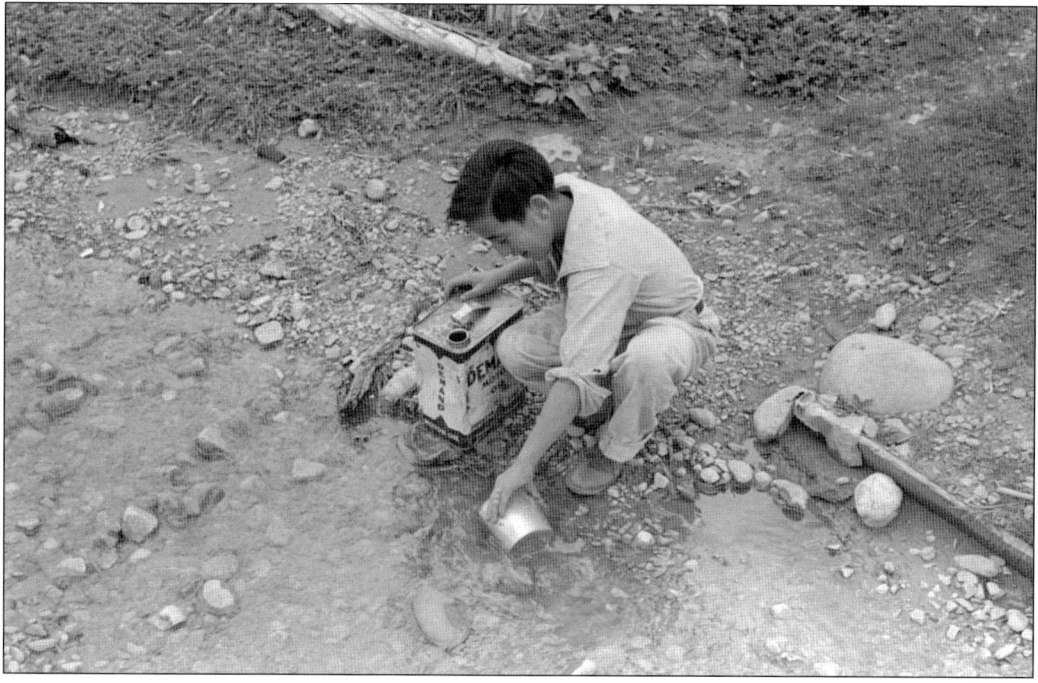

GATHERING WATER FROM THE ACEQUIA, JULY 1940. Acequia water was used not only for irrigating farm fields, but also for household purposes, such as drinking and washing. The boy is collecting water to pour into an old Demand Motor Oil can. (Russell Lee, LC-USF33-012821-M3.)

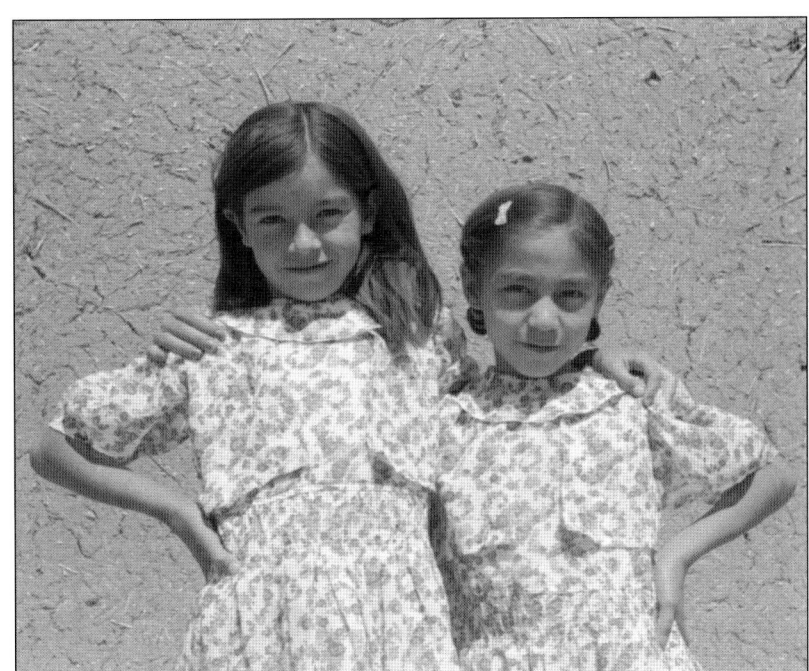

CHAMISAL SISTERS, JULY 1940. Two sisters pose in front of the adobe wall of their home. They are both wearing the same type of print dress, undoubtedly sewn by their mother. Women contributed to the family welfare by sewing clothes for the family, as seen with Maclovia Lopez in Las Trampas on page 68. (Russell Lee, LC-USF33-012835-M4.)

CHAMISAL FAMILY GATHERED FOR DINNER, JULY 1940. Twelve people of all ages are gathered around the table. The extended family often included grandparents and brothers and sisters of the parents. The large family unit took care of itself and provided labor for the many chores necessary to keep the farm successfully supporting the family. (Russell Lee, LC-USF34-037006-D.)

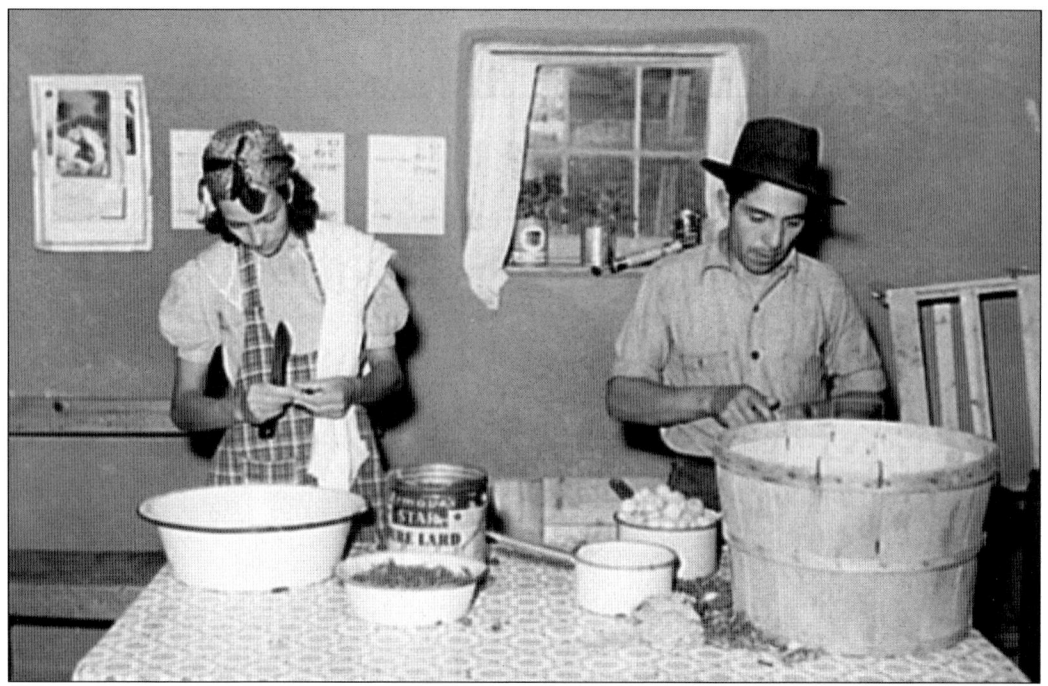

PREPARING FRUIT FOR CANNING, JULY 1940. A husband and wife cut up fruit in preparation for canning. Typical fruits grown in the area included apples, peaches, and apricots. (Russell Lee, LC-USF34-037098.)

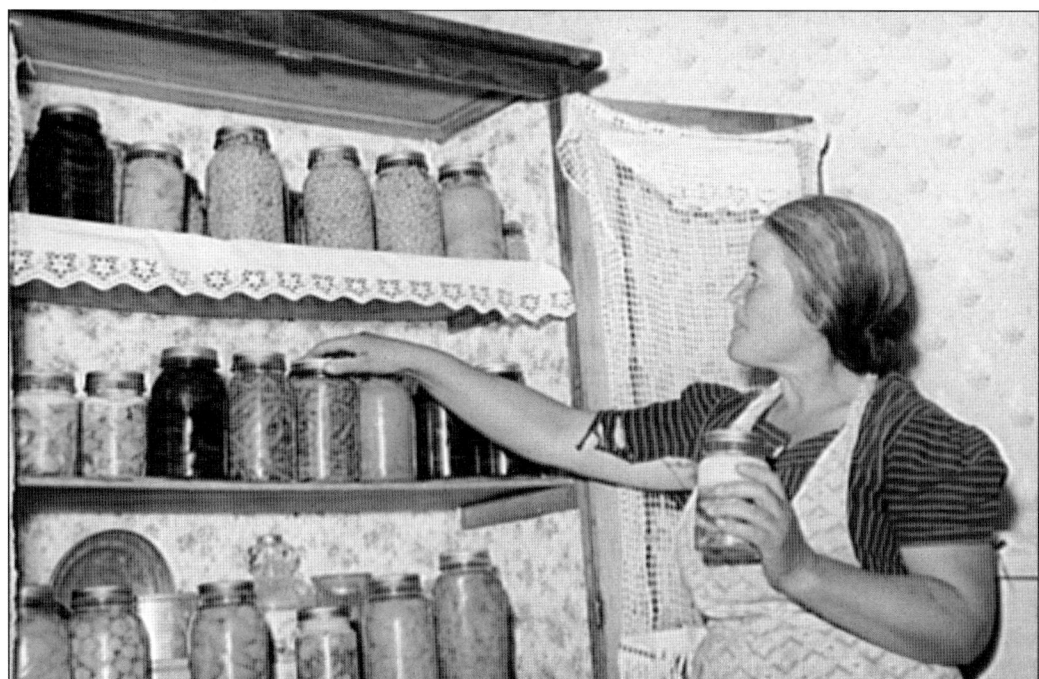

CANNED FRUITS AND VEGETABLES, JULY 1940. Evangelina Lopez of Chamisal checks her stock of canned fruits and vegetables. Canning was very important, as it provided nutritious food for the family throughout the winter. (Russell Lee, LC-USF34-037140-D.)

Washing Clothes, July 1940. This young woman washes the family clothes in a tub using a washboard. Water was brought from the acequia for this purpose. After washing, the laundry was hung to dry on a clothesline. (Russell Lee, LC-USF33-012820-M4.)

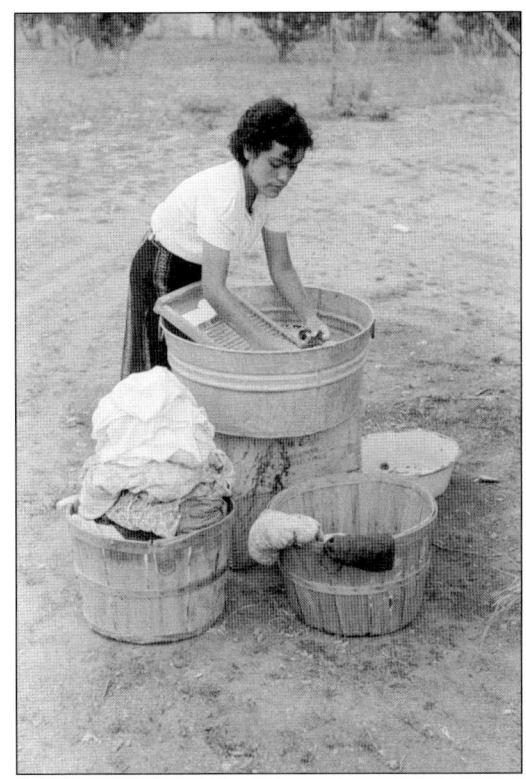

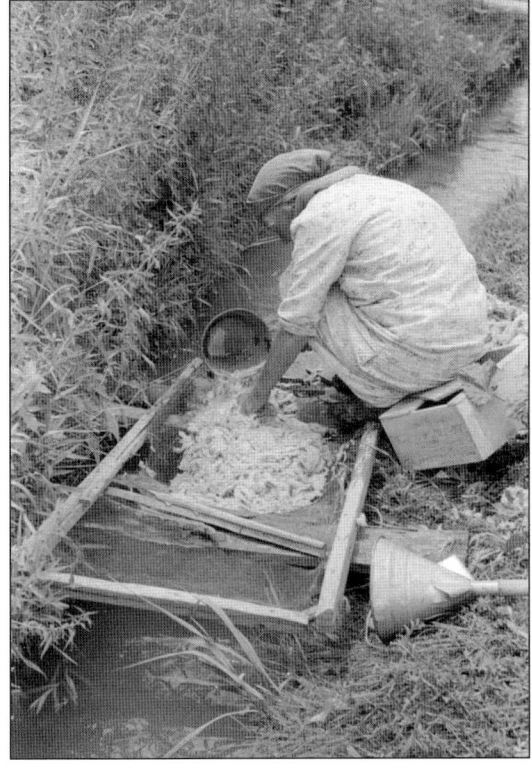

Washing Wool in the Acequia, July 1940. Gomasinda Martinez washes wool in a screening device placed over the acequia. Wool, shorn from the family's herd of sheep, had to be washed free of grease and dirt before it could be spun into thread, as Maclovia Lopez did in Las Trampas (page 69). (Russell Lee, LC-USF33-012815-M1.)

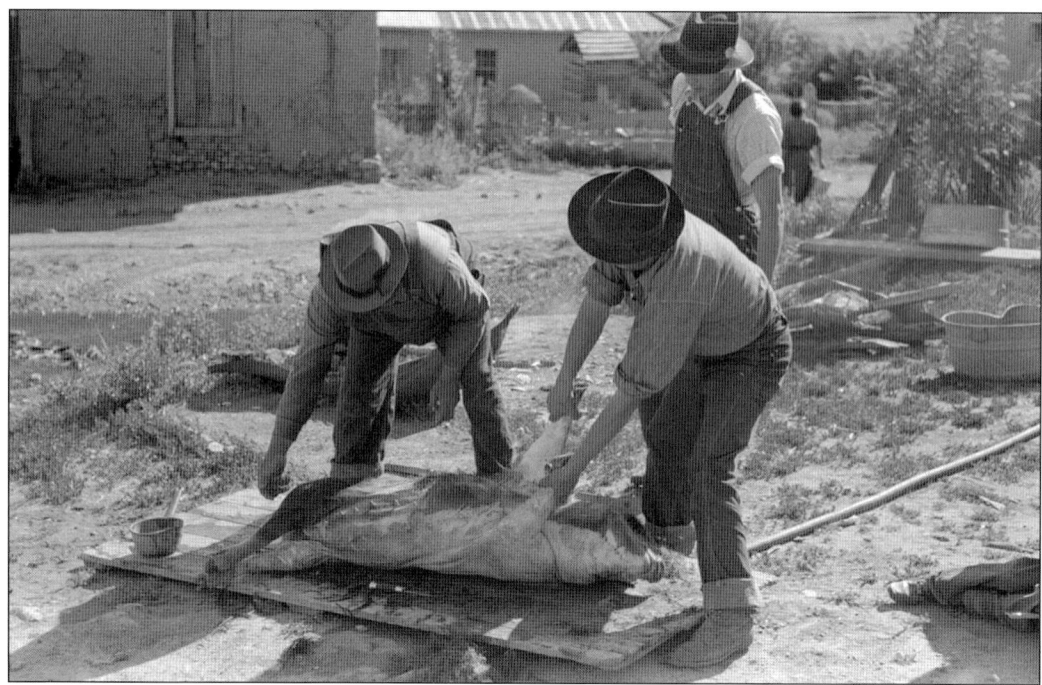

Dressing a Slaughtered Hog, July 1940. The *matanzas de marrano* (hog killing) was a day of celebration for family and friends. Three men work on a hog that has been killed for butchering. The meat will be shared among their families. (Russell Lee, LC-USF33-012837-M1.)

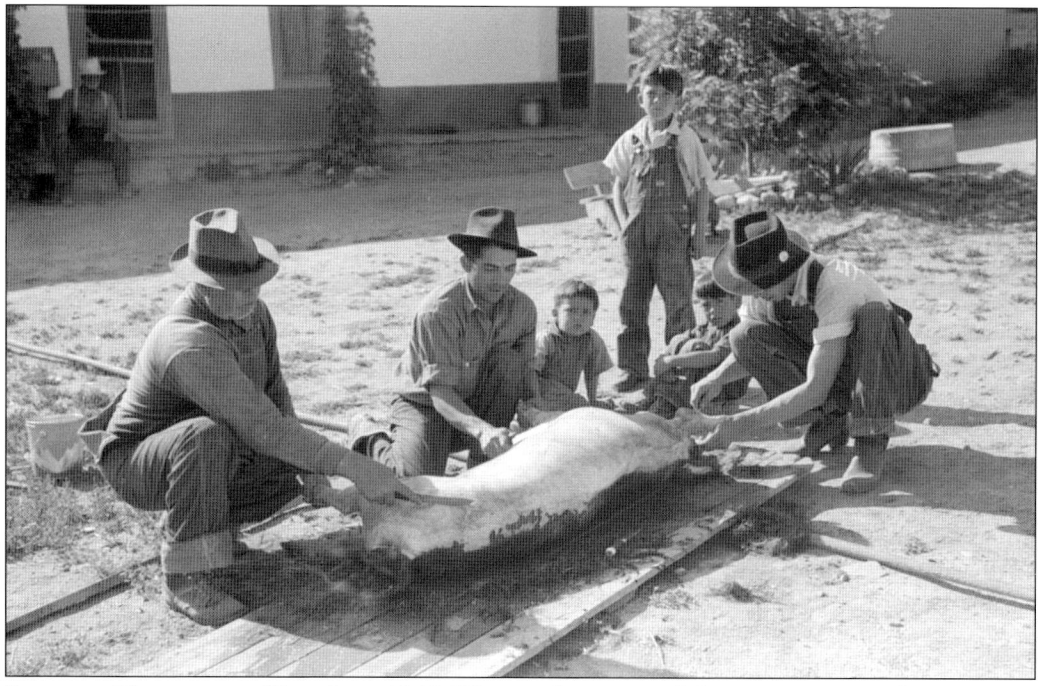

Scraping Hair off the Hog, July 1940. The men have turned the carcass over and are scraping hair off. Once the hair is off, the butchering process can begin. The three boys watch the process with great interest. (Russell Lee, LC-USF33-012837-M2.)

BUTCHERING THE HOG, JULY 1940. The men are dipping blood out of the hog before cutting away sections of meat. The blood will be used in pudding. The intestines will be used for sausages. All parts of the hog were used in some manner. (Russell Lee, LC-USF33-012840-M1.)

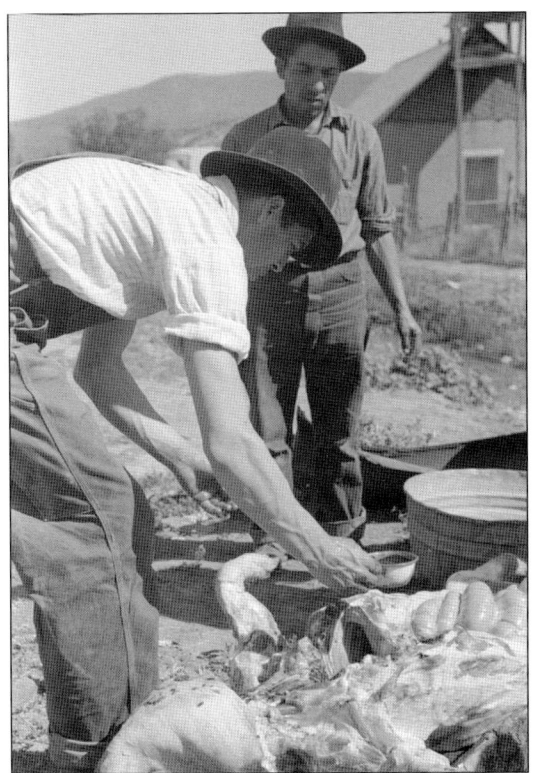

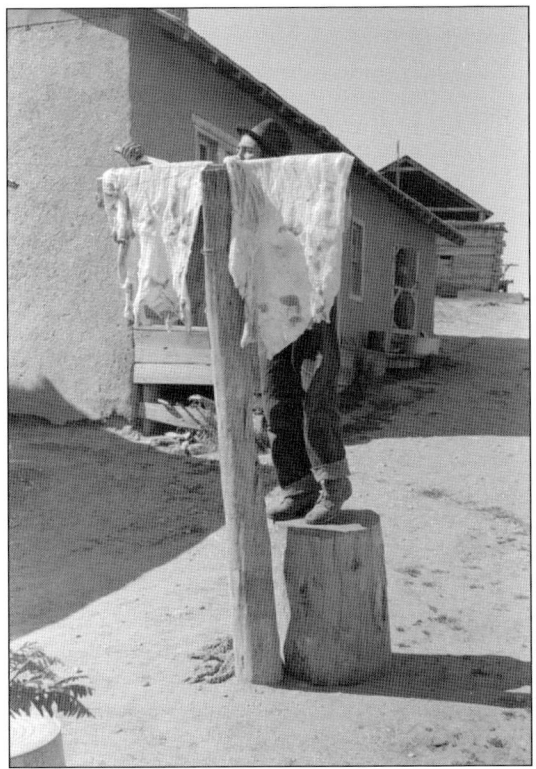

DRYING THE HOG FAT, JULY 1940. Strips of fat from the butchered hog were hung up to dry on high poles. When dry, the fat was used in making lard. Two hundred pounds of lard could be produced, which would serve a family for a year. (Russell Lee, LC-USFd33-012840-M4.)

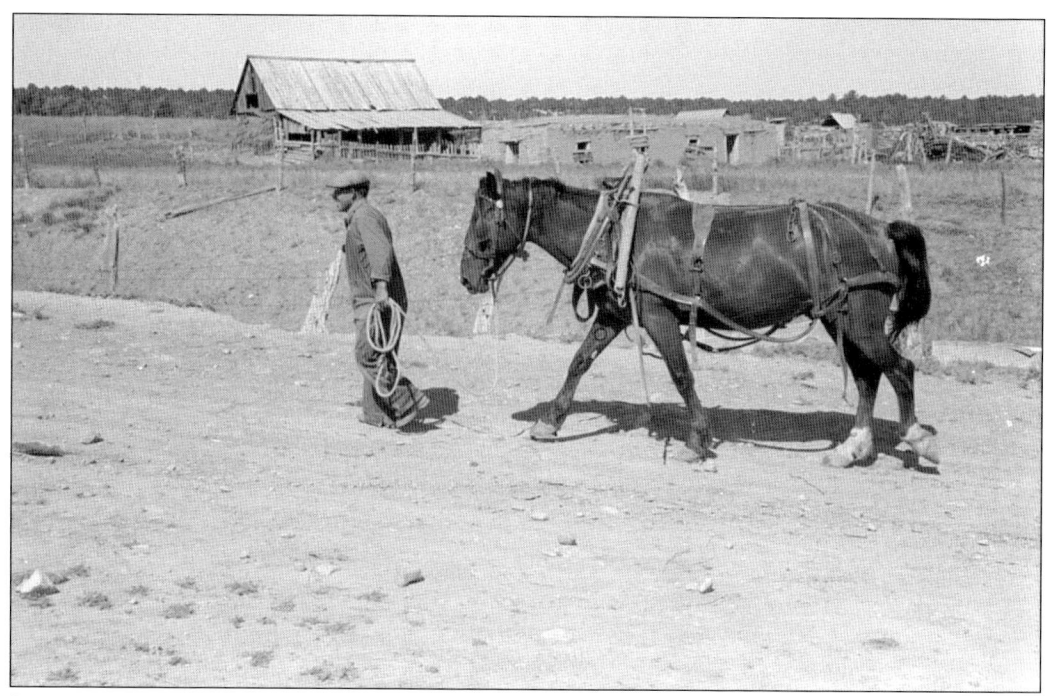

LEADING A HORSE TO WORK, JULY 1940. This Chamisal farmer has his horse harnessed and ready for work. The task facing the horse is shown in the photograph below. Horses were used for a variety of tasks on the farm, as automotive power was very rare in Chamisal in 1940. (Russell Lee, LC-USF33-012841-M1.)

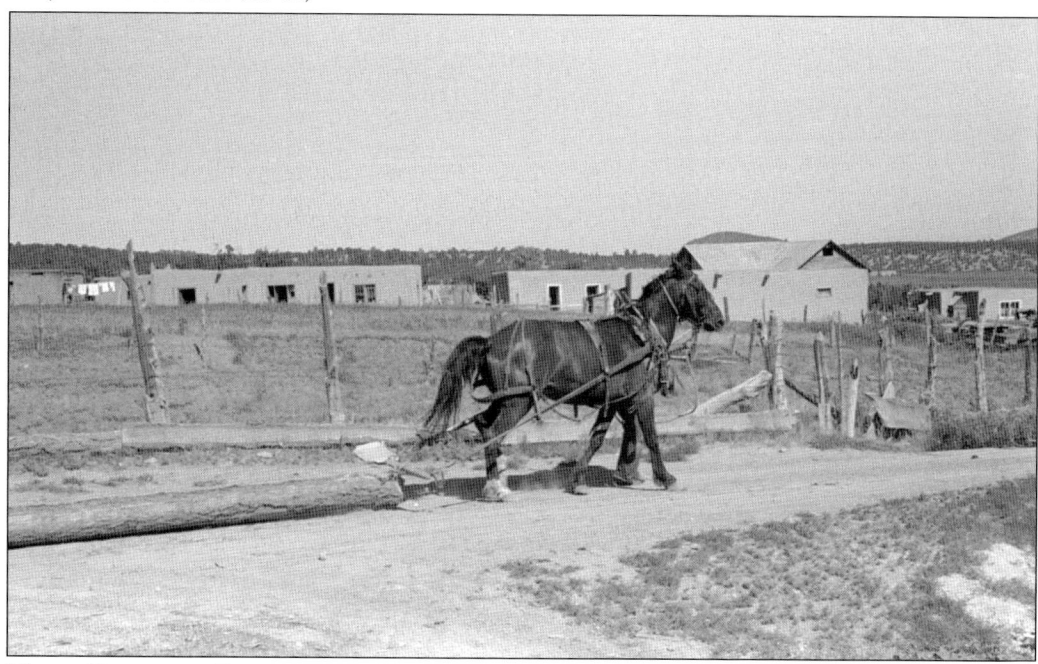

HORSE PULLING A LOG, JULY 1940. Where has the farmer gone? He is actually leading the horse—his legs can be seen between the two front legs of the horse. The log might be used as a viga (beam) in a roof, or in building a barn or corral. (Russell Lee, LC-USF33-012839-M2.)

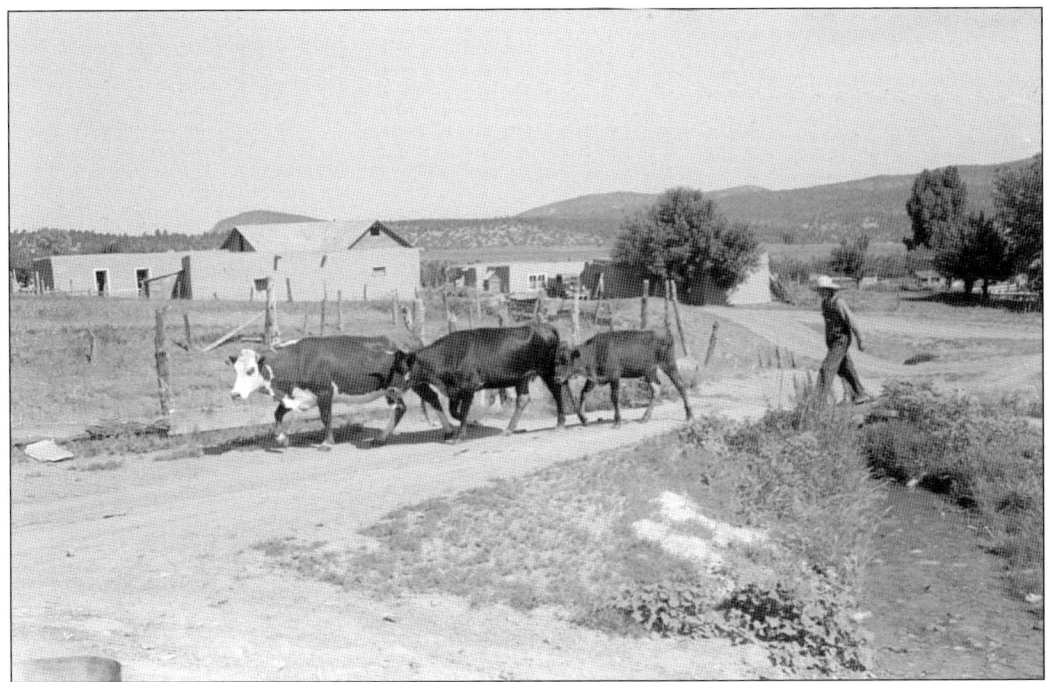

DRIVING CATTLE, JULY 1940. The farmer and the cattle have just crossed a bridge over the acequia seen in the lower right foreground. He may be moving the cattle from the common grazing area back to his own barn and corral. (Russell Lee, LC-USF33-012841-M5.)

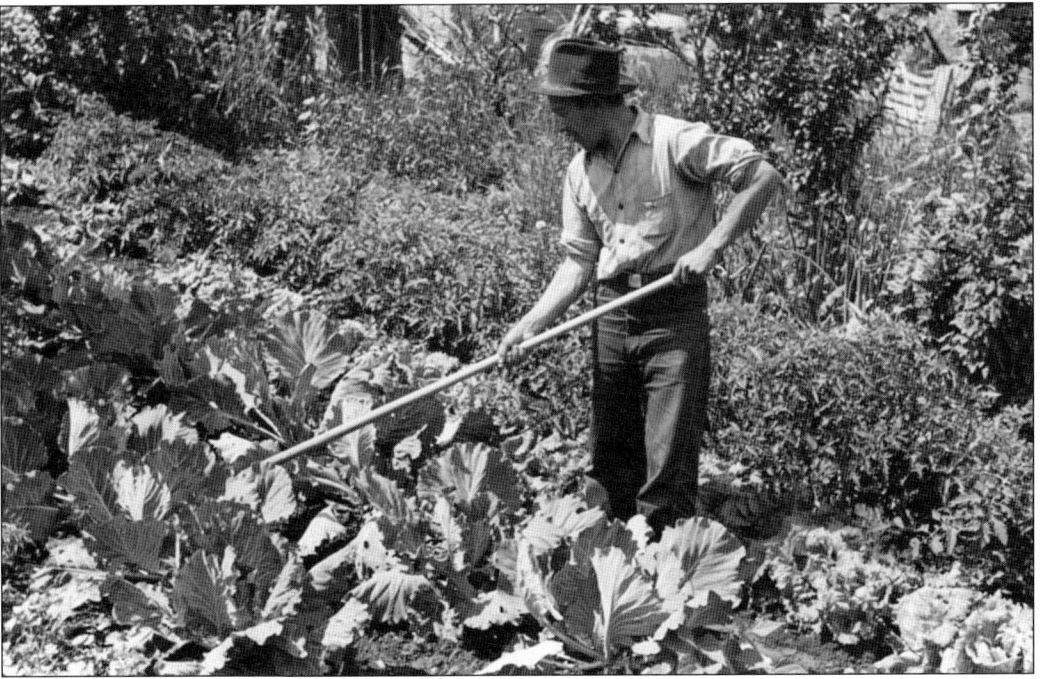

HOEING THE CABBAGE PATCH, JULY 1940. Besides cabbage, it looks like this Chamisal farmer is growing tomatoes, corn, and fruit trees on his small section of land. The crops were watered by diverting water from the acequia. (Russell Lee, LC-USF33-012811-M1.)

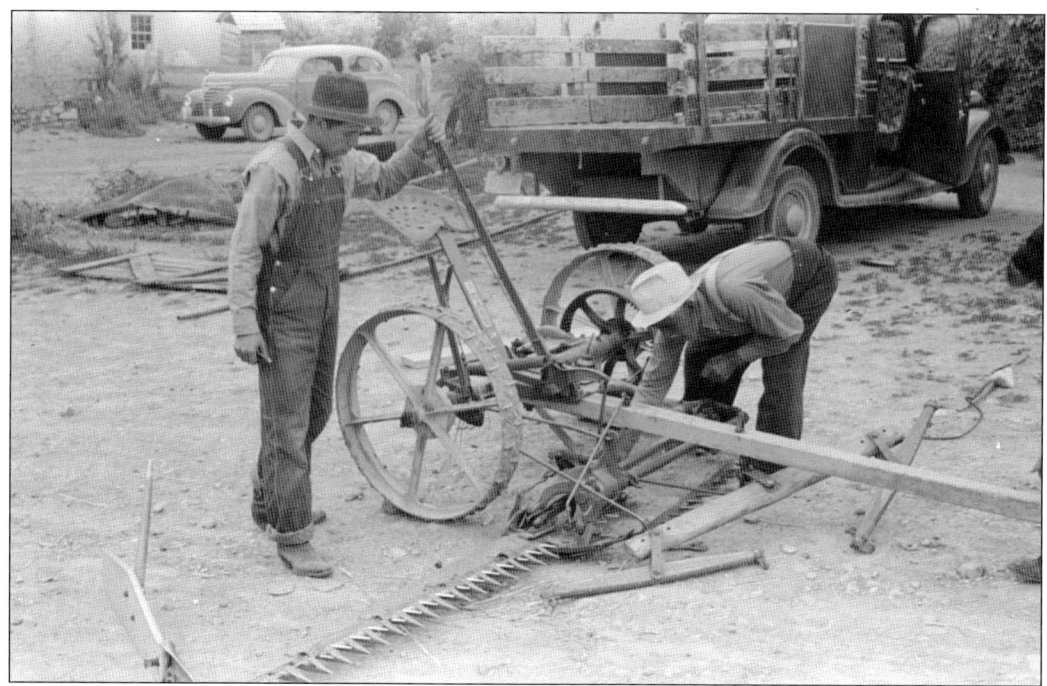

WORKING ON A MOWER, JULY 1940. Pictured are Benjamin Dominguez (left) and his grandfather Jose Fresquez. They are performing some maintenance work on a mower, which will then be loaded onto the truck in the background. (Russell Lee, LC-USF33-012828-M2.)

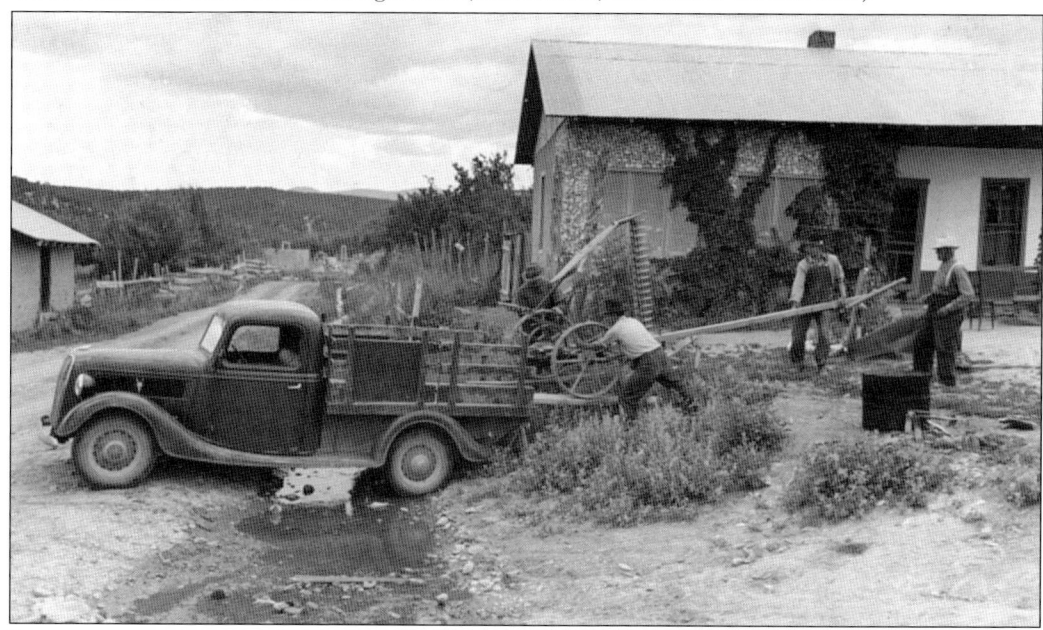

LOADING THE MOWER ONTO THE TRUCK, JULY 1940. Pushing the mower onto the bed of the truck are the Dominguez brothers. From left to right are Candide, Salomon, and Benjamin, with their grandfather Jose Fresquez watching at the far right. They are probably moving the mower from an equipment shed out to a field where it will be hitched up to a horse to cut hay. (Russell Lee, LC-USF33-012802-M1.)

Mixing Mud and Straw, July 1940. This Chamisal man is mixing water, earth, and straw to make adobe clay. The mixed clay will be placed in the square form to the left of the man to create a brick. Finished adobe brick houses are seen in the background. (Russell Lee, LC-USF33-012807-M1.)

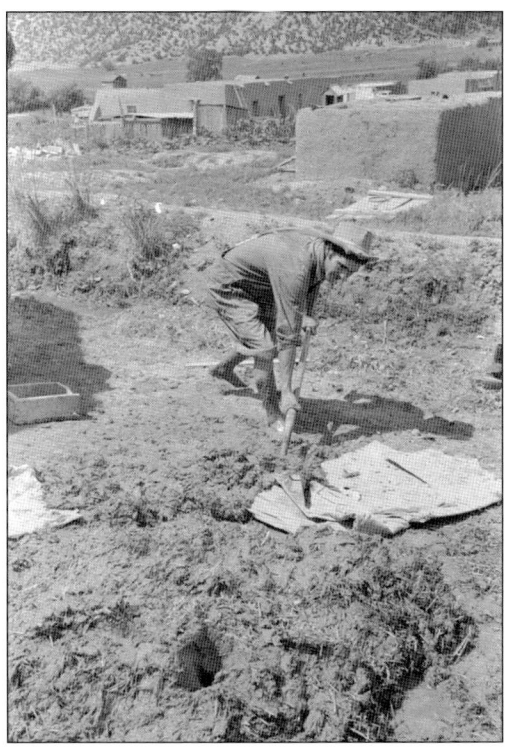

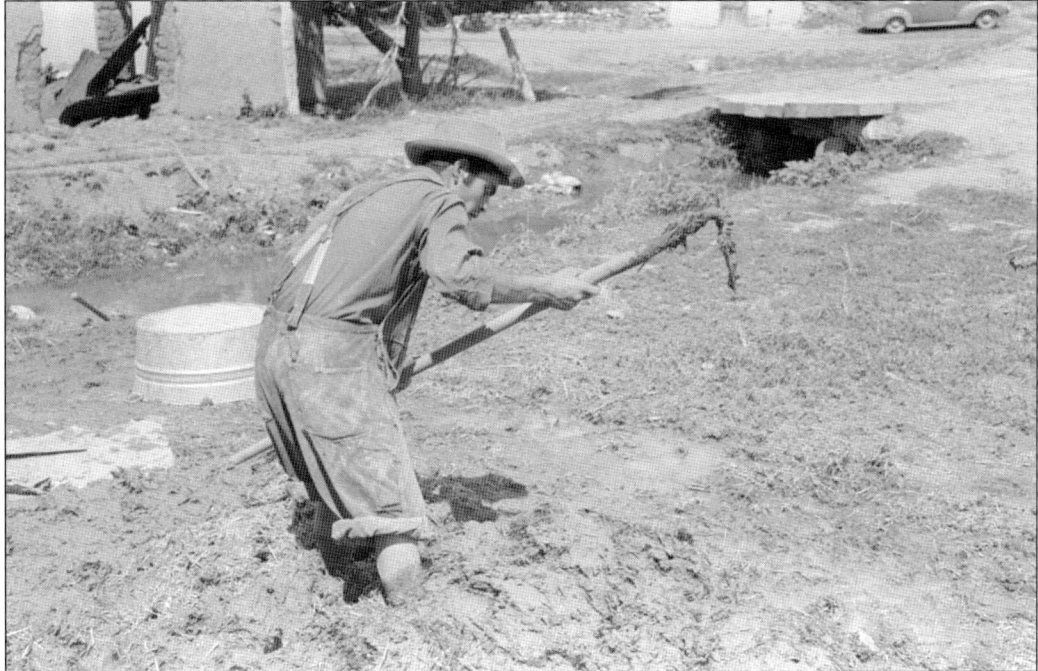

Mixing Adobe Mud, July 1940. Water has been gathered using the tub behind the man. The water is from the acequia flowing under the small bridge seen at the top right. This backbreaking work requires the man to stand barefoot in the mud and mix the ingredients together with a hoe. (Russell Lee, LC-USF33-012811-M3.)

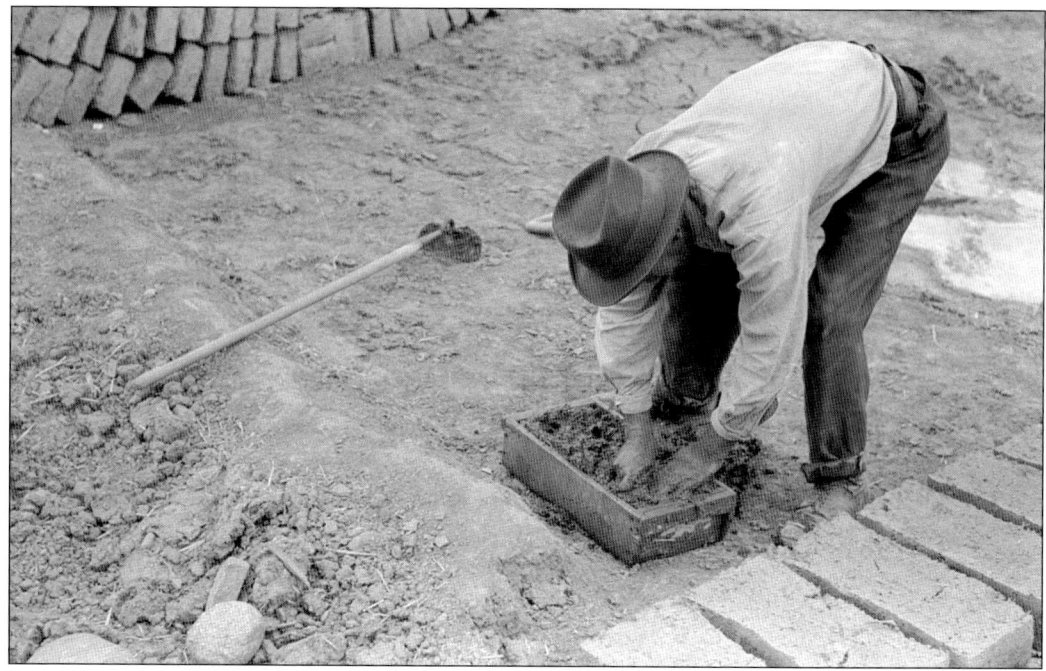

FORMING THE ADOBE BRICK, JULY 1940. The soft mud is placed in the form and packed down tight with bare hands. The finished product is the stack of bricks seen above and to the right. (Russell Lee, LC-USF33-012817-M1.)

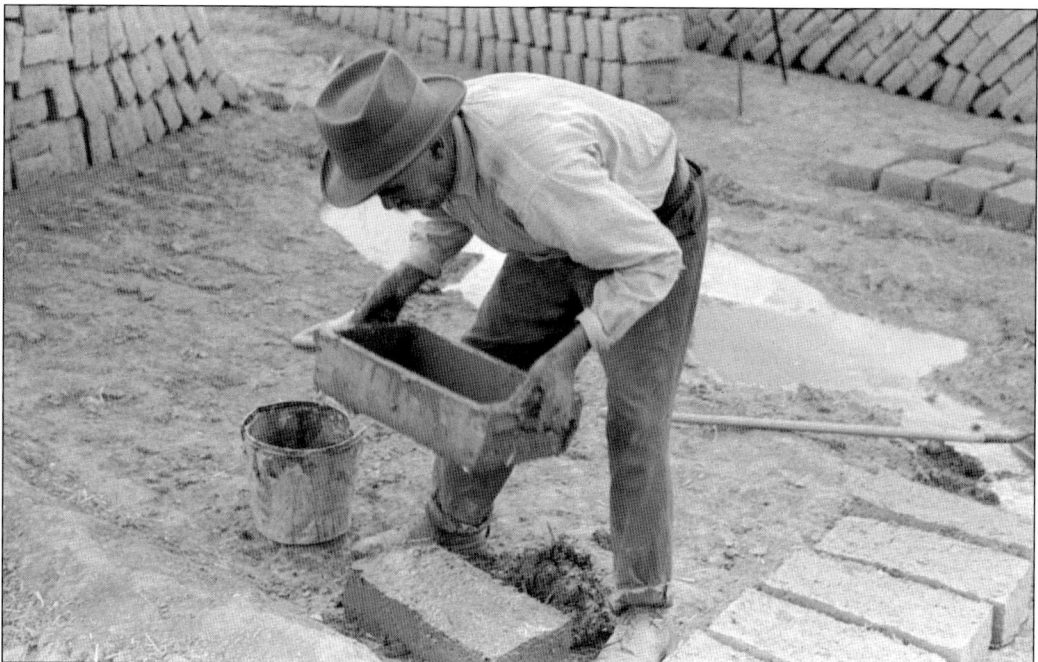

REMOVING THE BRICK, JULY 1940. When the mud has been compacted tightly in the form, it is pushed and shaken out gently to the ground below. The adobe brick is then left to dry thoroughly in the sunshine. The bricks are used in building walls for houses, as seen in the Peñasco homes in the next chapter. (Russell Lee, LC-USF33-012819-M3.)

TOSSING STRAW FOR PLASTERING, JULY 1940. When a home is built of adobe bricks, the walls are covered over with a layer of plaster formed from mud, straw, and water. Here, a woman empties a wagon of straw for plastering. (Russell Lee, LC-USF33-012808-M1.)

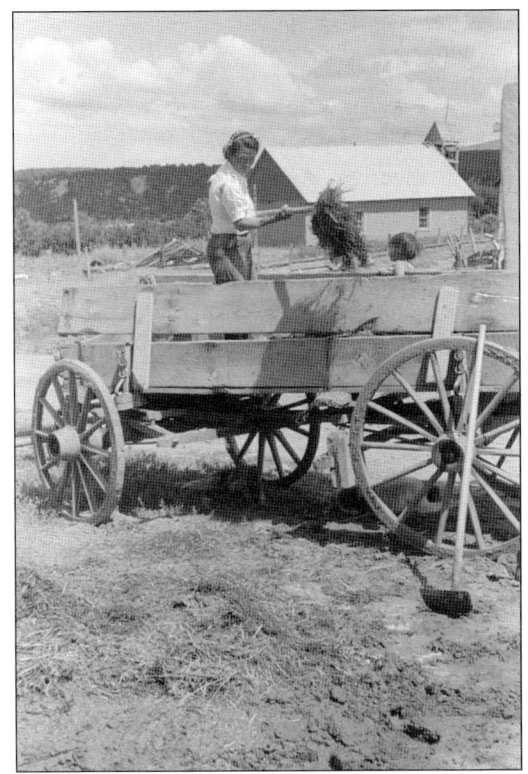

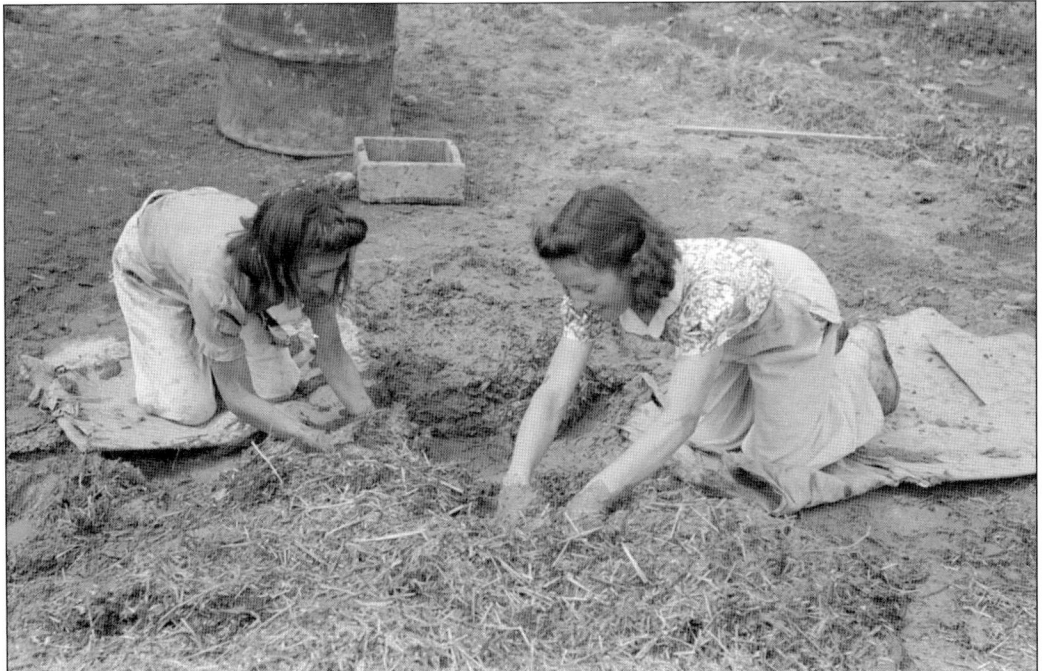

MIXING MUD BY HAND, JULY 1940. The straw, mud, and water are mixed by hand by these Chamisal young women. Note how they keep their knees clean by kneeling on cardboard or canvas. While men made the bricks, plastering was a job for the women. (Russell Lee, LC-USF33-012808-M4.)

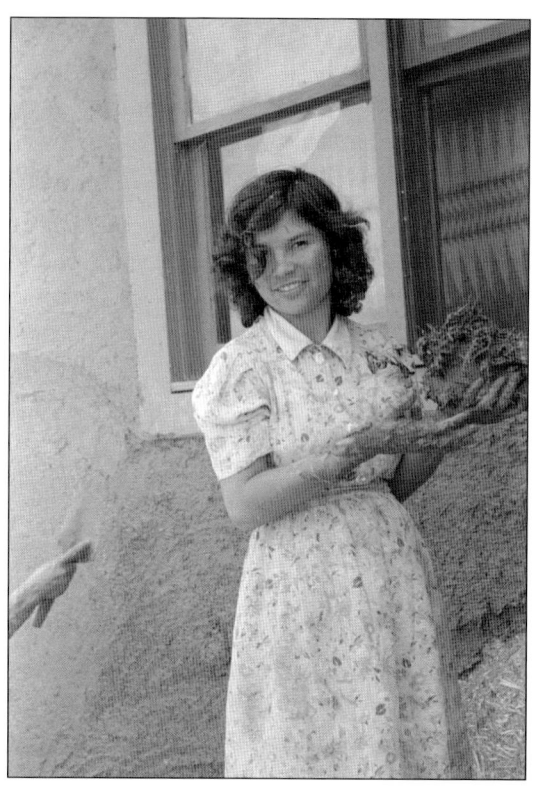

READY TO PLASTER, JULY 1940. Adobe homes must be replastered almost every year, as the harsh climatic elements wear down the plaster. Without replastering, the adobe bricks underneath would be exposed to water and eventually would decompose. (Russell Lee, LC-USF33-012807-M2.)

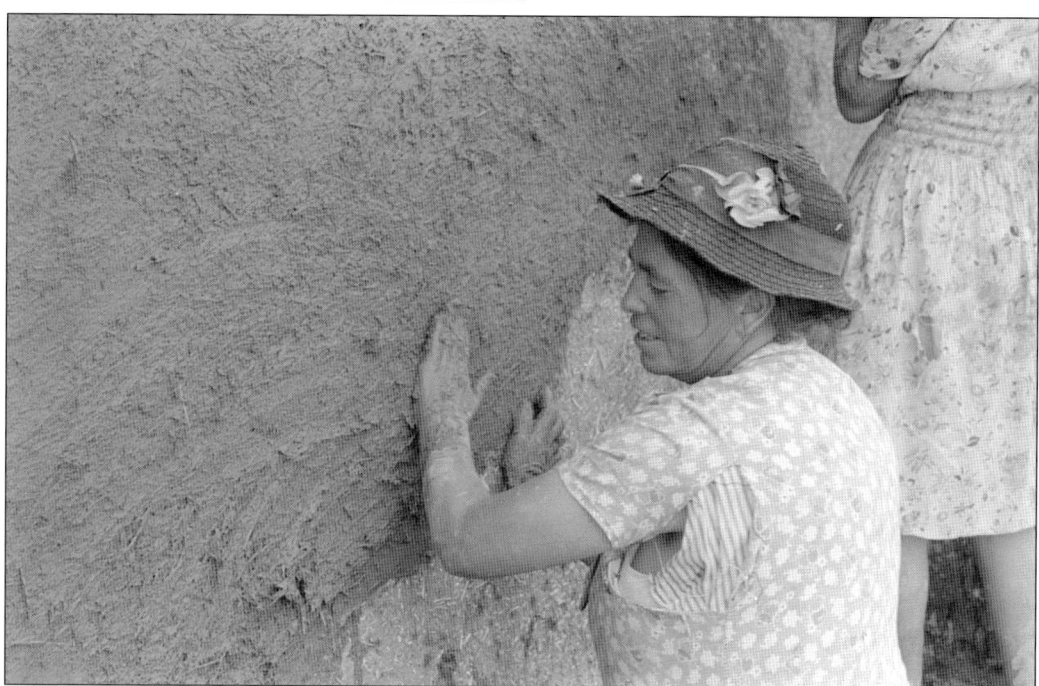

PLASTERING BY HAND, JULY 1940. This is Cleofas Lopez, considered to be one of the best plasterers in Chamisal. She is applying the plaster by hand, and it will be smoothed by a trowel before drying. (Russell Lee, LC-USF34-012811-M5.)

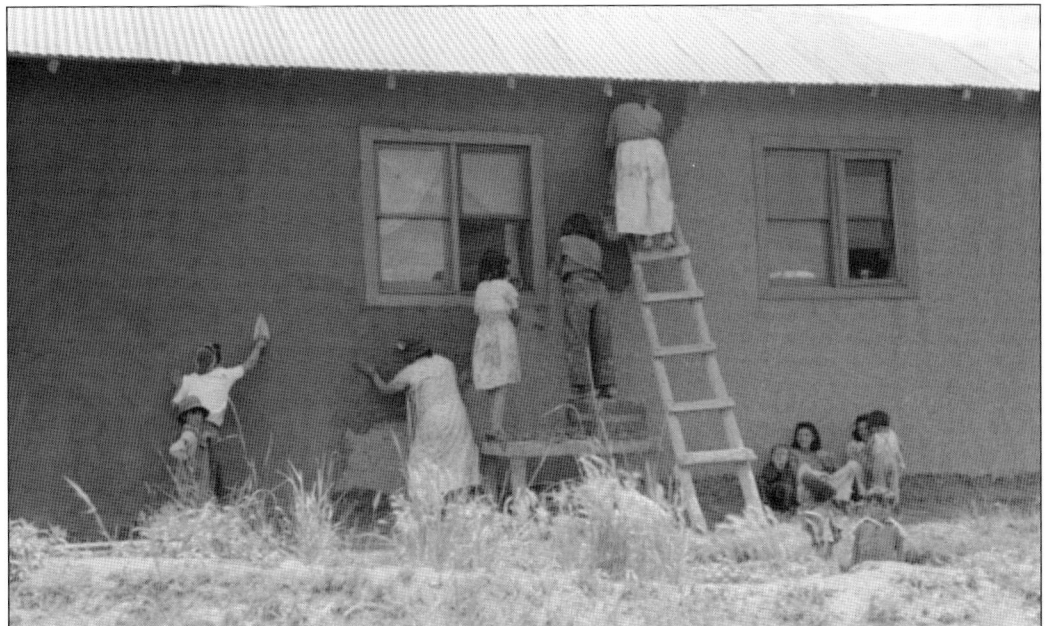

REPLASTERING A WALL, JULY 1940. Cleofas Lopez (second woman from the left) is applying plaster by hand. She is followed by the woman on the far left who smooths the plaster with a trowel. Note that all the laborers are women, and the children rest in the shade of the house. (Russell Lee, LC-USF33-012807-M4.)

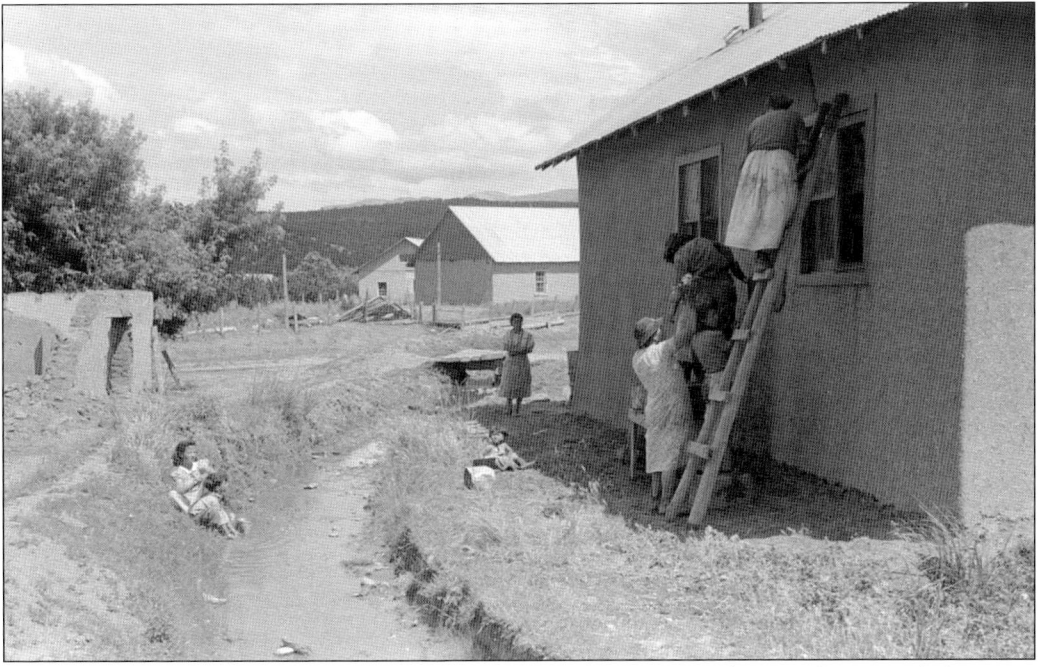

FINISHING UP AROUND THE BACK, JULY 1940. Cleofas Lopez is standing on the ground plastering the wall, while other women apply plaster from the ladder. Note the acequia running right behind this home, providing a handy source of water for the plastering process. (Russell Lee, LC-USF33-012810-M4.)

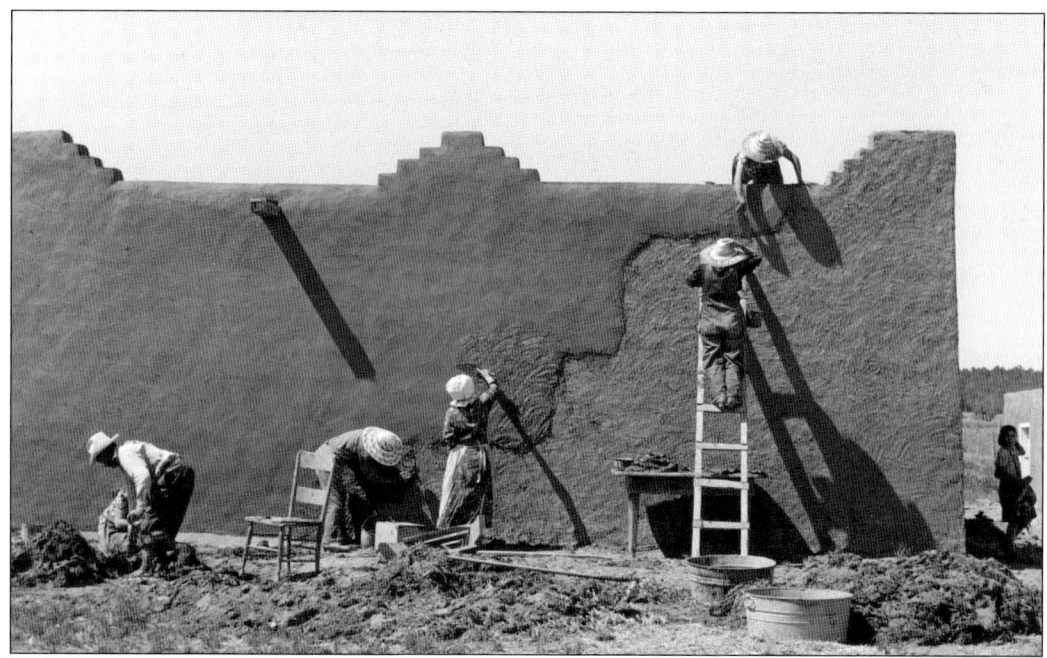

MAKING PROGRESS ON THE WALL, JULY 1940. These women have just about completed plastering one wall of the adobe home. The women were often relatives in the same family, although neighbor women would help each other out with the plastering also. Note how thick the layer of plaster is that they are applying. (Russell Lee, LC-USF34-037082.)

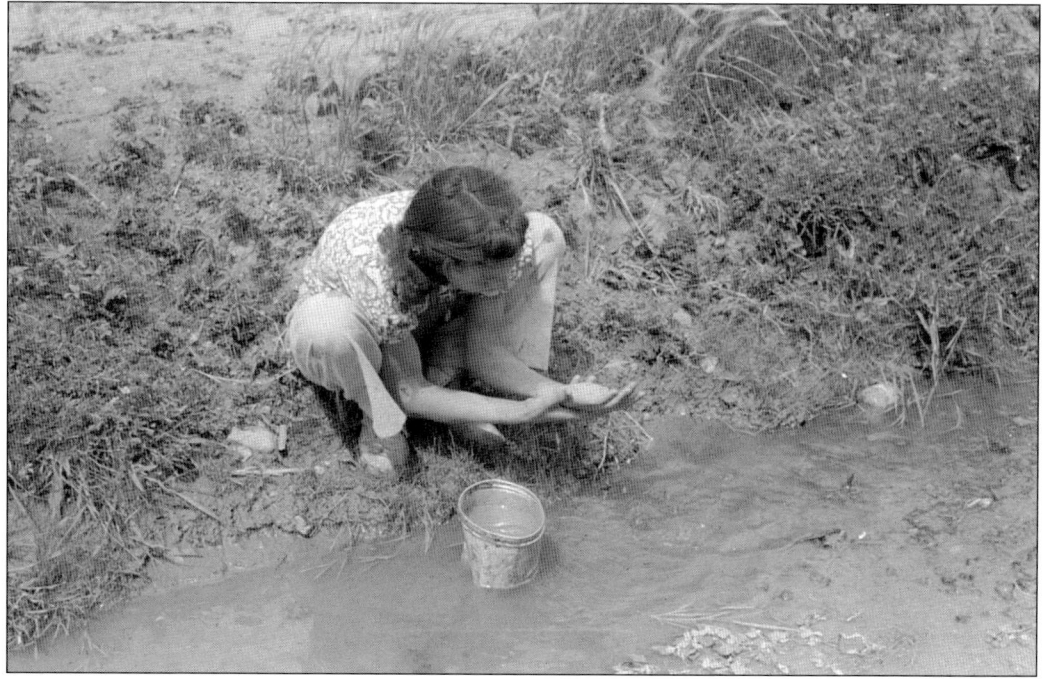

WASHING UP, JULY 1940. After a hard day of plastering, women would wash their hands in the nearby acequia. They celebrated the completion of a job well done until the next summer's replastering. (Russell Lee, LC-USF33-012809-M1.)

Five

Picurís Pueblo, Peñasco, Vadito, and Placita

At the junction of New Mexico Highway 76 and New Mexico Highway 75, the traveler can turn left and go one mile to Picurís Pueblo or turn right to head to Peñasco. Picurís was first settled by Ancestral Puebloans about 1250 and later by Puebloans who abandoned their settlement at Pot Creek (see chapter 6). The first Spaniard to view Picurís was Gaspar Castaño de Sosa in 1591. He noted that the pueblo was about seven stories tall. However, the natives did not seem friendly, so he moved on. On July 13, 1598, Gov. Don Juan de Oñate visited the pueblo and called it El Gran Pueblo de los Picurís. Although it was originally called Piwetha by the natives (meaning "mountain pass"), the name Picurís (meaning "those who paint") became the official name of the pueblo.

A Spanish mission church was built in Picurís, but it was destroyed in the Pueblo Revolt of 1680. In 1746, the San Lorenzo (St. Lawrence) de Picurís church was built, but it was destroyed by raiding Comanche Indians in 1769. About 1776, the church was rebuilt, and the present-day church was modeled after that structure.

Peñasco is just about a mile east of the junction on New Mexico Highway 75. The Peñasco area was settled in 1796. Three men from Las Trampas—Valentine Martinez, Eusebio Martinez, and Juan Olguin—recognized the farming potential of this land surrounding the Rio Santa Barbara, and they petitioned Gov. Fernando Chacon to establish two towns. The governor granted their request providing that they had at least 50 people to live on the land and that the land could not be sold for 10 years. Thus, two communities arose: Llano de San Juan on the high plain above the river and Santa Barbara (now Rodarte) along the river. Some settlers from these communities eventually moved a couple of miles west and formed the village of Peñasco, encroaching upon the Picurís Pueblo grant. Peñasco means "large rock," and the village is named after a large rock formation just west of town. Two more small villages exist on the High Road heading east—Vadito and Placita, both founded by settlers from Peñasco.

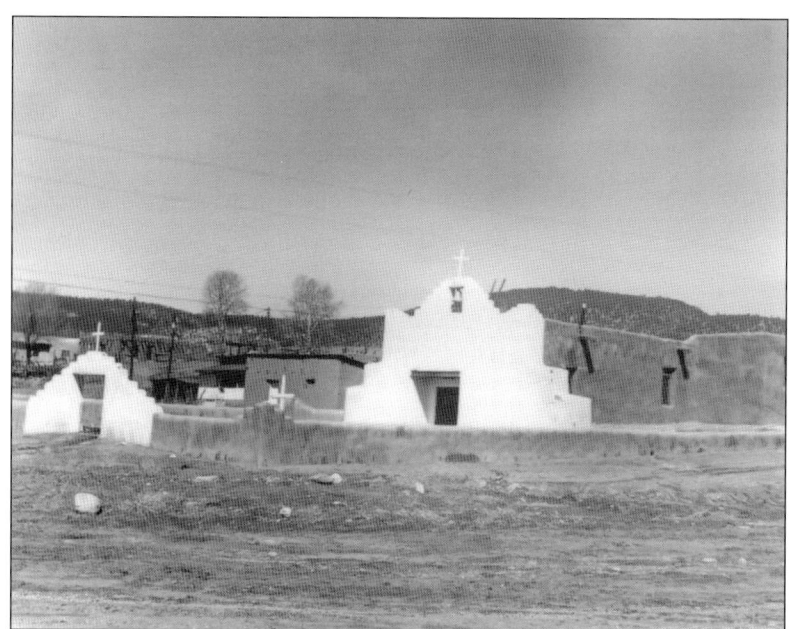

SAN LORENZO DE PICURÍS CHURCH, MARCH 20, 1973. This is the church that was built in 1776. The church was restored in 1960, but it collapsed in 1986 and was leveled in 1987. The church that is standing today was built in 1988, using the same floor plan as the 1776 church. (Richard Federici, courtesy of National Register of Historic Places.)

PICURÍS PUEBLO, MARCH 20, 1973. The San Lorenzo de Picurís Church is the white structure at the right. About 100 residents live in the pueblo today. The seven-story structures seen in 1591 all collapsed in the 1800s, and residents today mostly live in one-story adobe homes. (Richard Federici, courtesy of National Register of Historic Places.)

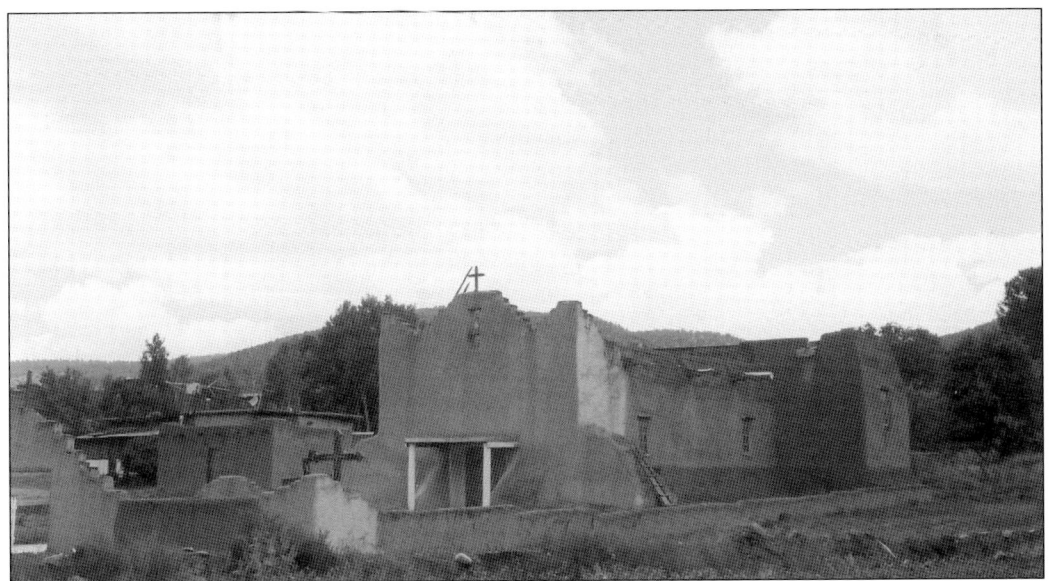

SAN LORENZO DE PICURÍS CHURCH, SEPTEMBER 2007. The present-day church was constructed in 1988. It took about 32,000 adobe bricks to build the church, and volunteers from nearby communities and all over New Mexico came to help with the work. The outer gate can be seen at the lower left.

CHURCH GATE, SEPTEMBER 2007. The entry gate to San Lorenzo de Picurís Church can easily be seen with the white picket fence inside it. This gateway is all that remains of the 1776 church.

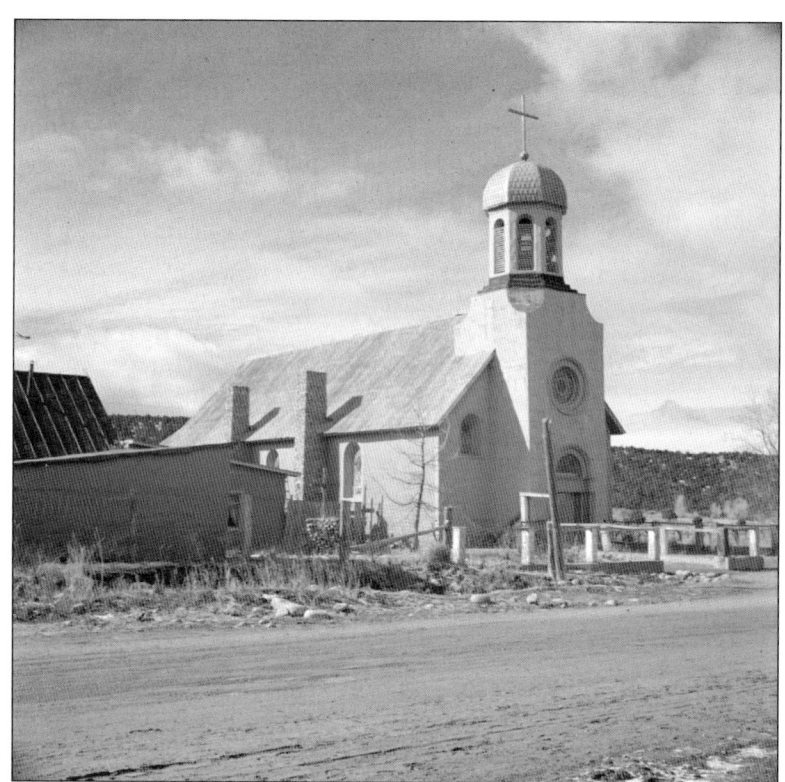

SAN ANTONIO DE PADUA CHURCH, PEÑASCO, JANUARY 1943. Three church buildings in Peñasco have carried the name of St. Anthony of Padua. The first church was built in 1867. It was replaced by the larger church pictured here, which was constructed between 1911 and 1916. It burned down in 1961 and was replaced by a new church built in 1962. (John Collier, LC-USW3-017295-E.)

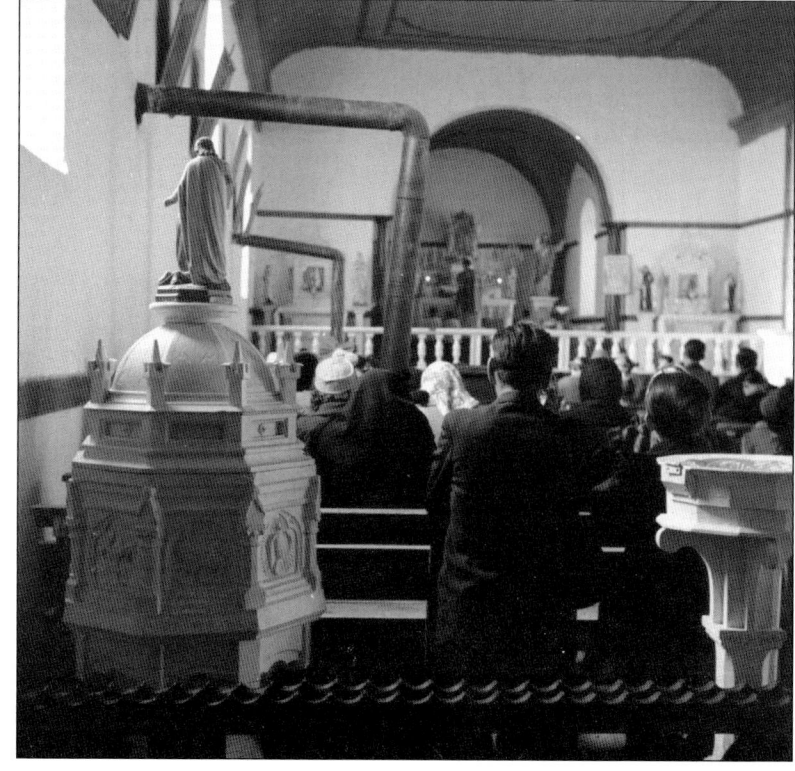

MASS, SAN ANTONIO DE PADUA CHURCH, JANUARY 1943. This tall church was built in the French style, influenced by French missionary priests who served in New Mexico in the 1800s. The replacement church constructed in 1962 was built in the Southwestern style, but it was only one-story high because a lack of funds prevented the planned two-story structure. (John Collier, LC-USW3-017263-E.)

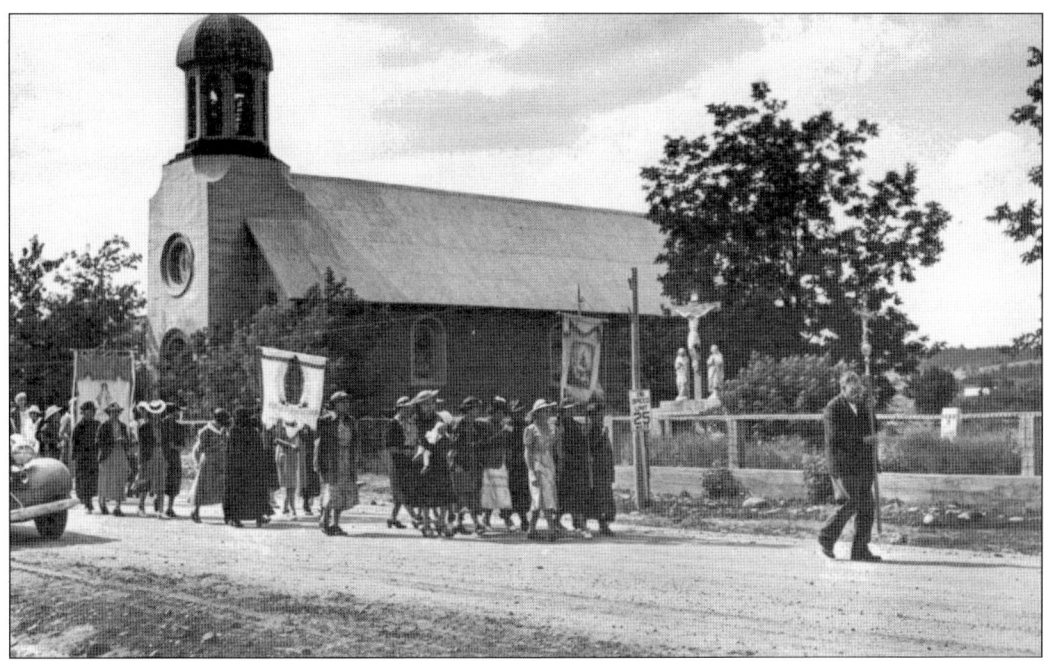

FEAST DAY PROCESSION, JULY 16, 1940. Celebrating the feast day of Our Lady of Carmel, these parishioners, led by Fecundo Medina, march on Main Street past the church. Three sets of banners are seen: the first (right) displays the image of Our Lady of Carmel, the second is of Our Lady of Guadalupe, and the third is of the Blessed Virgin Mary. (Russell Lee, LC-USF34-037147.)

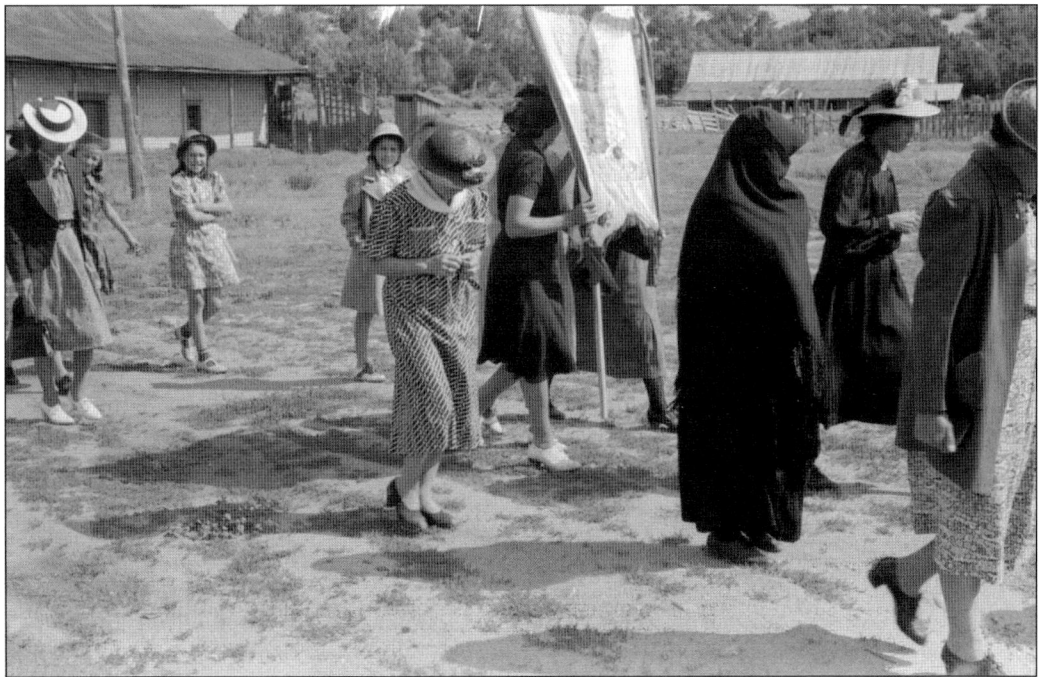

MARCHERS IN THE PROCESSION, JULY 16, 1940. This close-up view of some of the marchers shows the banner with the image of Our Lady of Guadalupe. That is the banner seen in the middle of the previous photograph. (Russell Lee, LC-USF33-012827-M1.)

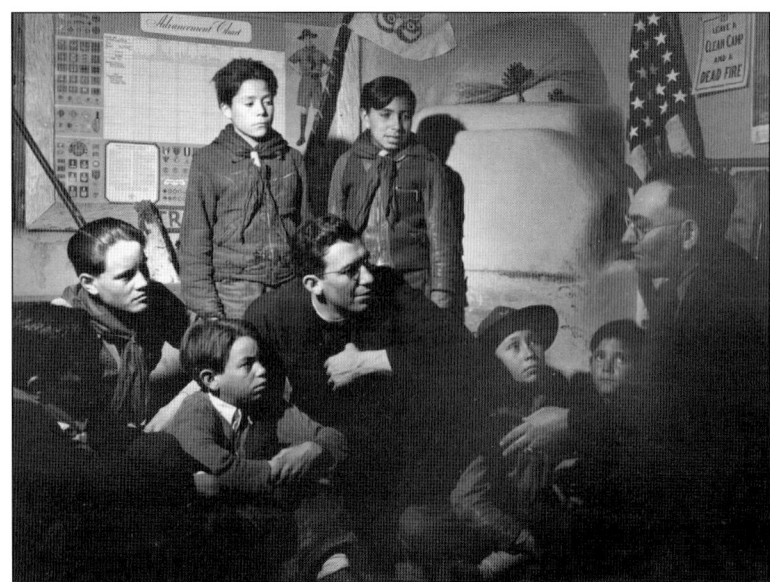

FATHER CASSIDY, PEÑASCO, JANUARY 1943. Father Cassidy was the parish priest in Peñasco and served several churches in the area, including San Jose de Gracia in Las Trampas. His parents were from Ireland, and they settled in Mora County, New Mexico, southeast of Taos. (John Collier, LC-USW3-017399-C.)

BOY SCOUT EXCURSION NEAR PEÑASCO, JANUARY 1943. Father Cassidy (center) led the boys up this hill near Peñasco on a warm January day. Father Cassidy is seen in many of John Collier's photographs, as he was very involved in the lives of his parishioners in Peñasco and the surrounding communities. (John Collier, LC-USW3-017346-C.)

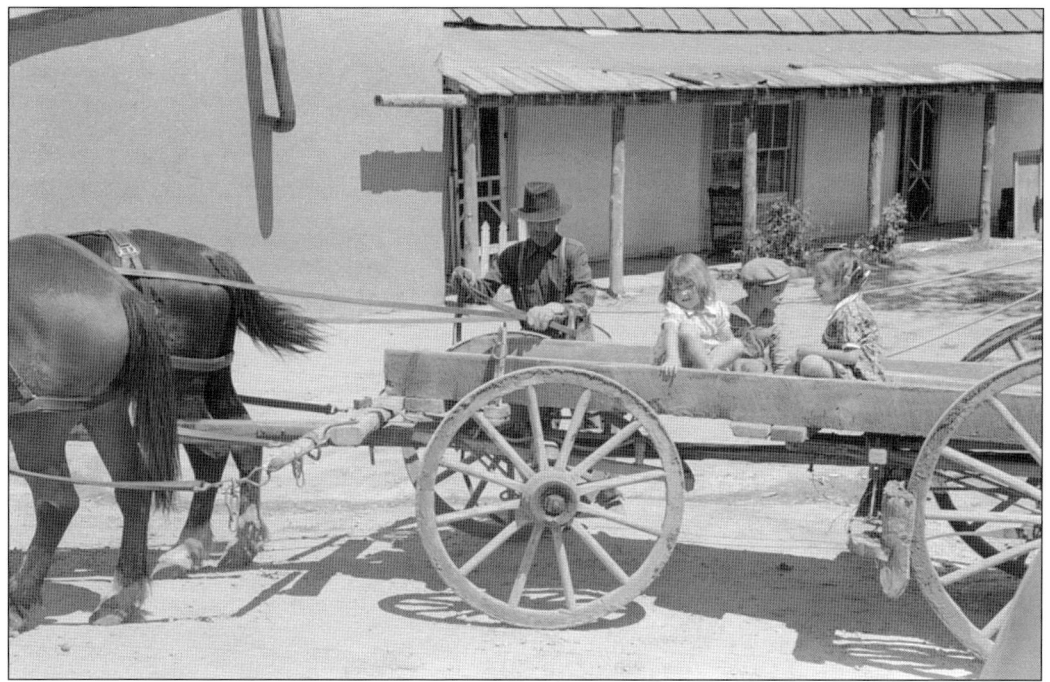

ARRIVING TO SHOP IN PEÑASCO, JULY 1940. Eloyda Roybal Romero, born in Rodarte in 1938 and raised in Peñasco, wrote: "My father always had his team of horses and wagon that he took real pride in. Having a good team of horses and wagon was like having a new truck. He depended on those horses for everything." (Russell Lee, LC-USF33-012806-M5.)

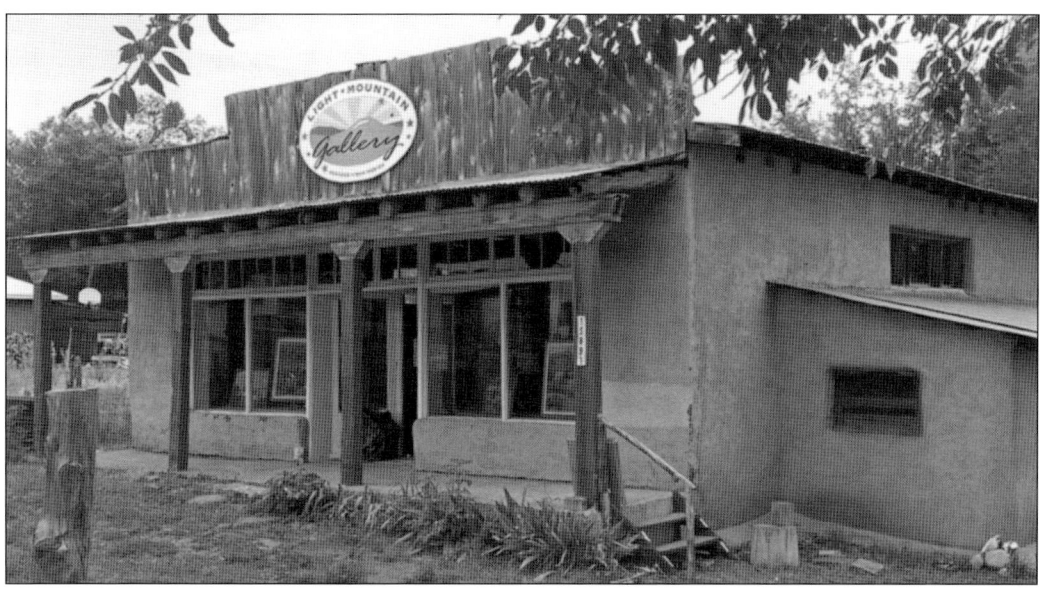

LIGHT MOUNTAIN GALLERY, PEÑASCO, SEPTEMBER 2015. High Road artist Leigh Gusterson opened this gallery in Peñasco in time for the annual High Road Studio Tour at the end of September. The building was a general store dating back to the early 1900s. (Courtesy www.leighgusterson.com.)

CONOCO GAS STATION, PEÑASCO, JULY 1940. Peñasco in the 1940s was just starting to see more vehicular traffic, but most residents still depended on their horses for transportation. This gas station advertised itself as a traveler service station, offering groceries, candy, cigarettes, tires, tubes, and accessories. (Russell Lee, LC-USF34-037161-D.)

CHANGING A TIRE, PEÑASCO, JULY 1940. Roads were rough, and flat tires occurred fairly often. Peñasco was a crossroads community, with traffic flowing in from Dixon on the west, High Road villages on the south, and Taos to the north. (Russell Lee, LC-USF33-012805-M1.)

AT THE PEÑASCO CLINIC, JANUARY 1943. The health clinic in Peñasco was operated by the Taos County Cooperative Health Association. This vehicle was used as an ambulance as well as transportation for nurses to visit far-flung rural families. (John Collier, LC-USW3-014564-C.)

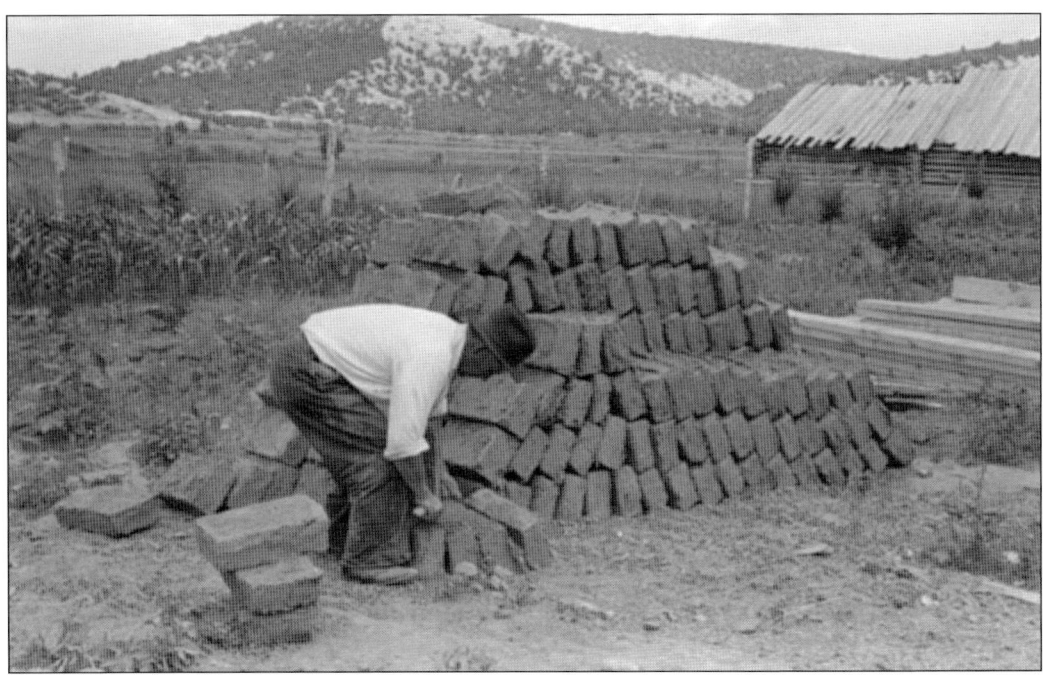

WORKING ON ADOBE BRICKS, PEÑASCO, JULY 1940. The worker is smoothing the rough edges of an adobe brick with a trowel. Here, as in Chamisal and all other High Road villages, adobe was the main building material for homes. (Russell Lee, LC-USF33-012825-M1.)

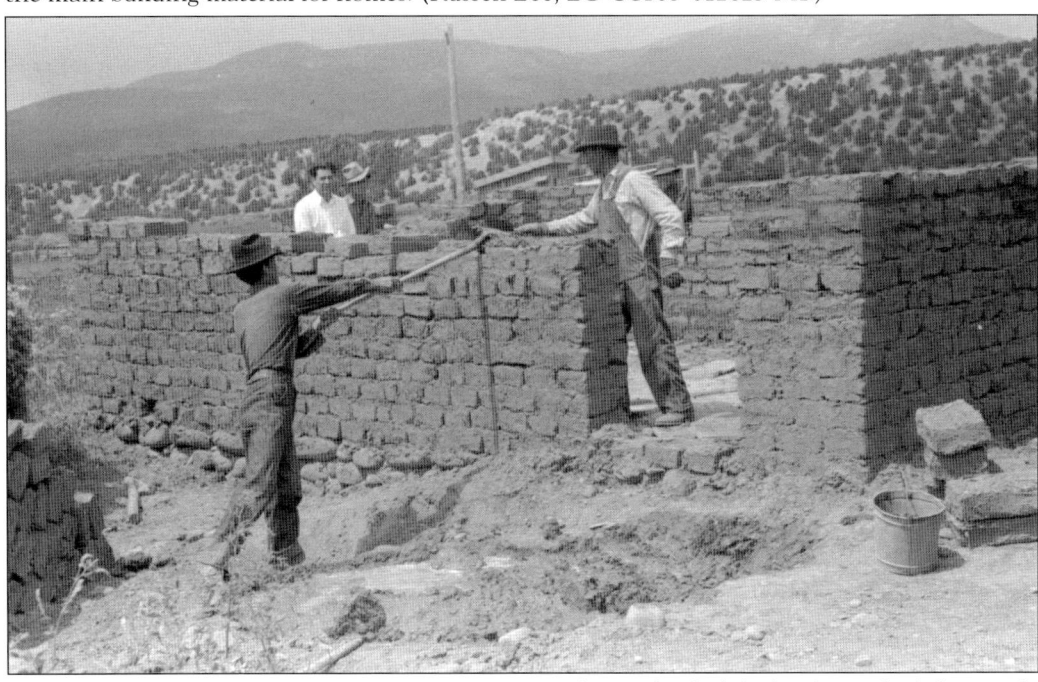

BUILDING AN ADOBE HOME, PEÑASCO, JULY 1940. The stack of adobe bricks at the left is ready for placement on the walls of the home. The man on the left is tossing plaster on the wall to hold the bricks in place. The plaster is a mud and straw mix made from dirt dug up in the front yard. (Russell Lee, LC-USF33-012826-M2.)

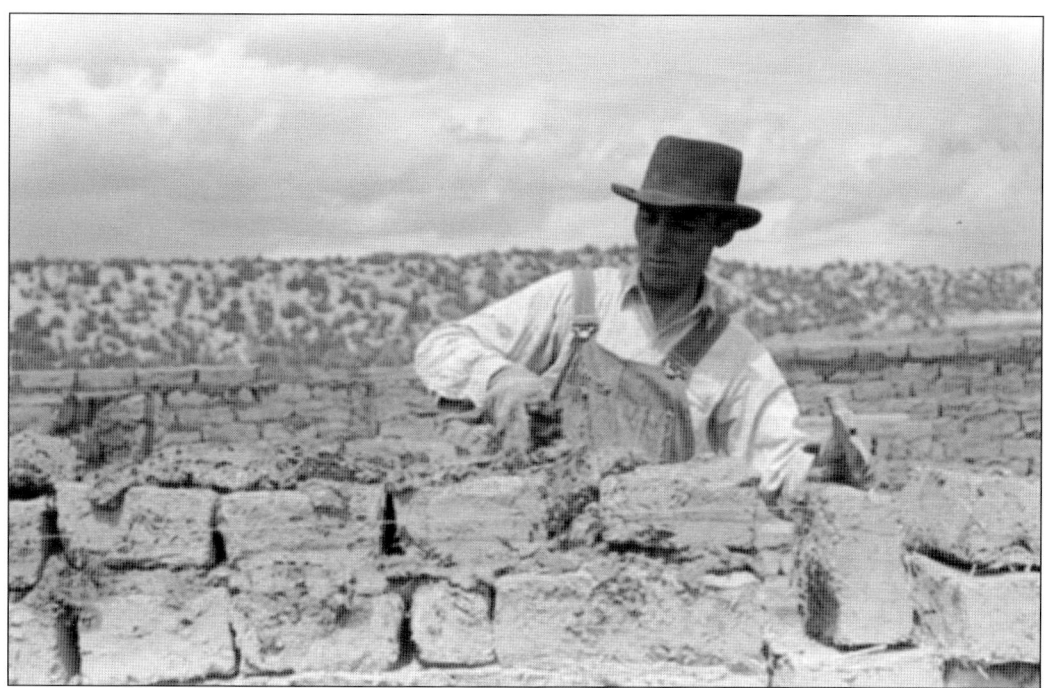

"Cementing" the Bricks Together, Peñasco, July 1940. Jim Martinez, an adobe mason from Peñasco, is applying the mud plaster to hold the bricks together. When the walls reach the proper height, women will come to cover the bricks with plaster, as seen in the photographs of Chamisal. (Russell Lee, LC-USF33-012826-M1.)

Leveling the Bricks, Peñasco, July 1940. Jim Martinez is using a level to be sure the bricks are straight for placement of a window. Since adobe homes have to be replastered every year and the bricks can decompose if exposed to water, most modern homes do not use adobe. Instead, lumber framing is used, and exterior walls are coated with stucco to imitate the look of adobe. (Russell Lee, LC-USF33-012825-M3.)

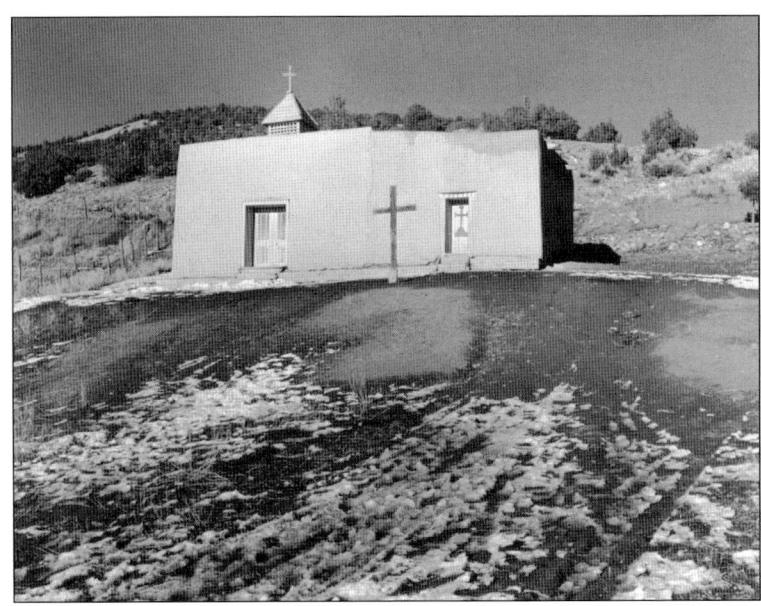

VADITO CHAPEL/ MORADA, MARCH 1943. John Collier Jr. identified this as a "chapel." It is still standing and serves as a penitente morada. The church shown in the next image was built directly in front of it in 1961. About three miles east of Peñasco, the village of Vadito ("little ford") straddles New Mexico Highway 75. The name probably refers to a nearby ford in the Rio Pueblo. (John Collier, LC-USW3-018037-C.)

VADITO CHURCH, SEPTEMBER 2014. The Nuestra Señora de Dolores (Our Lady of Sorrows) Church was built in Vadito in 1961. The feast day of this church is September 15. Feast days throughout High Road villages honor the church's patron saint with a special Mass, feasts, parades, and celebrations. Vadito was settled in the late 1790s by people from the Peñasco area.

PLACITA, JANUARY 1943. Placita is a tiny village just south of New Mexico Highway 75, about two miles east of Vadito. Placita (also spelled Placitas) means "little plaza," referring to a small cluster of houses. (John Collier, LC-USW3-361-904.)

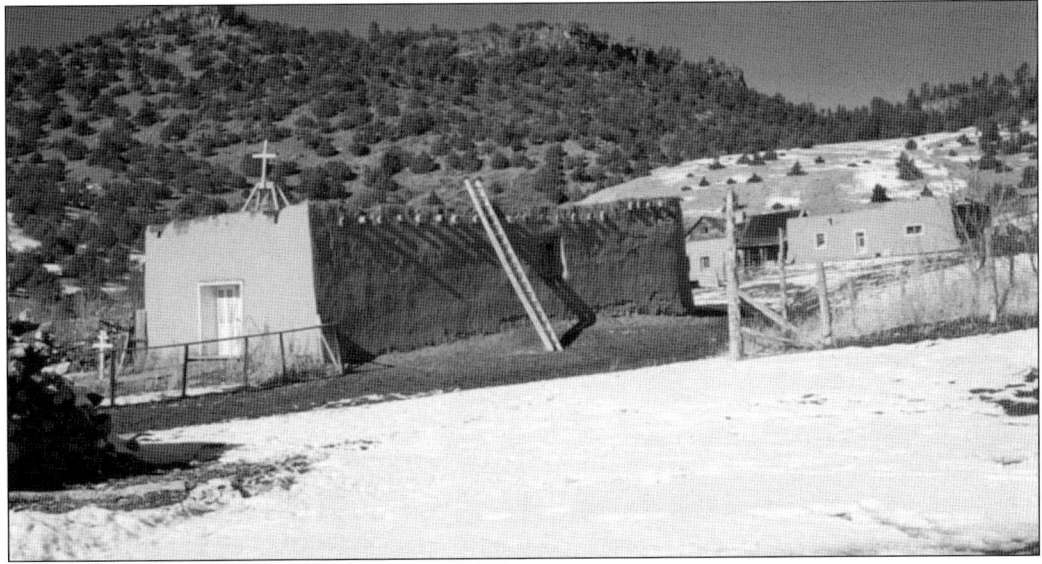

PLACITA CHURCH, JANUARY 1943. This view northwest shows the Placita church Nuestra Señora de la Asuncion (Our Lady of the Assumption). This adobe church was built around 1870. The feast day is August 15. (John Collier, LC-USW3-017988-C.)

PLACITA, JANUARY 1943. Placita was also founded by settlers from the Peñasco area in the late 1790s. The church is seen in the center, and there is a log building in front of it. Some type of construction or repair was occurring, as there is a pile of logs next to the church and a ladder leads to the roof. (John Collier, LC-USW361-939.)

PLACITA CHURCH, SEPTEMBER 2014. Nuestra Señora de la Asuncion is still standing in Placita. The pitched roof was added some time after the John Collier photographs of 1943.

Six

Pot Creek, Fort Burgwin, Talpa, and Ranchos de Taos

East of Placita, the High Road takes a left turn, heading north toward Taos on New Mexico Highway 518. Winding steeply over US Hill, the road then drops sharply into the valley of the Rio Grande del Rancho. Here, virtually across the road from each other, are Pot Creek Cultural Site (east side) and Fort Burgwin (west side). Pot Creek was settled by Ancestral Puebloans between 1100 AD and 1200 AD, and they eventually established a large multistory structure. This pueblo was abandoned about 1320, and residents moved to Picurís or Taos Pueblo.

Cantonment Burgwin (later named Fort Burgwin) was built in 1852 by the US Army to protect local residents and travelers on the Santa Fe road from attacks by Jicarilla Apaches and Ute Indians. It was abandoned in 1860 when attacks decreased, and its soldiers transferred 50 miles east to Fort Union. In the 1950s, Kansas businessman Ralph Bounds purchased the site, excavated the original foundations, and constructed a replica of the fort. In 1964, Southern Methodist University purchased the site. Today, the university's 423 acres includes both Fort Burgwin and Pot Creek, where archeological studies are performed.

Four miles north of Fort Burgwin is the village of Talpa, founded in 1823 when local rancher Manual Lucero gave a piece of land to area citizens for the purpose of building a defensive plaza. Two *capillas* (chapels) were constructed in Talpa—the first built in 1828 and the second in 1838. Only the 1828 chapel survives today. It can be viewed by High Road travelers on the west side of the highway in the center of the village.

The Ranchos de Taos area was settled by a few Spanish ranchers in the 1730s, and by 1760, a small community had grown up. The settlement was abandoned during fierce Comanche raids from 1760 to 1779, and the settlers took refuge in Taos Pueblo. They returned in 1779 to build a defensive plaza in what is today Ranchos de Taos. The historic St. Francis of Assisi Church was completed in the plaza in 1815, and it makes an appropriate ending point for the High Road to Taos.

POT CREEK ENTRANCE, AUGUST 2015. Visitors must park outside the gate and walk into the site. The first residents of Pot Creek arrived about 1100 AD and lived in circular pit houses dug into the ground. About 1200 AD, they began building adobe structures on top of the pit houses.

RECONSTRUCTED ADOBE HOME, POT CREEK, AUGUST 2015. Once the Ancestral Puebloans of Pot Creek emerged from their pit houses and began building above ground, they started constructing homes on top of each other. Eventually, from 1260 to 1320, they built a multistory pueblo. There is some evidence that a great fire was the reason for the abandonment of the pueblo about 1320.

Reconstructed Fort Burgwin, August 2015. The US Army had three classifications for a defensive structure, ranging in size from smallest to largest—camp, cantonment, and fort. Cantonment Burgwin was built in 1852. It was named after Capt. John Burgwin, who was killed in Taos during the revolt against US troops in 1847. Reconstructed in the 1950s, it was renamed Fort Burgwin.

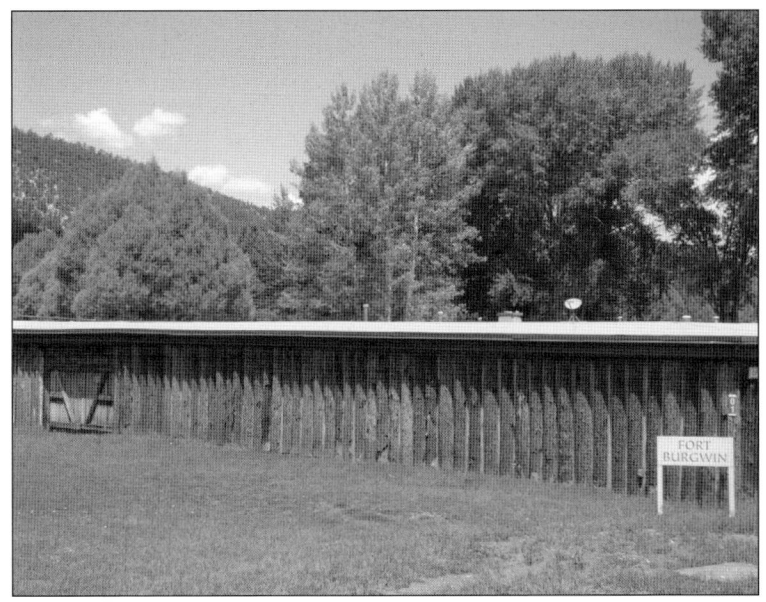

Fort Burgwin, August 2015. There were two connected plazas in the cantonment. There were no windows on the outer walls (as seen in the top image). This was to keep attackers out. All doors and windows faced the open plazas within. In 1854, forty soldiers from Burgwin were ambushed and killed by Apache and Ute Indians while on their way to Fort Union. Fort Burgwin was abandoned in 1860.

Nuestra Señora de San Juan de Los Lagos, September 2014. Translated as Our Lady of St. John of the Lakes, the chapel is still standing and is very well preserved. It has two miniature towers and a bell tower in the center. It can seat about 125 people. It is set back off the west side of New Mexico Highway 518 in the center of Talpa. The chapel was built in 1828 by Don Bernardo Duran on the plaza donated by Manuel Lucero.

TALPA HOME, SEPTEMBER 2014. This beautiful home is on the plaza next to the chapel. It is in approximately the same location as the homes shown on the previous page. The home has a wall in front with two gates. The gate on the left has a red chile *ristra* (wreath) hanging on it. Trees and bushes provide shade and color.

SECOND TALPA CHAPEL, MARCH 15, 1934. Named Nuestra Señora de Talpa (Our Lady of Talpa), this chapel was built in 1838 by Nicholas Sandoval on a site next to his home on the Rio Chiquito, which flows through Talpa. It was photographed in 1934 by James M. Slack for the Historic American Buildings Survey, a Depression-era program designed to hire unemployed architects and photographers. (James M. Slack, LC-HABS NM, 28-TALP, 1.)

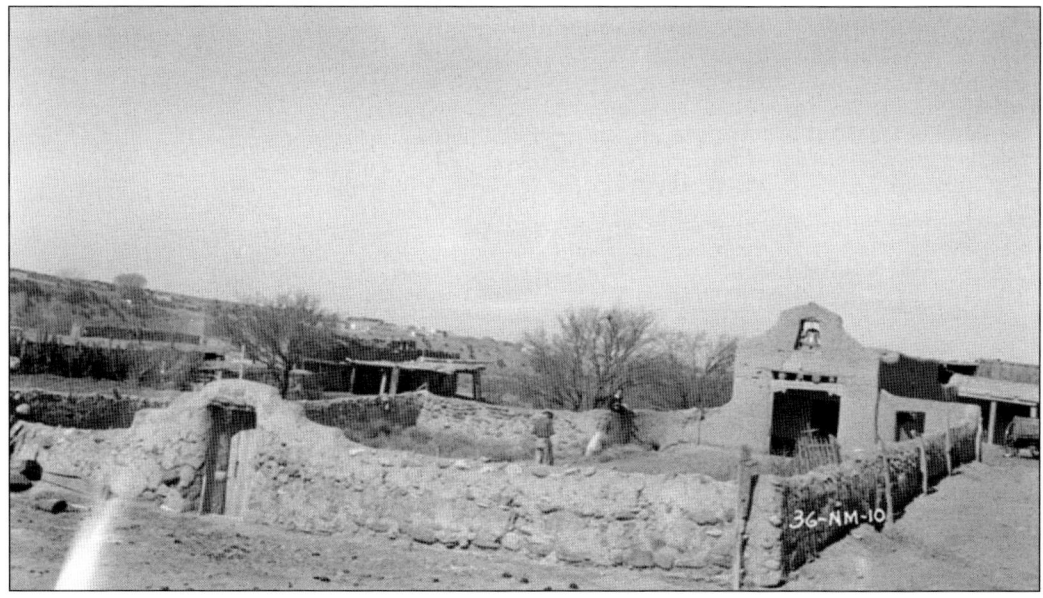

LA CAPILLA DE NUESTRA SEÑORA DE TALPA, MARCH 1934. The chapel had an adobe wall around it with a gate in front. Through family marriages, Leandro Duran became owner of the chapel in the early 1900s until his death in 1950. Due to lack of funds, the chapel was abandoned after that and today lies in ruins. (James M. Slack, LC-HABS NM, 28-TALP, 2.)

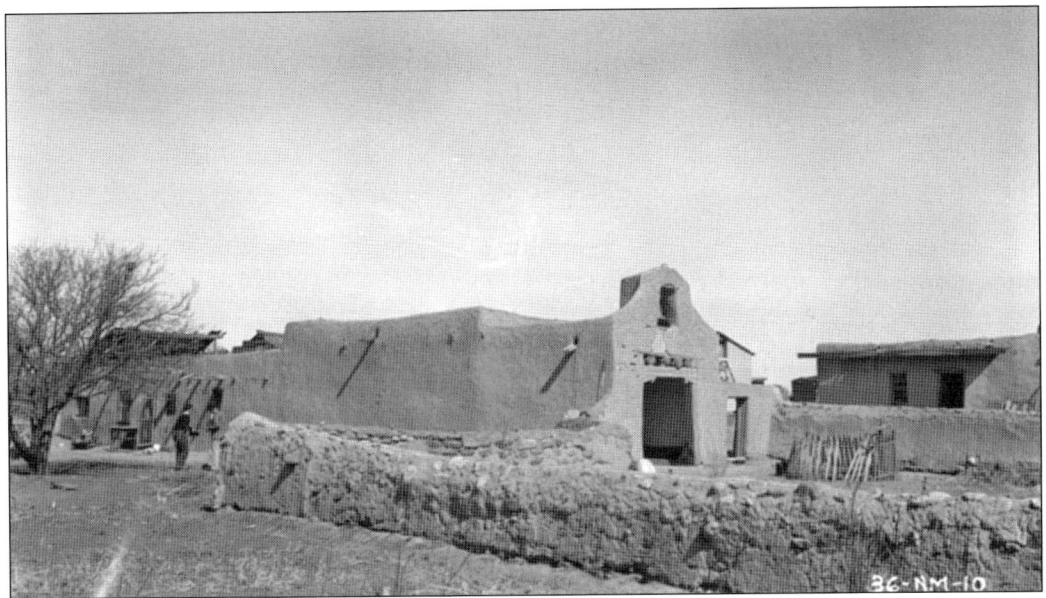

SIDE VIEW OF CHAPEL, MARCH 15, 1934. Architects from the Historic American Buildings Survey took measurements from all angles inside and outside of the building and drew detailed plans, which are now preserved in the Library of Congress. While in Talpa, they stayed at Ruth Swaine's ranch La Cumbre (the Summit). (James M. Slack, LC-HABS NM, 28-TALP, 3.)

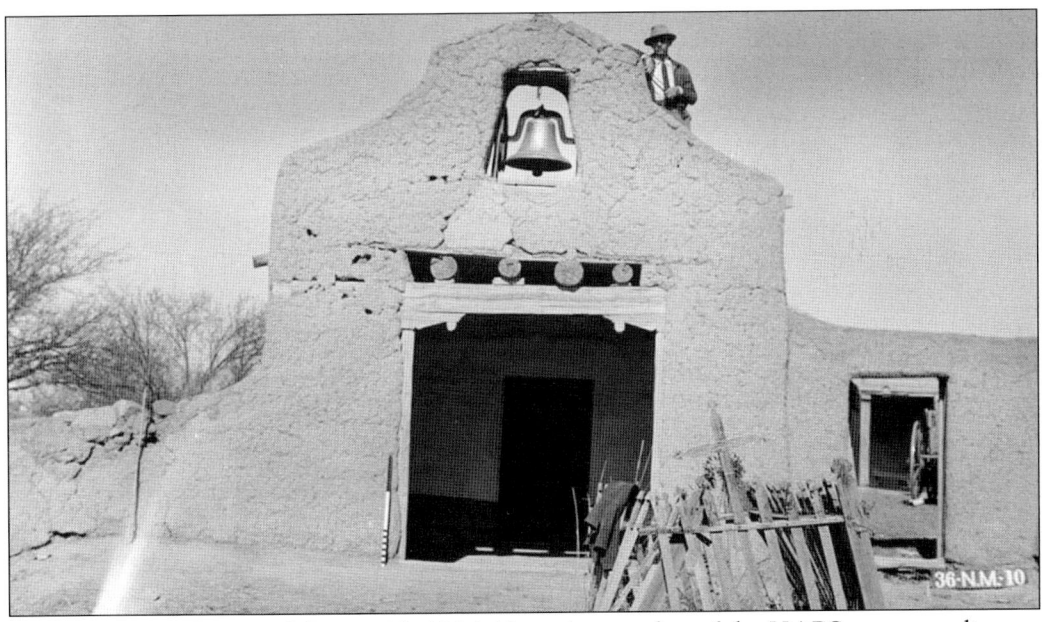

FRONT VIEW OF CHAPEL, MARCH 15, 1934. Note the member of the HABS party standing on the roof. At Ruth Swaine's ranch, they met many of the famous citizens of Taos, including artist Victor Higgins, socialite Mabel Dodge Luhan, writer Spud Johnson, and Rebecca James, a close friend of artist Georgia O'Keefe. (James M. Slack, LC-HABS NM, 28-TALP, 4.)

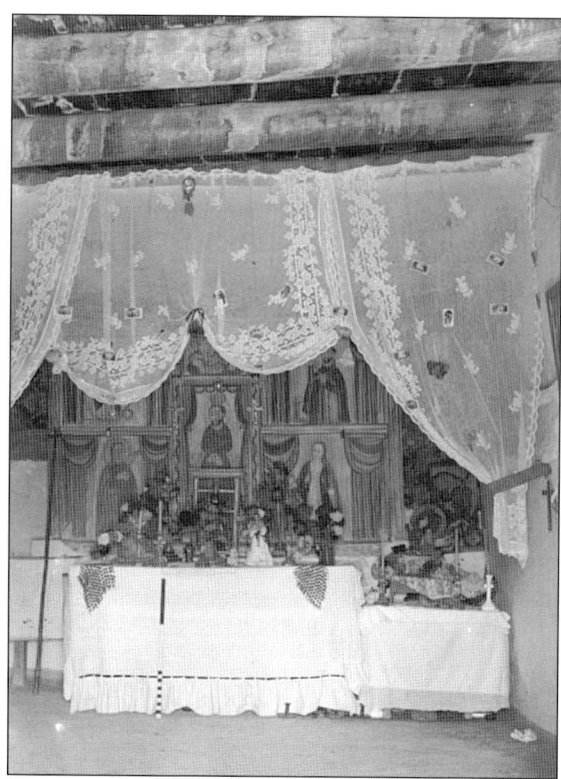

ALTAR SCREEN, NUESTRA SEÑORA DE TALPA, MARCH 15, 1934. In the 1940s, a desperate effort was undertaken to save the chapel from ruin. Despite the efforts of many well-known Taos folk, fundraising fell short. The interior furnishings, such as the altar screen and bultos (carved images of saints), were sold to the Taylor Museum of Colorado Springs. The chapel fell into ruins in the 1950s. (James M. Slack, LC-HABS NM, 28-TALP, 6.)

TALPA, SEPTEMBER 2014. One of the old structures lining the main street (New Mexico Highway 518) in Talpa is Vigil's Talpa Tavern, which was established in 1902. It is no longer in business.

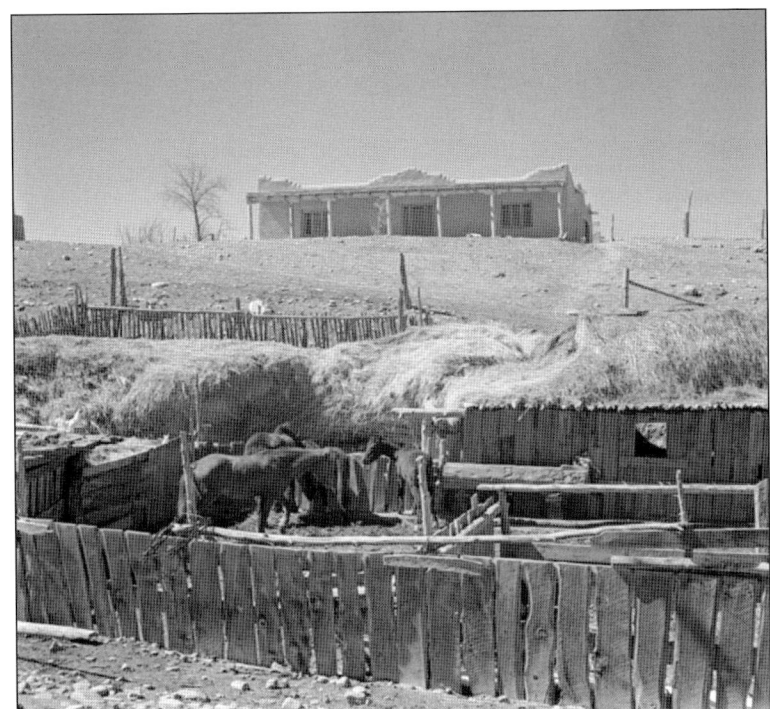

RANCHOS DE TAOS HOUSE AND HORSE CORRAL, APRIL 1936. The town of Ranchos de Taos is located on the Cristóbal de la Serna land grant, which was awarded in April 1710 to Capt. Cristóbal de la Serna, who was stationed at Taos Pueblo. The first settler on the grant appears to have been Francisco Xavier Romero, who established his hacienda Talachia there in the 1730s. (Arthur Rothstein, LC-USF34-001920-E.)

RANCHOS DE TAOS HOUSE, WELL, AND CORN, AUGUST 1936. The covered well can be seen at the far left center. The ranching community formed in the 1730s had many different names, but the most common was Las Trampas de Taos ("the traps of Taos") because of the many beaver traps set in the nearby river. (Frederic Nichols, LC-HABS NM, 28-RANTA, 4-1.)

RANCHOS DE TAOS ADOBE HOME, JANUARY, 1943. This home was owned by Meliton Struck. Las Trampas de Taos had adopted St. Francis of Assisi as its patron saint by 1765. In the 1800s, the community became known as El Rancho and eventually Ranchos de Taos. (John Collier, LC-USW3-013733-C.)

RANCHOS DE TAOS STORE, APRIL 1936. Photographer Arthur Rothstein did not identify this photograph any further except that it was taken "at noon." This was probably a general store selling groceries, hardware, and livestock supplies. (Arthur Rothstein, LC-USF34-001695-D.)

RANCHOS DE TAOS CHURCH AND PLAZA, JANUARY 1943. This view is toward the northwest with a buttress of the St. Francis of Assisi Church on the left and businesses of the plaza in the distance. The plaza was completed in 1779 for defensive purposes to protect settlers from raids by Comanche, Apache, and Ute Indians. (John Collier, LC-USW3-013735-C.)

OLD MARTINA'S RESTAURANT, RANCHOS DE TAOS, SEPTEMBER 2014. This is the modern restoration of some of the buildings on the northwest side of the plaza. The building complex was renovated by Martina Gebhart, and Old Martina's Restaurant was named in her honor. New Mexico Highway 68 is the road in front, cutting between the northwest part of the plaza and the southeast part.

THE MAGIC SKY, RANCHOS DE TAOS, SEPTEMBER 2014. This artist gallery on the south side of the plaza is no longer in business. When originally constructed, the defensive wall around the plaza enclosed two acres, large enough to hold all of the villagers' animals in case of Indian attack.

SALOON, RANCHOS DE TAOS, SEPTEMBER 2014. Andy's La Fiesta Saloon is a large two-story building still standing at the southeast corner of Ranchos plaza. It advertised "Banquet and Meeting Rooms, Cocktails & Imported Beers," as well as a restaurant, discount liquors, and a curio and gift shop. The building stands vacant today.

CHURCH AND PLAZA, RANCHOS DE TAOS, JANUARY 1943. The view is toward the southwest from the rear of the St. Francis of Assisi Church. With the frequent Comanche Indian attacks of the 1760s, the governor of New Mexico ordered the dispersed settlers to build new homes adjoining each other in a continuous enclosed square plaza to keep the attackers out. (John Collier, LC-USW3-013732-C.)

CHURCH AND STORE, RANCHOS DE TAOS, MARCH 15, 1934. San Francisco de Asís (St. Francis of Assisi) Church was completed in 1815 in Ranchos de Taos plaza. To the left is the T.A. Rivera General Merchandise store. Tómas Rivera owned this store on the southwest side of the plaza in the early 1900s. Rivera is said to have owned the first automobile in Ranchos. The church extends for a length of 120 feet. (James M. Slack, LC-HABS NM28-RANTA, 1-2.)

St. Francis of Assisi Church, March 15, 1934. Population growth at Ranchos de Taos in the early 1800s spurred desire for a local church so that residents would not have to travel to Our Lady of Guadalupe church in Taos or San Gerónimo church in Taos Pueblo to worship. On August 4, 1812, Ranchos de Taos residents applied for a license with the Archdiocese of Durango, Mexico, to build a church. (James M. Slack, LC-HABS NM28-RANTA, 1-1.)

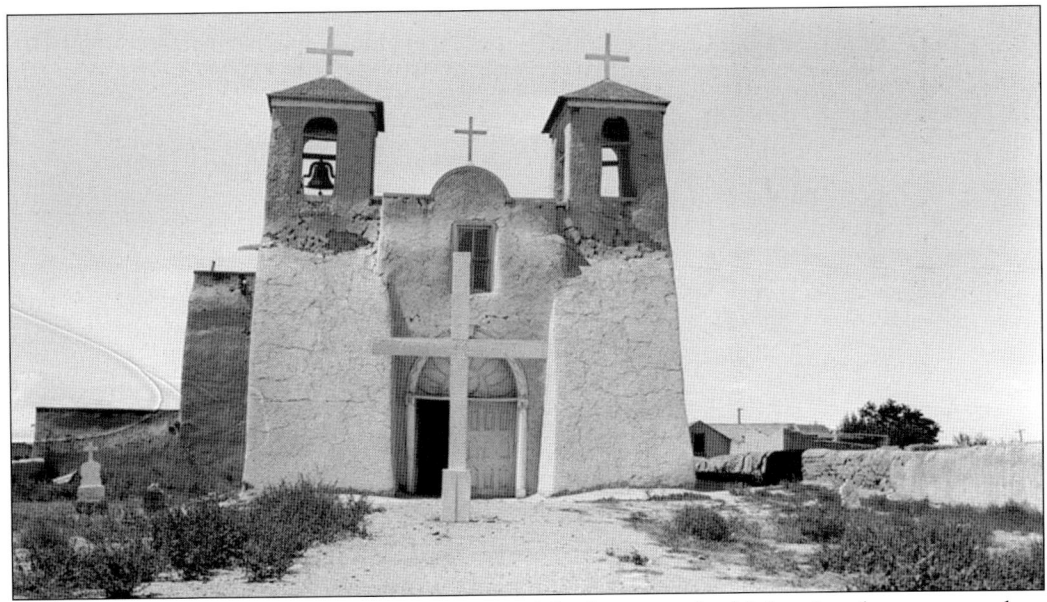

St. Francis of Assisi Church, August 1936. The license to build the church was granted on September 20, 1813. Construction may have begun before the license was received since work was completed in 1815. The adobe walls must be replastered with mud every year. This photograph shows significant deterioration of the walls from only two years prior, as seen in the previous photograph. (Frederic Nichols, LC-HABS NM, 28-RANTA, 4-2.)

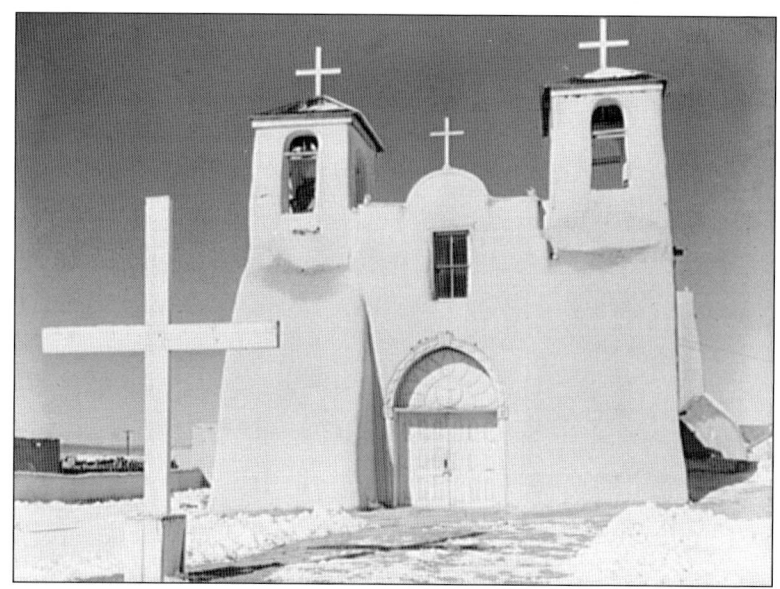

ST. FRANCIS OF ASSISI CHURCH, JANUARY 1943. Construction of the church was a massive undertaking for Ranchos de Taos residents. One hundred thousand hand-formed adobe bricks were made. Thirty-two vigas, each at least 32 feet long, were cut to span the nave along with 28 vigas for the transept, each at least 25 feet long. (John Collier, LC-USW3-013737-C.)

ST. FRANCIS OF ASSISI CHURCH AND PLAZA, JANUARY 1943. The harsh winter weather speeds the deterioration of the mud plaster on the church walls, so that replastering (a process known as the *enjarre*) must be done every summer. Traditionally, women (known as *enjarradoras*) did the replastering. Today, men and women join the *enjarre*, which takes about two weeks and involves several hundred laborers. (John Collier, LC-USW3-013736-C.)

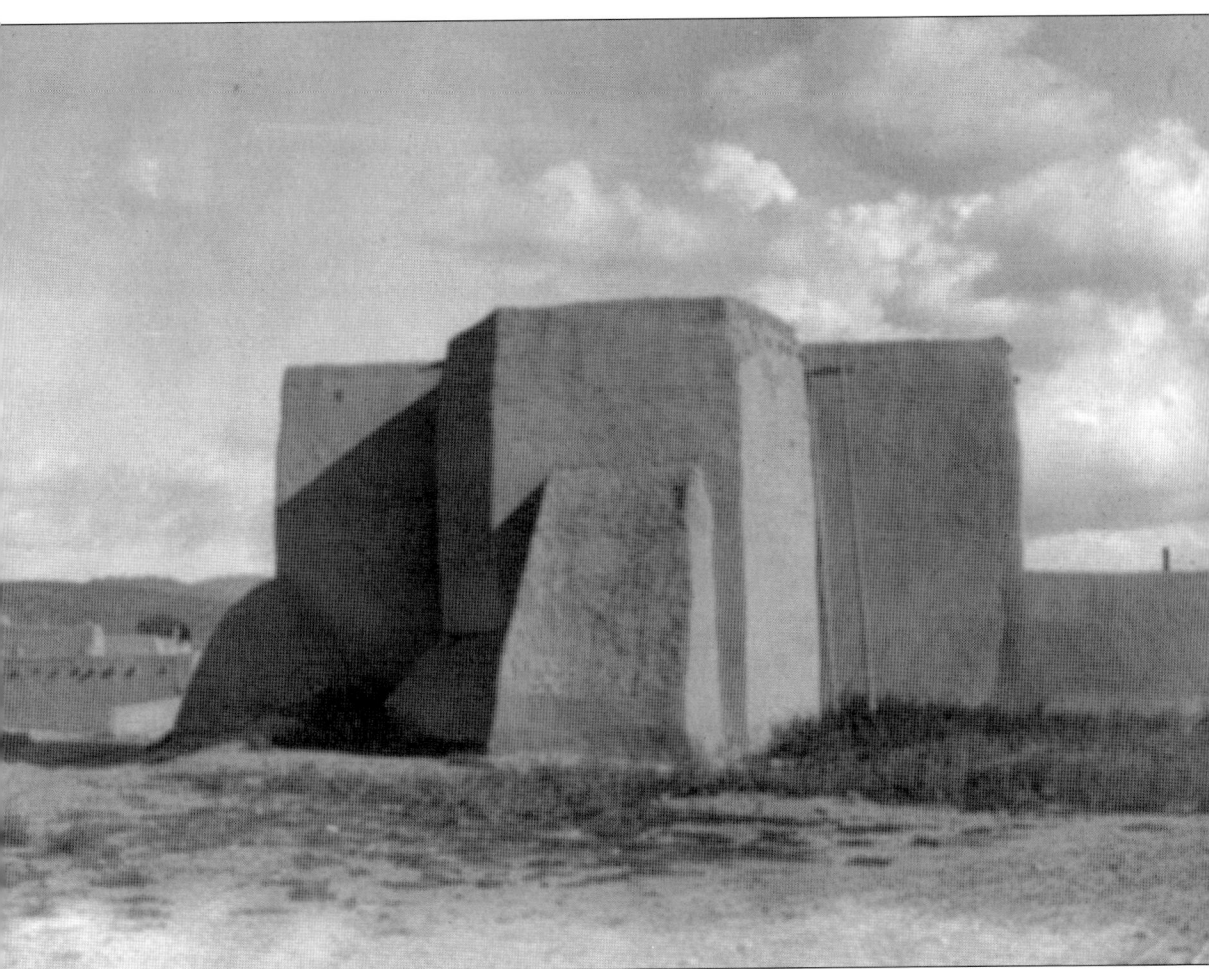

St. Francis of Assisi Church Rear, c. 1920. The massive buttresses supporting the rear walls of the church are up to 10 feet wide. In 1967, it was decided to replaster the walls and buttresses with a hard cement stucco instead of the traditional mud. It was thought the stucco would last longer and eliminate the need for the annual replastering. The cement stucco turned out to be a disaster. Cracks formed in the stucco and water seeped in. When the stucco was removed in 1979, it was found that many of the bricks were mostly mud or loose dirt. New adobe bricks were made and the walls were then mud-plastered, as they have been every year since 1980. (Arnold Genthe, LC-USZ62-41570.)

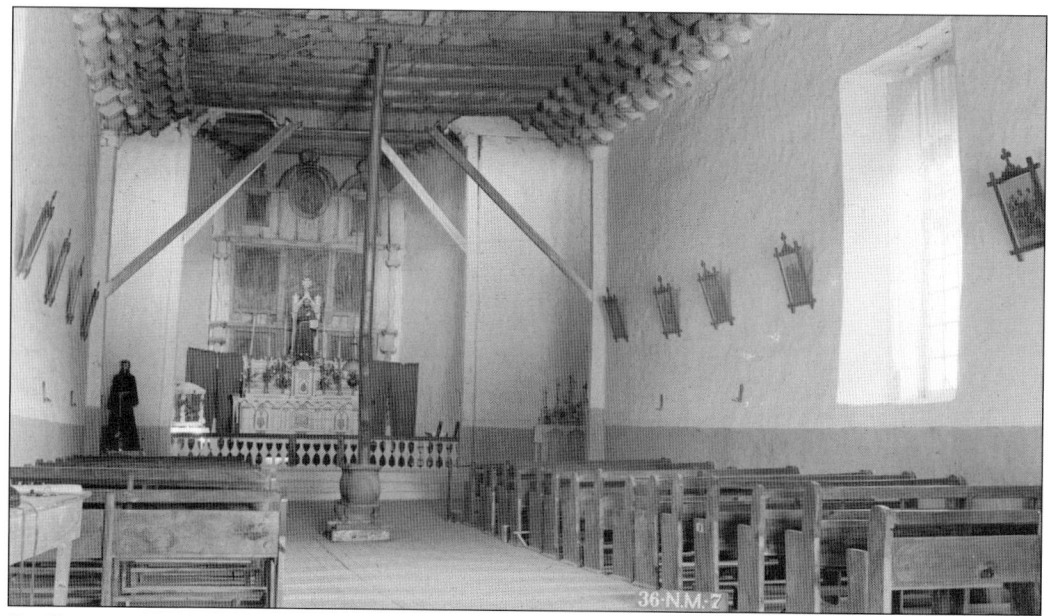

St. Francis of Assisi Church Interior, March 15, 1934. In 1934, the pews extended only halfway to the back of the church. The church was heated by the cast-iron potbellied stove at center. These stoves were first brought into New Mexico about 1860. Before that, churches were not heated, and worshippers had to bundle up in blankets and furs to try to stay warm during the service. (James M. Slack, LC-HABS 28, RANTA, 1-5.)

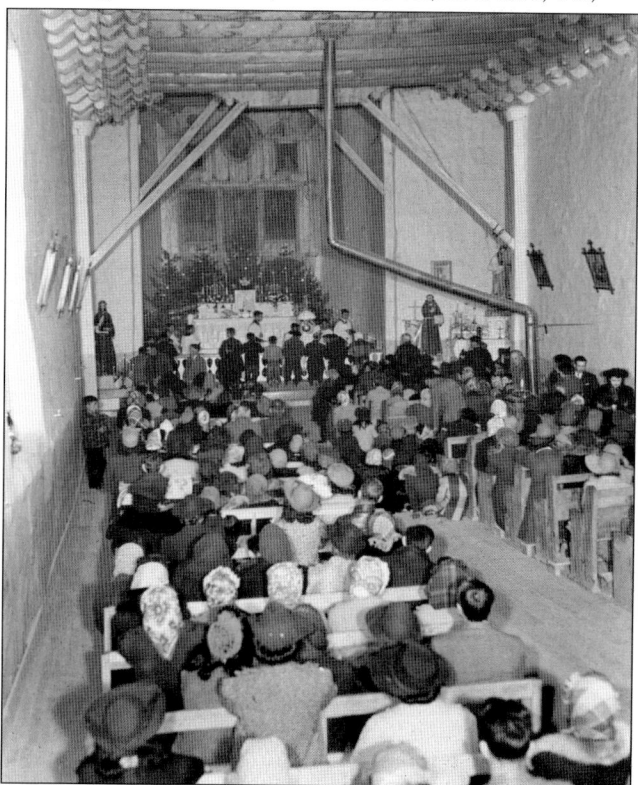

St. Francis of Assisi Church Interior, December 1942. Pews have been added all the way to the back of the church since 1934. Also there is a side aisle, which is not there today. Note that the stove has been moved to the far right, necessitating a lengthy angled stovepipe. (John Collier, LC-USW3-013746-C.)

St. Francis of Assisi Church Choir Loft, March 15, 1934. Stairs rise at the back of the church up to the choir loft. Pews stop halfway back. Note the 32-foot-long vigas across the top, which support the roof. Every viga is supported by a carved corbel at each end. (James M. Slack, LC-HABS NM28-RANTA, 1-6.)

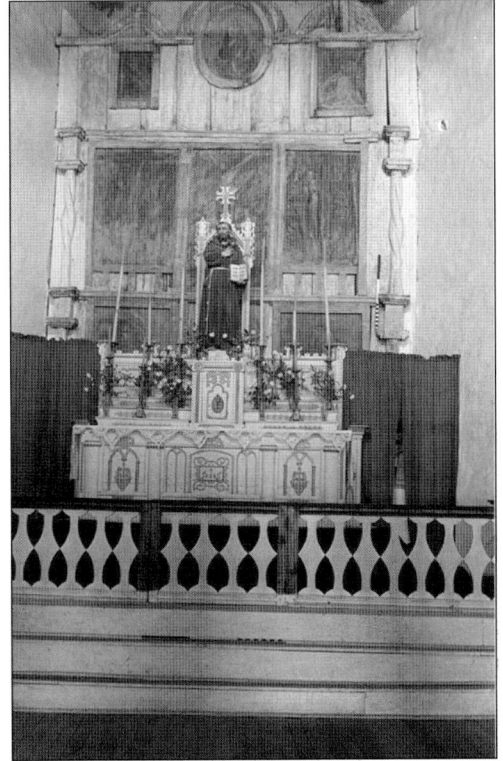

St. Francis of Assisi Church Altar and Screen, March 15, 1934. The altar was a French design and on it stood a bulto (carved image) of St. Francis. Behind the altar, the reredos (altar screen) had two carved wooden pillars and eight paintings of various saints. The altar screen paintings were quite faded. They were restored between 1979 and 1980. (James M. Slack, LC-HABS NM28-RANTA, 1-8.)

St. Francis of Assisi Church, December 1942. Children are performing a Christmas pageant in front of the altar. Note how the middle of the altar rail swings open to allow access to the altar area. (John Collier, courtesy of Maxwell Museum of Anthropology.)

St. Francis of Assisi Church, November 2015. The grand old church celebrated its 200th anniversary in 2015. It has been kept alive by the faithful who help with the *enjarre* every year. It is a truly magnificent sight and a most appropriate location for the end of the High Road to Taos.

BIBLIOGRAPHY

Bullock, Alice. *Mountain Villages*. Santa Fe, NM: Sunstone Press, 1981.
Cash, Marie Romero. *Built of Earth and Song: Churches of Northern New Mexico*. Santa Fe, NM: Red Crane Books, 1993.
Colson, J.B., et. al. *Far From Main Street: Three Photographers in Depression-Era New Mexico—Russell Lee, John Collier, Jr., and Jack Delano*. Santa Fe: Museum of New Mexico Press, 1994.
Fugate, Francis L. and Roberta B. *Roadside History of New Mexico*. Missoula, MT: Mountain Press Publishing, 1989.
Hemp, Bill. *Taos Landmarks and Legends*. Los Alamos, NM: Exceptional Books, 1996.
Hooker, Van Dorn and Corina A. Santistevan. *Centuries of Hands: An Architectural History of St. Francis of Assisi Church*. Santa Fe, NM: Sunstone Press, 1996.
Kay, Elizabeth. *Chimayó Valley Traditions*. Santa Fe, NM: Ancient City Press, 1987.
Mays, Buddy. *Indian Villages of the Southwest*. San Francisco, CA: Chronicle Books, 1985.
Nava, Margaret M. *Along the High Road*. Santa Fe, NM: Sunstone Press, 2004.
Romero, Eloyda Roybal. *The Roybal Legacy: Growing Up In Peñasco*. Albuquerque, NM: Quillrunner Publishing, 2012.
Romero, F.R. Bob. *History of Taos*. Taos, NM: Studio Karina, 2015.
Santistevan, Corina A. and Julia Moore, eds. *Taos: A Topical History*. Santa Fe: Museum of New Mexico Press, 2013.
Simmons, Marc. Foreword to *The WPA Guide to 1930s New Mexico*. Compiled by Writers Program of the Work Projects Administration. Tucson: University of Arizona Press, 1989.
———. *New Mexico: An Interpretive History*. Albuquerque: University of New Mexico Press, 1988.
Wroth, William. *The Chapel of Our Lady of Talpa*. Colorado Springs, CO: Taylor Museum of the Colorado Springs Fine Arts Center, 1979.
———, ed. *Russell Lee's FSA Photographs of Chamisal and Peñasco, New Mexico*. Santa Fe, NM: Ancient City Press, 1985.

Discover Thousands of Local History Books
Featuring Millions of Vintage Images

Arcadia Publishing, the leading local history publisher in the United States, is committed to making history accessible and meaningful through publishing books that celebrate and preserve the heritage of America's people and places.

Find more books like this at
www.arcadiapublishing.com

Search for your hometown history, your old stomping grounds, and even your favorite sports team.

Consistent with our mission to preserve history on a local level, this book was printed in South Carolina on American-made paper and manufactured entirely in the United States. Products carrying the accredited Forest Stewardship Council (FSC) label are printed on 100 percent FSC-certified paper.